D

E

F

BEHAVIOR OF PIGMENTS IN PAINTS

The
PAINTER'S
CRAFT

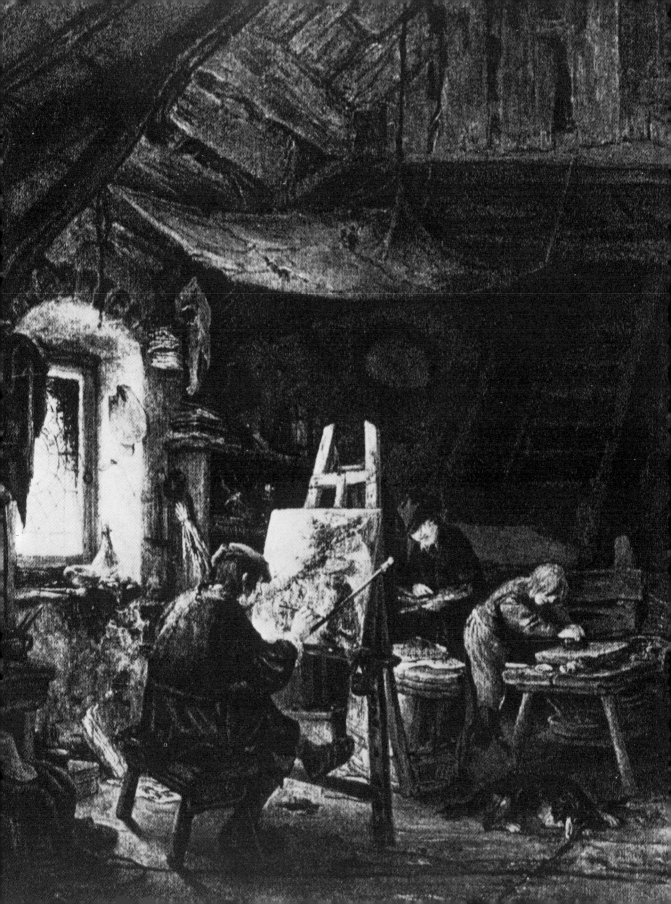

The PAINTER'S CRAFT

An Introduction to Artists' Methods and Materials

Ralph Mayer

A Studio Book The Viking Press New York

Frontispiece: "The Painter in His Studio" by Adriaen van Ostade. The Rijksmuseum, Amsterdam. Photo: Courtesy of The New York Public Library.

Third edition first published in 1975 by
The Viking Press, Inc., 625 Madison Avenue, New York, N.Y. 10022

Published simultaneously in Canada by
The Macmillan Company of Canada Limited

SBN 670-53569-9

Library of Congress catalog card number: 75-1578

Printed in U.S.A.

PREFACE

This book is designed both as a text for class or workshop instruction and as a guide for the practicing painter who wishes to acquire by independent study a systematic knowledge of the standard data relating to the craft on which his art is based. It presents the basic background knowledge that any artist must have in order to succeed as a competent professional or amateur.

Although planned for the beginner as an introduction to the technical part of artists' work, it should be of much value to the mature painter as an additional source of knowledge, especially when he has not been so fortunate as to have received formal training. The plan and content of the book have been guided by experience gained in a large contact with practicing painters and in courses and lectures given to artists and students.

I have endeavored to confine the present volume to standard materials and procedure, and to avoid those ramifications which lie beyond the compass of a general textbook. After an outline of the important basic principles which underlie the behavior and use of paints, the physical aspects of color are discussed in Chapter 2, solely for their application to the techniques of painting and divorced from any aesthetic involvements. The section on pigments includes only such matter as is essential for a grasp of the subject, yet it omits no important information that the painter should know. The chapters on the various methods or techniques of painting follow the same plan, except that the section on the preparation of gesso panels and also the section on homemade pastels are expanded to somewhat greater detail. One reason for the lengthier treatment of these topics is that they are typical studio activities and have not, to my own satisfaction, been well described elsewhere. Conversely, the chapter on mural painting has been very much condensed and generalized because, by its very nature, anything less than the most complete volume of detailed information about this subject would not be of much further practical value.

Throughout the book, emphasis has been placed on the basic principles rather than on the "how-I-do-it" method of instruction. Definite recipes and instructions almost always require much alteration to suit individual requirements, variable raw materials, and divergent purposes. The artist who has a sound grasp of fundamentals is in a better position to solve new painting problems more successfully than the one who follows a recipe or set of directions by rote.

The color demonstration on the inside of the front cover illustrates a number of points brought out in several parts of the text concerning the color effects of pigments and the extent to which they are influenced by various circumstances. The swatches were made with actual pigments dispersed in an oil-resin vehicle and printed by the silk-screen process. Consequently, they are real paint films of appreciable thickness, and they display actual color, opacity, and gloss effects instead of the partial rendering or approximation that would be shown by printer's ink.

This demonstration appeared as a frontispiece in the first edition of this book in 1948, which is believed to be the first time the silk-screen process had been applied to this purpose. It was, unfortunately, omitted from the 1966 revision because the cost of tipping the page into the book had become prohibitive. The problem has been ingeniously solved in the present edition by Mr. Peter Grant, Production Manager of Studio Books, The Viking Press, and once more this aid to understanding pigments can be used.

"A" represents the appearance of dry, powdered ultramarine blue; "B" the same pigment made into a gouache paint; and "C" the same pigment as it appears in an oil paint. "D" is straight burnt sienna in oil as applied in normal brushstroking; "E" shows the same paint diluted and applied in a thin, transparent manner; and "F" is burnt sienna when tinted with titanium white to about the same value as "E."

During the few years since this book was last revised, more new materials have been introduced and more changes in old ones have taken place than at any other period. Chapter 10 reviews the new materials and practices; there isn't much one can report on a product of recent development. Our traditional mediums have the benefit of centuries of experience and much can be written about them; with a recently adopted technique there are few do's and don'ts, and mostly a recital of its good points, the advantages over traditional methods, as well as any shortcomings as compared to the older materials.

The author is indebted to Murray Pease, Harry Carnohan, and Bena Frank Mayer for valuable assistance in reading and criticizing his manuscript, to Alvin Taylor and Maurice Bratter for executing the photographs.

I am indebted to Mr. Walter Russell for his painstaking work on the new illustrations and on necessary retakes of some of the older ones.

RALPH MAYER
May 1975

CONTENTS

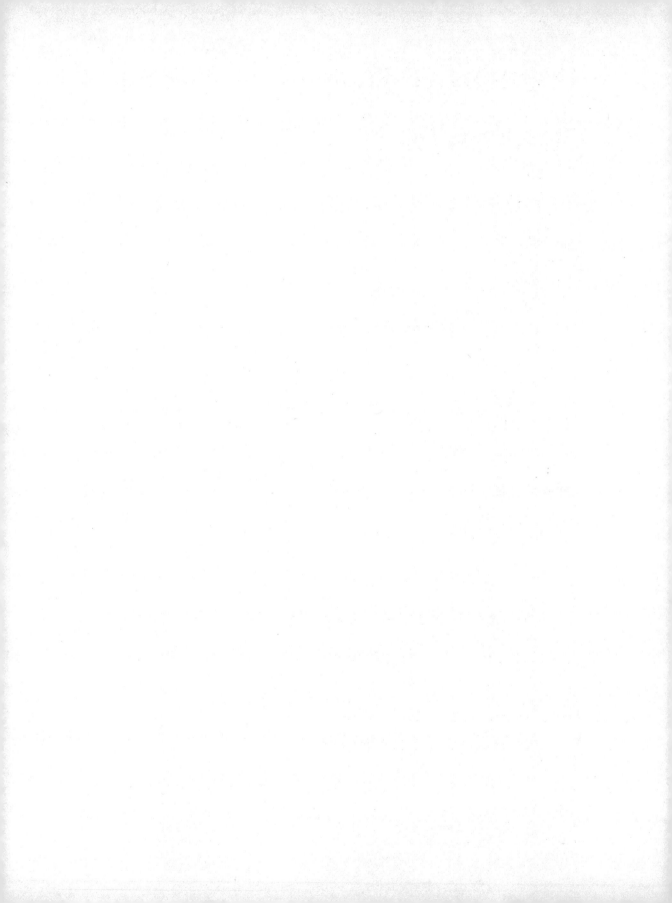

INTRODUCTION 1

The *craft* of painting is a study apart from the *art* of painting; yet the two are closely interrelated and overlapping. The artist cannot entirely divorce the artistic or aesthetic aspects of his work from his studies of materials and methods by treating the subject on a completely scientific or mechanical basis, nor can he ignore all technical considerations in his efforts to establish a personal technique for the expression of his aims.

However, there are so many different artistic intentions among artists, and so many divergent theories and purposes among groups or schools of thought, that the subject of painting materials and methods must be presented by the teacher to the artist or scholar as a separate technical study, free from aesthetic implications. At the same time, it is understood that few persons will want to study this subject for its own sake; that always behind the effort to become proficient in the media of his craft lies the desire to apply this proficiency to the requirements of the specific form the individual has selected for his art.

Artists and schools of art have strong disagreements and arguments among each other on practically every point concerning the technique of painting, except when it comes to the correct selection and application of painting materials. Here they stand on common ground (or should do so) because the rules of craftsmanship apply equally to the painter who aims at perfection of finish or tight draftsmanship and to the artist who paints in a loose, rough manner; to the one who emulates traditional ideas and to the one whose ideas are in the modern style or of an experimental nature.

The artist must be master of the technical side of his painting for three reasons, all of equal importance:

1. *To assure permanent results*

If his choice of materials and their application are correct, he will avoid those physical failures and blemishes to which improperly executed paintings are subject with the passage of time. Correct modern procedure is founded on rules and laws, based on scientific and logical principles and substantiated by the experiences of the past.

Permanence in an artist's work means absolute permanence; that is, the work is designed to endure as long as it is humanly possible to insure its survival. It should not be confused with relative permanence, the basis on which our industrial products are designed. Good paints for houses, boats, or signs are expected to wear out and be replaced within a

9

limited period; the difference between a nonpermanent and a permanent industrial paint or varnish is merely that one will fail quickly whereas the other will last for a reasonable number of years before requiring replacement. All the accepted, traditional art techniques in painting are of equal permanence if the pictures are given the care and preservation which works of art are normally intended to receive, except that some are more fragile than others when subjected to more drastic treatment. All of us are familiar with the cracked, blistered, or wrinkled condition of some of the old oil paintings or the faded condition of some old watercolors. On the other hand, there are many examples of old pictures that have remained intact, just as the painter intended them to be seen. We would like our own work to survive indefinitely in good condition, and our only assurance that it will is to follow the established procedures, which are primarily based on knowledge gained from the experience of the past.

2. To secure proper control of manipulations

It is not enough for a paint to be permanent—resisting the ravages of aging and the effects of sunlight and atmospheric conditions—but, in order to be an acceptable material for artists' use, it must also be capable of being manipulated; that is, it must be under the control of the artist at all times so that the effects he seeks can be obtained without overlaborious and troublesome procedures. For example, for some styles of painting a paint must be capable of being brushed out thinly and smoothly to a transparent layer that will not sag, drip, or run; for others it must be applied in a thicker, more opaque coating. Again, some paints are required to produce crisp, clean brushstrokes; with others a softer, blended effect is required. Also, the color of a paint must be clean, clear, true to its type, and there are several requirements it must meet in order that the painter may control color effects.

Artists' materials of the highest grade do not necessarily have to be so perfected in these respects that they will respond automatically to any sort of casual or careless attempts to apply them, but they should be sufficiently controllable so that it will not be beyond the ability of the average painter to acquire the skill necessary for successful manipulation after a reasonable amount of experience.

These requirements have not always been in effect. For instance, the very early European easel painters used materials that seem to us awkward and difficult to command. They paid considerable attention to the use of permanent materials, but they overcame difficulties in these matters by developing a very high degree of skill rather than by improving the working qualities of their materials. The later painters either adopted new materials or developed improvements designed to facilitate the executive properties of their paints; by the eighteenth and nineteenth centuries they had even gone so far as to subordinate permanence of results to ease in manipulating paint, or to obtaining special color and textural effects with little or no regard for their lasting qualities.

10

This led eventually to use of the most impermanent materials and methods; the training and instruction of painters were confined solely to manipulations and aesthetic doctrines, while artists developed their work in ignorance of the most elementary principles regarding permanence. The modern painter has the advantage of improved materials and methods, which have been developed and standardized through the ages and verified by scientific controls, combined with the opportunity to study the basic underlying principles of his craft. This substitute for the earlier apprentice system was either not available or not grasped by many painters of the recent past.

3. To choose appropriate techniques

The choice of a technique that will be most appropriate to the subject at hand, or to the ultimate function of the work, or to the artist's own personal requirements obviously involves several considerations besides purely technical ones. But the final choice is largely influenced by technical considerations, and the artist who has a broad general knowledge of all painting methods—regardless of which one is his specialty—has a great advantage. He is thereby able to modify and alter his technique to suit his personal requirements by taking what he needs from other technical methods of painting; he is also able to vary his technique to suit the different types of painting he may want to do from time to time.

The question of which technique or modification of a technique to use depends on a number of circumstances. A correct decision on this point is quite as important to the artist as his choice of permanent materials, because success or failure in expressing himself depends to a great degree upon it.

Some of our methods of painting are quite flexible as technical processes, with much leeway permitted in the observance of rules and regulations; other methods are more critical and the artist must comply more strictly with the letter of the law. The intelligent painter will soon learn the common-sense application of materials and methods and with experience will be able to judge for himself. The rules of correct procedure should not be a deterrent to free expression in painting and need not hamper an artist by presenting continual restrictions or bugaboos; rather, they should free him to go ahead and paint with the knowledge that he is doing the right thing. On the other hand, the basic, fundamental rules must not be ignored if permanence and successful manipulations are to be achieved.

The importance of observing all the individual precautions and in following correct procedure in all details may be realized if one considers that frequently a painting is defective or disappointing because of a complication of mistakes. Even in the more flexible procedures, if each one of its elements is a little off, the accumulation of faults will cause a failure, whereas if all the rules have been carefully observed one small discrepancy may not matter appreciably.

11

Painting is the application of color to a surface. This is the simplest general definition that can be made.

Pigments. The colors used in painting are known as pigments. The pigments are dry powders which are manufactured from raw materials (natural and artificial) and which, in order to function properly, must be carefully made to meet very strict requirements. The simplest form of painting, therefore, is to smear dry pigments on a rough surface. This is done in pastel painting; pastels are pigments or mixtures of pigments, molded with water and a little gum into the form of crayons and then dried.

Pigment requirements. The pigments used in the various kinds of paint—oils, watercolor, and so on—are the same; the difference lies in the liquid used. This is merely a broad general statement (as will be seen by referring to the remarks about pigments for each technique), since a pigment that is suitable for one kind of paint does not always meet the requirements of another. Some techniques require transparent pigments, some require opaque pigments, and some are limited to the use of pigments with very special properties. All modern methods of painting require a pigment to be a very smooth, finely divided powder, as brilliant and clear in color as its type can be made, free from impurities, and insoluble in its vehicle. It must be absolutely permanent, impervious to the effects of sunlight, also of atmospheric and other conditions under which the painting is expected to endure.

Vehicles. Paint, in the ordinary sense of the term, means a fluid material into which a brush may be dipped in order to apply the fluid to a surface and spread it around. Such paints are made by combining dry, powdered pigments with various liquids. When this is done with true pigments of the correct properties, the colors do not dissolve but remain in suspension, completely dispersed in the liquid. After the paint has been applied to a surface and has become dry, the layer of pigment imparts its typical color to the surface; its precise tone, value, or brightness is subject to modifications depending upon the conditions which surround it, these being due mainly to the nature of the liquid used as a vehicle. In practice, virtually no successful paints can be made by a simple mixing of the dry pigments with the vehicle, because for several reasons a paint usually requires thorough grinding by strong friction if it is to behave correctly.

The functions of vehicles. Thus far only one function of the liquid ingredient has been considered—putting the pigment in a fluid form so that it is possible to apply and brush it out. This may be called its *executive* function, but there are three other functions a vehicle may serve. We could demonstrate the first, or executive, property of a vehicle by using plain water or turpentine as our liquid, which would suffice for this purpose alone, but would result in a spread-out layer of pigment entirely unsatisfactory as a paint. It would be smeary, irregular, and

dull. When dry it would soon rub off or drop from the surface, since both water and turpentine are completely volatile—that is, they evaporate into the air on drying and leave no residual substance that has any effect on the pigment. Such "paints" have not been used since the prehistoric cave painters, unless one includes the body painting practiced by primitive tribes.

Binding. If we use a mixture of starch paste and water for our liquid and grind the pigment into it thoroughly, then the paint on becoming dry will hold together, because the pigment particles are pasted or bound into single mass by the starch after evaporation of the water. This illustrates the *binding* property of a vehicle.

Adhesiveness. However, such a mixture of starch paste and pigment alone does not make a very good paint. The film is very likely to crack and may flake or peel away from the surface because this particular combination of pigment and paste does not have good *adhesive* qualities. If, instead of the starch, we use a glue (made from animal skins) or casein (which is made from the curd of skim milk) or egg yolk or gum arabic (a vegetable product obtained from a North African tree), paints can be produced which will have all the three desirable properties: (1) they can be brushed out nicely; (2) the pigment particles will be bound together in a uniform film; and (3) they will adhere well to most surfaces. It should be noted that the term "binder" is used interchangeably with "vehicle"; the two terms indicate the same ingredient of a paint but in reference to different functions; it is called a vehicle because it carries the pigment, and it is also called a binder because it binds the pigment particles to each other and to the ground. The industrial paint technicians have a third term for the same ingredient—film former.

Optical. The fourth influence which the medium of a paint has on the pigment is optical in nature; it changes surrounding conditions because, if the pigment is coated or surrounded by the binder (and not by air as it was in the dry state), it will exhibit a different color effect, in conformance with a law of physics. If we make our paint with a well-chosen oil or varnish, the full depth or intensity of the pigment is brought out; the dried layer or coat of such a paint will have color effects different or modified from those produced with a water vehicle even when identical pigments are used. (See B and C, Front endpaper; for further explanation, see page 24.)

Balance of Properties. Not only must paints be mixtures of the best pigments and vehicles, but, in order to meet the requirements of the various techniques, the amounts or proportions of the ingredients must be carefully adjusted; also, the vehicles themselves, which in many instances are mixtures of several components, must be well balanced in order to function properly. Certain techniques are more exacting in this respect than others since the materials required for these must be compounded within very strict limits, whereas the rest allow more latitude

13

both in selection and proportions of the materials used. In the formulation of a paint it is sometimes necessary to sacrifice superlative performance in one direction for the sake of some more important quality. House paint, for example, may often sacrifice permanence and extreme durability because of the deliberate use of materials designed to make the paint act in a certain manner—to dry more rapidly, or to brush out easily to a smooth, flawless coat, or to remain indefinitely in a soft, liquid condition on the dealer's shelf. Similarly, it would be quite simple for the maker of artists' paints to produce materials with superlative brushing-out or working qualities, extremely brilliant in color, lower in cost, and exceeding the superficial properties of honest paints—if the restriction of utmost permanence were ignored. Even if a paint has superlative quality in one respect, it is not a successful or desirable material unless it also conforms to all the other required standards. The correct balance of properties for paints will be found listed among the requirements for the materials employed in the various techniques.

Grounds. The nature of the ground or surface upon which the painting is done is of primary importance to the successful performance of all these properties of paints. The role of the ground in relation to the optical behavior of oil paints is noted on page 22, to permanence and adhesion on page 92, and to executive or manipulative control on page 93. The other methods of painting—watercolor, tempera, pastel, fresco, and so on—also have their very exacting requirements for grounds and supports; no amount of care and attention paid to the paints themselves will give successful results unless the equally important requirements for grounds are also fulfilled. A full discussion of paper as a ground begins on page 130.

Easel Painting. This term means a bit more than just a picture that has been painted on an artist's easel. It denotes the kind of painting that is meant to be hung on a wall, usually in a picture frame, as distinguished from a mural painting, which is either painted directly on the wall or pasted to the wall. Easel painting is also distinguished from works by commercial artists, illustrators, and designers, which are exclusively done for reproduction in or translation to other materials (for example, printer's ink). Such work need not follow the rules for permanent painting, since the original is seldom valued as a unique work of art, and if it must be preserved for future reference, is kept away from light in a portfolio or file. By inference, the easel painting has been done in accordance with the rules for permanent painting.

PAINT QUALITY

We now come to an attribute of paintings that might be said to go beyond the purely technical and to verge on the aesthetic part of painting.

The term *paint quality* describes the intrinsic beauty of a paint

coating or the satisfactory material accomplishment of the painter's intentions in paint, as opposed to an inept handling or a paint surface that falls below the accepted standards of good craftsmanship. The term is primarily used in connection with normal oil painting where it implies an acceptably full, substantial paint layer as contrasted with dull or smeary effects, but it may also be used to denote the successful appearance of the paint in other techniques.

Paint quality in a picture is immediately apparent. Some of the elements that contribute to it are correct choice of materials, reasonably skillful manipulations, and control of color effect. There are no universal laws to which painting must conform in order to get this combination of texture, color, and appropriateness because there are so many divergent intentions among painters and because of the different qualities inherent in the various techniques and materials of painting. Painting that is intended to be bold and vigorous demands a different treatment from that in which delicate and subtle effects are wanted. The standards of taste and appropriateness that guide the painter in this respect are not based on arbitrary rules or upon fashion but are universal in their appeal. Ever since the earliest recorded critical estimations of painting as an art form, this attribute of paint quality has been regarded as an essential element of excellence. It is a thing apart from excellence of design or artistry, and the most primitive as well as the most refined works may have it or lack it.

Paintings are sometimes greatly appreciated on the basis of supreme accomplishment in a single direction—for some aesthetic or emotional element, for qualities of design, form, draftsmanship, color effect, even when they are obviously lacking in other of these attributes, since few important schools of painting have ever insisted on a picture's having everything. But few works of art have been held in highest esteem in any period unless the technical possibilities of their *mediums* were exploited to the extent where certain minimum standards of technical excellence were fulfilled, and the attribute called paint quality is always one of these.

Excellence of technique or technical accomplishment also involves a confident, masterly brushstroking and an absence of timidity and "pickiness." All these enter into the creation of paint quality; in fact there is very little in the sum total of our best attempts to establish a good working technique that does not contribute toward that excellence of material which distinguishes successful techniques from those that fall short of their expectations.

HISTORICAL DEVELOPMENT OF MATERIALS

In prehistoric times and from the earliest recorded periods of history, man's use of color—not only for artistic purposes but also for many other functions—has brought about a continual search for pig-

15

ments and mediums to fulfill the requirements that have been outlined in the foregoing pages. The use of most of the colors and of all the binding materials employed in our traditional techniques is of great antiquity, and scholars have recorded the various developments in materials and methods that have led from early times to our present-day traditions. We have a record of behavior with respect to materials and methods that goes back more than two thousand years in written accounts and far beyond that through relics and early examples. These may be studied in the various books on special subjects (see page 194). Two of the most complete and well-known treatises that have come down to us are the works of Theophilus Presbyter, a monk who lived in Northern Europe in the eleventh or twelfth century, and an Italian painter of the fourteenth century, Cennino Cennini, whose book is referred to on page 123. Numerous smaller books and manuscripts of the early days, as well as later works of every period, are available in English translations in art libraries. This study is a valuable adjunct to the painter's understanding of his techniques and bears the same relationship to the techniques of painting as the study of art history does to the practice of art today.

Few painters are interested in following out the exact procedures of the past in order to make exact copies of old masters; a knowledge of the history of materials and methods is useful to the present-day painter primarily because it explains the reasons which underlie the development of our current techniques and because it supplies us with information regarding the permanence and capabilities of our materials.

Development in materials and methods followed the changes and development of art, largely as reflected in the type, nature, and purposes of the works of art which were required in various periods; also, it was naturally influenced by climatic conditions and the availability of supplies. Although careful studies have been made both of painting materials from all past ages, and the schools of painting in which they were employed, the average present-day painter still suffers from a lack of fundamental knowledge of his materials, a condition which he inherits from the painters of the eighteenth and nineteenth centuries.

The "secrets of the old masters." As is well known, the early painter received training in craftsmanship in the studio of a recognized master. There, over a period of years, he not only acquired instruction and practice in draftsmanship and painting but he also had duties to perform, arduous tasks and labors in and out of the studio such as were necessary in those days when communications, sources of supplies, ready-made materials, and labor-saving devices were rudimentary. He was taught, and gradually entrusted with, the selection of raw materials, the mixing and grinding of paints, the preparation of varnishes, and the making of grounds. He saw these materials consumed, he took part in criticisms, and he thus played an active part in the historical development and improvement of the various techniques. By the time he be-

came qualified to take commissions as a master in his own right, there were few technical secrets hidden from him; and if one studio excelled in any particular technical detail it was not long before its contemporaries could duplicate those results. The handful of masters who are outstanding figures in the history of art were men who combined the common knowledge of their times with extraordinary powers of artistic or creative genius and a high degree of skill.

As conditions changed with the years, a combination of circumstances caused a gradual decline in the basic knowledge of the painter's craft. Gradually earlier studio traditions were abandoned, and by the latter part of the eighteenth century the average artist had changed from a craftsman to a gentleman who had little or no concern with the details of the craft, relying on the shops for materials and, as a rule, confining his entire creative output to whatever single method of painting was in vogue in his particular circles. By the nineteenth century, the lack of permanence and the difficulty of controlling effects had led artists to strive for an improvement in craftsmanship; the most popular of these efforts became a search for the mysterious and elusive "secrets of the old masters." To this day, complicated mixtures of materials and intricate methods of procedure are occasionally invented or unearthed from discarded methods of the past and offered to artists as the means by which the older painters achieved their remarkable results. By employing these systems, the present-day painter is supposed to be able to duplicate such results despite his own lack of skill and training.

Although the general level of craftsmanship in painting may have reached a low mark during the nineteenth and early twentieth centuries, it must be remembered that there have always been careful painters who have studied their craft and used rational methods of painting. With our present standardized and improved materials easily available and our present opportunities to study the subject, there is no reason why the conscientious painter of today cannot learn to produce as permanent and controllable results as those of past ages.

Today a mass of reliable data is available for the guidance of artists who want to improve their techniques or adopt new ones, and the present situation is favorable for experimental work on the development of new techniques. Courses of instruction on practical studio or workshop methods, as well as courses embodying the basic principles of painting technology, are given in various art schools and colleges. Not a very large proportion of those who complete such work—either in educational institutions or independently by themselves—will care to continue all the procedures they have learned, but the knowledge is indispensable.

Few painters, for example, will want to make all their own colors; but, once a painter has learned how they are made, he finds he has elevated himself to a point where he does not hesitate to use his judgment and knowledge in selecting and applying materials to any purpose. There are, of course, certain techniques where it is desirable and profit-

able to prepare one's own materials; there are some materials that cannot be obtained in any other way; and there are the ever-present emergencies with which artists have to cope. Thus, the ability to make certain supplies or to adapt materials to other purposes can be turned to very practical use.

THE FINE ARTS PAINTING METHODS

Each kind of painting has its variants or subdivisions, and each is adaptable to a number of purposes. Hundreds of years of experience have shown us that, when preserved under the normal conditions usually afforded to works of art, all are equally permanent, although some are more durable or less fragile than others when exposed to more severe conditions. The principal accepted methods of painting are listed below:

Oil painting. The typical or customary example is a picture painted in straight oil colors on a stretched linen canvas which has been primed with white oil paint.

Watercolor. Painting on pure white rag paper with prepared transparent watercolor paints sold in tubes or pans.

Gouache. Painting on white or tinted paper with the same materials as watercolor except that opaque instead of transparent colors are used.

Tempera. Painting on an absorbent gesso ground with emulsion paints which can be thinned with water. Tempera paints differ from the other water- or aqueous-medium paints in that they can be manipulated to a greater number of effects and with more finesse, and in that, when dry, they may be overpainted with other coats of tempera or oil paints without being disturbed.

Pastel. Painting with pure pigment in the form of crayons without the use of fluid mediums.

Fresco. Painting on freshly applied, wet, lime-plaster walls with colors made by grinding the pigments in water. There are several other less widely used methods of easel and mural painting which will be mentioned in the text.

The accepted techniques of painting have all survived the test of time because they fulfill certain requirements which fine-arts mediums must possess. In the present period of art there is far less of the feeling of the recent past that oil painting is the noblest or most serious form of easel painting and that watercolor and the other recognized methods are minor techniques, but each one of these kinds of painting is appreciated for what it is, a particular method which the artist has chosen to express his intentions, using the plastic or technical means most appropriate to his purposes.

Synthetic Resin Paints. It is difficult to make generalized comments on the paints with binders wholly composed of synthetic resins. They are discussed in the section beginning on page 167.

SUMMARY

To summarize the basic principles covered in this chapter, the following points can be emphasized:

1. A paint is made by grinding a dry, insoluble pigment into a liquid vehicle.

2. A paint vehicle has four equally important functions; the first concerns the liquid paint, and the other three the dry paint film.

Executive. The vehicle keeps the paint fluid, so that it can be applied and manipulated as required.

Binding. It holds the pigment particles together in a continuous layer, so that the layer will be strong and durable enough to withstand the service required of it.

Adhesive. It secures the pigment layer permanently to the surface to which it is applied.

Optical. When dry, the substance of the vehicle surrounds the particles of the pigment and thereby alters its color effect, changing it from its original state in which the particles were surrounded by air.

3. A basic rule is that any paint must have balanced properties—that is, it must comply with all of the requirements of its type. Even if it is superlative in one single property, it is not a good or useful material unless it is also satisfactory as to its other requirements. The rule also applies to each component of a painting—a pigment, an oil, or a water medium, or the ground on which it is painted.

4. Paints must be composed of time-tested, accepted, thoroughly known ingredients, in order to comply with the painter's three main requirements: permanence, successful manipulation, and appropriateness of materials and method according to the work in hand.

COLOR 2

The painter uses color as a direct means to realize his creative expression. In order to control color effects, he must understand certain fundamental technical points regarding the physical behavior of his materials. Color has been studied from many viewpoints; countless books have been written, and many divergent theories and systems have been evolved, covering its various aspects—aesthetic, psychological, purely scientific. In connection with the materials and methods of painting, however, the only aspects of color with which we are concerned are the few fundamental rules of physics and optics which govern its behavior when used as an instrument or tool of painting. Systems of color classification, arrangement, and color harmony are studies apart from the present one.

Although we use color in accordance with the principles of art—or personal interpretations of them—rather than with those of science, there are basic physical facts that we cannot ignore; some familiarity with them, or at least with the consequences or results of the behavior of materials, will aid us in controlling our color effects. The tools and materials we use are physical things; so, for that matter, are our finished canvases, and as such they are subject to physical and chemical laws just like any other objects.

Definition. Color is not a standard property of a substance. It is not one of its definite, unalterable attributes, such as weight, hardness, or crystalline structure, but is an effect produced by a substance under certain circumstances on the vision of the beholder.

A scientific definition of the term "color" would be that it refers to all sensations aroused in the mind of a normal observer by the response of the retina of the eye and its attached mechanisms to the radiant energy of certain wavelengths and intensities.*

In order to see color, it is necessary to look at landscapes or people or still-life objects; a blow on the eye or pressure on the eyeball will make you see colors; also, you can see or perceive colors with your eyes shut. Such effects are called stimulus colors.

Pigments and light. When daylight passes through a prism, it is separated or broken up into a number of colored rays, creating the familiar spectrum of rainbow hues. This simple and well-known phenomenon is used to demonstrate the theory that white light is made up of a mixture of these component rays, each one having a definite wavelength which can be measured by laboratory methods.

* The word is also used in several other senses; for example, artists' paints are called colors.

Because of its physical, chemical, or crystalline properties, every substance has the property of selectivity absorbing some of these wavelengths from the white light; like a radio set it tunes in on these waves, and that is why their hues are different. Ultramarine blue, for example, absorbs all except the blue portion of the spectrum, a percentage of which it reflects back, thus producing the sensation we perceive as blue. Cerulean blue absorbs less of the spectrum; it reflects back, together with blue portions, some of the waves which give the green sensation; hence we perceive it as a more greenish blue pigment. Colored bodies do not all reflect the same percentage or amount of light, each one varying in this respect; some are much less reflective than others.

Subtractive and additive color. The mixing of colored paints or pigments comes under the description of *subtractive* mixture, so called because the more hues in the mixture, the more color is subtracted or absorbed from the white light. Each pigment in the mixture absorbs or subtracts from the white light its characteristic quota, so that only the hues reflected in common by all the component pigments are transmitted to the eye.

The *additive* method of color mixing is a term applied to the mixture of colored beams of light, as if each separate color of the spectrum were focused on the same spot. In the subtractive method a paint mixture of the three primary colors, red, yellow, and blue, will produce black. In the additive method the three primaries are beams of a magenta, a cyan-blue, and a yellow light, which if focused or projected on the same spot will produce white light by being added to each other. It has been said that some small element of this principle enters into the effect produced by the impressionists and especially the pointillists and also in the loose scrambling of paints instead of mixing them intimately. However, the pigments used in such techniques are the same as those in the usual kind of painting, and the blending of tones in the eye of the observer functions on much the same basis as the ordinary mixture of pigments. The subtractive principle of color mixing is the only one that has much practical interest to the painter.

Value. Black pigments absorb virtually all the visible components of light and reflect back little: white pigments absorb scarcely any and reflect almost all. Mixtures of the two, or grays, will perform according to their proportion, and the degrees of reflection are known to the scientists as *brightness* and to the painter as *values*.

Intensity and saturation. The chromatic colors react to light in the same way as do the achromatic colors (black, white, and intermediate grays); a pale or light color is one which reflects much white light from its surface, along with the colored rays, while a deep-toned or *intense* color reflects less. *Saturation* is a term which refers to the degree of vividness of hue of a color.

Other technical color terms are defined under pigments on page 31 because their descriptions and their usage are more pertinent to the

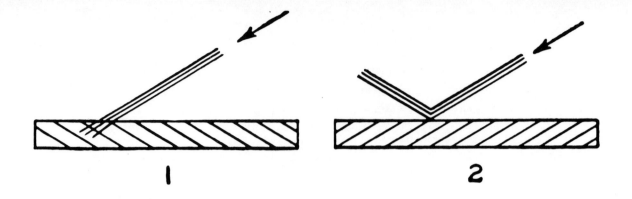

pigments themselves than to color discussed from a theoretical stand-point.

The Behavior of Light Waves

When beams of white light impinge on the surface of a painting, three things happen to them:

1. Some of the waves are absorbed.
2. Some are reflected, as by a mirror.
3. In the case of transparent or translucent substances, some are transmitted.
4. In the case of a transparent or translucent layer of paint over an opaque or reflective ground, the diagram looks like number 3 on top of number 2.

Generally all three things happen: some of the light gets reflected by the surface; some is absorbed by the paint; some gets transmitted through the paint where it strikes the ground, the ground absorbs some of it, and the rest is reflected back through the paint film.

One of the most useful and practical applications of these principles is the lesson they teach on the importance of using a brilliant white ground for the majority of painting methods. A white gesso ground, a white oil canvas, or a piece of watercolor paper, placed in the sunlight or on a well-illumined wall, will reflect the light brilliantly. If, by some magic, you could retain such a secondary source of light and carry it into a dark room, it would illuminate the room like a lantern. This inner luminosity is what the transparency or glaze painter depends on for his color effects, and it also has a pronounced effect on opaque or body-color painting. Whether the painter utilizes thin areas of paint where it would be obvious, or relatively thick, opaque layers which appear to hide the ground, the effect of a brilliant, white, reflective ground usually has its influence on the final result and is a very desirable and necessary foundation for most kinds of paintings.

Although some of the great masters of the past employed dark grounds at various times and for special purposes, our experience

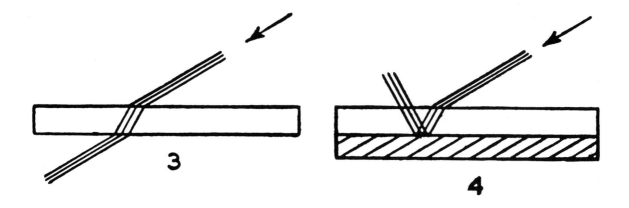

through the ages has taught us that the present rule of using white grounds will usually serve our purposes best and will produce the most satisfactory results.

Gloss. There is also another sort of reflection called *specular* which has to do with gloss and mat surfaces. A highly specular or mirrorlike surface will bring out the final degree of intensity or saturation of which a surface is capable. The reflection from a mirror or mirror-like surface is a different sort of thing from the diffuse reflection of light by a less glossy surface, which owes its reflective power to its brightness or whiteness.

Mat or diffuse reflection. Completely lusterless surfaces are called mat or flat finishes. Those with a faint, smooth sheen are called semi-mat or eggshell. A surface which is fairly glossy, but does not have the full, shiny gloss of a brightly varnished or polished area, is called semi-gloss.

A mat finish exists because its surface, instead of being perfectly smooth, is broken up into a texture of microscopic roughness. If you look at a piece of watercolor paper under a microscope or a magnifying glass (Figure 1), you will see that instead of a smooth, unbroken surface it is a mass of interlaced fibers of rough texture. Under the same enlargement, a piece of shiny paper, which has a smooth coating laid over the fibers, will reveal only the minor irregularities of the coating. A coat of watercolor or gouache paint has no gloss because its surface is microscopically rough or granular, made up of myriad little grains of pigment and paper fibers. A sheet of glass that has been ground and made translucent instead of transparent has no gloss because its surface is a mass of tiny pits and scratches.

When the light strikes one of these surfaces it does not reflect back directly, as it would from a mirror or from a highly polished smooth surface, but is first reflected back and forth among the myriad tiny facets of the irregular or coarse particles; therefore, the total light that is reflected from the surface comes from all angles, resulting in a diffuse reflection of light and producing the mat effect.

A watercolor, gouache, or pastel is mat or lusterless because of the roughness caused by the tiny particles of pigment lying on its surface.

23

A normal oil painting—and especially a varnished painting—is glossy because there is surplus vehicle surrounding or overlaying the pigment particles, encasing them in a film or flowing out to a smooth surface.

If an oil painting or some of its areas dry without gloss, as frequently happens,* it is because the same roughness of surface exists. A number of causes can produce this effect: an overabsorbent ground will drain out the surplus vehicle, as will overdilution with turpentine or overpigmentation in the manufacture of the paint. It can also be produced by the use of a dull coating (see page 94). Because it is obviously impossible to have the thickness or oil content of a paint mechanically uniform throughout the picture, there is frequently a difference in gloss in different spots; the thinner portions or the strokes containing less oil will retain less gloss over an absorbent ground.

Color variation. Color, not being a standard property of a substance, is subject to much variation, depending upon the ambience or conditions surrounding the material under observation. Several external conditions may alter the color effects of a pigment; for example, the quality and degree of intensity of the light under which it is viewed have a decided effect on the way colored substances look. Painters are familiar, also, with the strong effect on color that is caused by the juxtaposition of other colors—how a color can be altered by changing the colors of the areas which border on it.

The principal cause for variation in the color effect of a pigment, however, is the influence of the medium which surrounds it. If you will turn back to the diagram on page 22, which illustrates the transmission of light waves through a transparent solid, you will note that the beam takes a shortcut as it travels through the substance and emerges at a different angle from that at which it impinged upon the surface. Each substance will impede light to a different extent, and this property may be measured.

Refractive index is a term which denotes the numerical degree of this power. When two substances of varying refractive indexes meet, the greater the difference between their refractive indexes, the greater will be the amount of white light reflected at the points where they meet, and the brighter or whiter will be the result. The closer their refractive indexes are, the less will be the reflection of light and the greater the absorption of light at these points; the substance will therefore appear to be deeper or more intense in color. For example, an ultramarine blue, with a refractive index of, say, 1.50 in the dry state, has its particles surrounded by air (which has an index of 1.00), and it has a bright, but pale, almost azure hue and looks like A in the front endpaper as compared with the deep-toned, dark, navy blue appearance of the same pigment ground in linseed oil (which has a refractive index of 1.48)—like illustration C.

* This condition is known by the term *sinking in.*

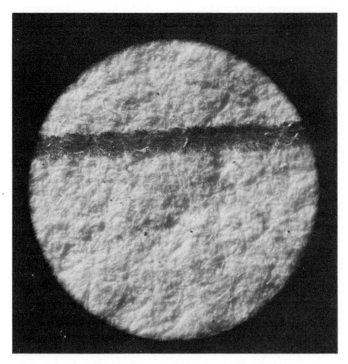

1. Photomicrograph: watercolor paper (streak is an ordinary pencil line).

In the case of ultramarine in oil, the indexes are very close to each other, so that less light is reflected, more is absorbed. Illustration B shows this effect. When the same pigment is ground in a casein or gouache vehicle, the intensity of the dried paint film is somewhere in between that of the dry pigment, with its high reflection of white light, and the deep-toned oil color, with its high absorption of light.

In the wet stage a gouache paint looks almost as deep as wet oil paint. On page 86 the change in color effect of a dry pigment being mixed with oil can be noticed, and on page 155 the same sort of change occurs when a pigment is mixed with a water binder. But because the bulk of the gouache liquid (water) evaporates on drying, whereas nearly all the oil vehicle is still present in the dried paint, the appearance of the dried paint is quite different. In the dried oil paint the pigment is completely surrounded and locked in a film of dried linseed oil. In the water paint there is no such large surplus of medium present, and there is no corresponding encasement of the pigment in its medium; there is rather just sufficient binder present to bind the pigment particles and hold them permanently to the ground. Consequently the pigment is practically exposed to the air, instead of being surrounded by a relatively thick coating of dried oil. The materials used as binders in water paints are powerful glues or adhesives as compared with linseed oil; hence a very much reduced amount of such binder can be used in water paints.

Variations in gloss and opacity. As noted in the preceding paragraphs, the same presence or absence of surplus medium, which makes

for color variation, also accounts for the mat or lusterless finish of water paintings as compared with the gloss or luster of oil paintings. The actual surface of normal oil paint is smooth (even where coarse brush strokes build up the paint to a seemingly rough texture) because it is a natural property of fluid oils and resins to flow out and dry to a smooth shiny surface, whereas all the water paints when dry have such a small percentage of solid binder present that the pigment particles lie virtually exposed on the surface, thus causing the microscopic roughness, which results in a diffuse reflection of light from its surface.

Just as color and gloss are affected, the transparency and opacity of a paint pigment can vary greatly, depending on its surrounding medium. Alumina hydrate, which is described under *Inert Pigments* (page 48), is an opaque white material in the dry powder state, but if it is mixed with oil, it becomes transparent because the refractive indexes of the oil and the pigment are close.

A familiar example of the effect of diffuse reflection is snow, which appears white because the light is diffusely reflected from the myriad planes and facets of its particles, whereas its substance (water or ice) when viewed in the mass is clear and transparent.

When surrounded by paint vehicles, pigments of low refractive index are more transparent than those of higher refractive index. As a general rule—to which there are several exceptions in the cases of certain individual pigments—there is also a direct relationship between the weight or specific gravity of a pigment and its opacity. For the most part, the lightweight, fluffy pigments are transparent while the heavy solid ones are opaque.

Variation in intensity. After noting the fact that the color of a pigment in an oil painting is deeper and more intense than that of the same pigment in a painting made with one of the water or aqueous paints, and also the fact that the depth and intensity of a painting is considerably increased by having a high gloss on its surface, it can be seen that full intensity of color effect in an oil or a varnished one may be the result of two conditions: (1) encasement of the particles in a medium of high refractive index; (2) addition of a higher degree of gloss to the surface.

Because our palette is made up of such a heterogeneous collection of substances having a wide range of chemical and physical properties, it would not be natural to expect any one medium to have the same effect on each color. And so we find that there is quite a range of degree in which the various pigments are affected by being surrounded with a paint vehicle; the color effects of some are altered enormously, whereas others are very slightly changed. This point is brought out very clearly in considering the action of fixatives on pastel pictures (page 144); and, as we shall see, it has a definite bearing on the appropriate selection of materials and techniques to achieve desired results.

Conclusions. Thus, besides influencing the color effects of the various pigments, the surrounding medium or vehicle of a paint also

determines its other visual properties. The binding vehicles of oil paints, watercolors, tempera, and gouache paints each combine with pigments to produce paints that have their own individual characteristics; the same pigment that gives opaque effects in one technique may be semi-opaque or transparent in a different paint. The opacity of our most dense pigments can be reduced under certain conditions.

The painter, once he has grasped these principles, need not struggle continuously to apply them. By becoming familiar with the individual properties of his various paints and pigments and their behavior in differing circumstances, he is free to use them without anxiety or puzzlement, and with the assurance that he can exploit the possibilities of his technique to its fullest extent.

Again the appropriateness of techniques. At this point it is most important to state that the examples used here to demonstrate the principles of gloss and mat effects, as well as the differences of color properties inherent in oil and aqueous paints, are not intended to convey or imply any superiority of one method over the other. Watercolor painting can have a beautiful intensity of color within its own range; and all the other techniques have desirable qualities of color, texture, and workability, each of which is appreciated according to its fitness or to the manner in which it may be adapted to the artist's aims.

PIGMENTS 3

Historical. The history of pigments is well documented; studies have been made of all the descriptions from old manuscripts and books dating back to the earliest recorded times. Actual analyses of pigments from relics of prehistoric civilizations and from all later periods have been systematically carried out. The student of the history of painting materials will find that throughout the history of European painting on down to the present day there has been a steady improvement in the quality, variety, and availability of pigments. Our present permanent pigments are superior to those of the past in all respects and are continually being improved. The current existence of fugitive and inferior pigments, which painters must avoid, is a circumstance no different from that of former times; these have existed in all ages and places, and careful painters have always had to know which ones were safe to use.

PROPERTIES AND REQUIREMENTS

The dry powdered pigments, from which artists' paints are made, must conform to several requirements in order to be acceptable for use in painting:

Color properties. Some pigments are characterized by brilliance and depth of tone, others are normally duller or paler, but each should be as clean, clear, and bright in color as its type permits. The transparency and the opacity of pigments must also conform to the highest standards of their types.

Pigment properties. This term refers to the significant physical and chemical properties of a pigment other than its color qualities. Paint pigments must be completely insoluble in their vehicles; colors that are soluble in water or other paint liquids are called dyes. *No soluble dyes are permanent.* They must be smooth, uniformly fine powders capable of remaining in suspension in the vehicles with which they are compounded, so that their color, degree of opacity, and general optical effects can be smoothly and evenly applied to the surfaces of paintings.

Permanence. An acceptable pigment must neither fade nor darken on continued exposure to light; it must not be chemically altered or harmed by the action of vehicles or of other pigments with which it comes in contact under the circumstances to which works of art are normally subjected. The quality of resistance to fading is known as lightfastness; a lightfast pigment is one whose color effect is unchanged by exposure to the conditions under which a product is expected to survive. For example, pigment for use in a printing ink that will be sheltered from light within the pages of a book does not require the same degree of lightfastness as does one which is to be used for printing out-

door posters. An easel painting (one intended to be framed and hung on a wall) is normally preserved indoors, away from direct sun rays, under average living conditions, and may contain a long list of pigments. The list of pigments suitable for fresco painting or outdoor murals is much shorter.

The fading (or darkening) of the color of a pigment on exposure to light is a definite chemical reaction, set in motion by the wave lengths to which the pigment is exposed. It is also dependent upon the intensity and the duration of such exposure, and in many cases it will not take place unless other chemical agents are present (for example, water or a moist environment).

All the pigments listed in this book as approved for use in the various techniques of permanent painting are inert to such actions. Only when the paints contain inferior pigments will the colors fade or darken. Some of the permanent artists' pigments can be made to undergo chemical changes (and consequently be altered in color effect) by use of drastic methods, but inasmuch as these paints will resist fading or other chemical changes indefinitely *under the conditions to which works of art are normally exposed,* they are accepted as permanent, lightproof colors. For example, alizarin red is an acceptably permanent artists' pigment showing no color change on normal exposure over long periods of time when used in easel paintings. However, if the same pigment is exposed to a powerful carbon arc machine for some days, a definite change can be induced; also, long and continued exposure to the direct rays of the sun, as on a roof, may have the same effect.

Likewise, other chemical treatments can alter certain pigments. Oil paints made with cadmium yellow mixed with flake white will not darken on exposure to light, but if cadmium yellow and flake white are taken into the laboratory and boiled together with water in a test tube, the mixture will turn quite dark. For this reason some chemists have stated that these two pigments should not be used together. Paintings, however, are seldom boiled, and so there have been no examples of an oil painting having darkened because of this mixture. Cadmium yellow has been on the artist's palette for more than a century, and flake white for more than twenty centuries. Flake white is on the approved list for oil painting only.

Because all the failures of nonpermanent colors are caused by chemical reactions, it follows that the pigments of the highest degree of permanence are those that have the most stable and inert chemical properties.

Purity. The highest-grade pigments are those that have been carefully made, washed free from all removable impurities, and are uncontaminated by foreign substances. The commonest impurities met with in inferior pigments are: inert materials or cheapeners with which the more expensive pigments may be adulterated; native impurities which occur, together with the original earths or stones from which some pig-

ments are made; noncoloring ingredients added, not primarily as adulterants but to improve pigments for uses other than as artists' materials (good colors, for ceramic processes, printing inks, and house paints often contain modifying ingredients that make them unsuitable as materials for permanent painting).

On the other hand, a pigment is not necessarily a single chemically pure compound, and the name or chemical formula of a pigment does not always mean that the principal substance of which it is composed is its sole ingredient. Frequently small amounts of modifying ingredients are necessary to develop the full perfection of a color; these are permanent in themselves, are recognized components of the pigment as known under its specific name, and are not considered impurities.

There are a few exceptions to the rule that all pigments must be concentrated, full-strength examples of their types. Prussian blue, phthalocyanine blue, phthalocyanine green, Indian red, and some of the alizarin or madder reds are occasionally improved by the addition of various amounts of inert pigment. The cadmium-barium colors and titanium-barium white, which contain relatively large amounts of barium sulphate, are perfectly acceptable pigments, although the same types are also obtainable and may be used in their concentrated, full-strength forms. The inert ingredients, in these instances, are produced or formed during manufacture, as an integral part of the pigment rather than as a substance added to or mixed with the finished color. Some pigments give dull or inferior results when used full strength in gouache paints and are brightened and improved in paint quality when the correct amount of inert pigment is mixed with them.

Emphasis is always placed on the purity, brilliance, and strength of the color characteristics of a pigment. This does not mean that one must paint all his pictures in an intense, clean, brilliant key, but such qualities are necessary because it is not possible to use color in painting to its fullest complete range and in complete manipulative control unless one has full command of all potential color values and qualities. The pigments provide a tool or means of expressing the all-important element of color in painting, and as such must be of the best available grade, just as brushes, carving tools, and other implements must be. The artist who paints in a free, spontaneous, or loose manner demands the same high-quality brushes as the one who does more precise, meticulous work, and the sculptor who carves rough and direct forms requires the same keen implements as the one who produces smooth, polished work. Likewise, when a painter works in a dull or low color key, he needs the same clean colors as when he paints a brighter picture; in the blending and mixing of hues and tones to produce somber results, purity and clarity of color characteristics play as important a role as they do when bright color effects are desired.

TECHNICAL TERMS

There are a number of technical terms employed in discussing the color qualities of pigments and paints; the following brief paragraphs will define them sufficiently to explain the meanings in which they are used in this book.

Mass- or top-tone. The surface or opaque body-color effect of a substance. For example, the mass-tone of burnt sienna in oil has a deep, rich mahogany hue when applied opaquely as in D in the front end-paper.

Undertone. The color characteristics of a pigment when it has been diluted with much white or when it is spread out to a thin, transparent layer. Burnt sienna oil paint applied as a thin transparent glaze is a fiery, orange-brown (illustration E). Mixed with a little white, it is a salmon pink or peach color (illustration F). This particular pigment was chosen because its undertones are so markedly different from its mass-tone and also from each other; most pigments do not show such great differences, and in some these differences are scarcely discernible.

Hue. Hue refers to the generic color identification of a substance; for example, one speaks of a thing as being red, or green, or bluish-gray in hue.

Tint. Tint refers to the modification of a color by the addition of other colors: for example, tinted paper is white paper which has been colored by the addition of a little pigment or paint; the tinting strength of a pigment is its degree of power to color white paint.

Shade is descriptive of a degree of variation in color—for example, a lighter or darker shade of pink, a more reddish shade of purple. In any system of color gradation, a step in the scale may be called a shade.

Tinge refers to a staining or permeating by a color; it usually implies a faint, weak, or partial coloration.

Cast is descriptive of a slight complexity or subtlety of color. It may also mean a tendency toward another color, not sufficient to classify it as being a definite shade; for example, two yellows may be of the same shade, yet one may have a slightly reddish cast.

Broken color. The pure hue of a pigment when used in a painting sometimes seems to the painter to be "raw" or garish. He will then tone it down by mixing in other colors, thus modifying it to suit his aims and usually making it more subtle or bringing it into harmony with the general key of the painting. This is called a broken color, in comparison with a pure or bright one. Since the days of the impressionists, another meaning has been attached to this term; mixed color effect produced by the juxtaposition of small strokes of separate colors

over an area, instead of by painting in a solid area of well-mixed paint, has also been referred to as broken color.

CP. This designation, which in chemical technology means chemically pure, when applied to pigments refers to full-strength, undiluted materials.

Let-down or *reduced* pigments are those that contain inert fillers or extenders.

Nomenclature of pigments. The artists'-material trade has emerged so recently from more than two thousand years of utter confusion in the naming of pigments that many confusing names are still in circulation. The pigment names used in this book are in accordance with standard American practice as specified in the Commercial Standard for Artists' Oil Paints (see page 188). For complete pigment lists which also include obsolete, discredited, or confusing names and synonyms, the reader is referred to the complete manuals and to old books on the subject.*

Classification of pigments. It is not sufficient for the artist to learn merely the general outline rules about pigments or to be familiar with them only as classified into groups. Because of the wide variation in their individual behaviors and properties, each one must be noted by itself, and its relative position in the general classification must be learned. The most satisfactory way to classify a pigment is according to its source, because most of the significant properties which any pigment groups may have in common can be attributed to their composition.

All paint pigments are manufactured products; regardless of whether they are obtained from natural or artificial sources, they will never be satisfactory unless they have been carefully prepared by expert methods.

The distinction between "natural" and "artificial" pigments is that the artificial are made by chemical reactions and processes from raw materials which are not in themselves pigments; the natural are refined from native ores or earths by physical and chemical treatments which convert these crude coloring matters into improved pigments with the desirable color and pigment properties.

1. *Native earths.* Highly colored clays, soils, and rocks occur all over the world; however, the best types occur in limited districts where superior brightness or clarity of tone or freedom from impurities makes them outstanding, or where there are well-established facilities for mining, pulverizing, and purifying them economically. The *approved* pigments made from natural earth sources are of absolute permanence for all paint uses.

* An all-inclusive list with an explanatory preface will be found on pages 37–76 of the author's *The Artist's Handbook of Materials and Techniques,* Third Revised Edition, 1970.

2. *Calcined native earths.* Upon calcining (roasting in a furnace), the earth colors tend to become warmer or more reddish and in some instances more transparent. The calcined or burnt earth colors have the same high degree of permanence as the raw earths.

3. *Artificial or synthetic mineral colors.* This term includes a multitude of inorganic chemical pigments, both good and bad; no general statement can be made to cover their properties, and the characteristics of each must be learned separately. Some are made by the simple mixture of two solutions of salts which will combine to make an insoluble, colored precipitate; others entail complex processes in several stages; all must be made under expert control. Some of our most permanent colors are among the artificial inorganic pigments, while others are not sufficiently permanent for artists' use. As a general rule, those with processes including a high-temperature furnace treatment are the most permanent of all.

4. *Synthetic organic pigments.* (The chemical term "organic" refers to compounds that contain carbon as one ingredient.) Originally the brilliant, transparent organic pigments were made from water-soluble dyes obtained from plant and animal sources. Scarcely any of these were sufficiently lightfast to qualify as a permanent pigment in the twentieth century. In the mid-nineteenth century the invention of a rainbow of synthetic colors was started; many of these were improvements over the earlier natural products, and one of them, alizarin (1876), is still in use. Because all of them were made from derivatives of coal tar and because most of these were made from the specific derivative aniline, they became known as coal-tar colors or aniline colors, terms that in recent times have been used as derogatory words. In the early twentieth century many pigments were developed that were vastly improved over the older ones; some of these are still in industrial use. Because several promising red pigments were prematurely adopted during this period and had to be withdrawn, the authoritative groups are slow to adopt new products until the most careful investigations have been made. My list on pages 34–36 is quite conservative; it contains only twelve of these modern synthetic organic colors (each marked with an asterisk) while during the 1960s more than three dozen were considered eligible for adoption. It was not until phthalocyanines were introduced in 1935 that brilliant pigments that could rank with the inorganic pigments began to be available.

As recently as 1966, the second edition of this book listed only the following synthetic organic colors: alizarin reds, phthalocyanine blue, phthalocyanine green, Hansa yellow, and, tentatively, the recently introduced quinacridone red. The same edition also uses the words "aniline colors" in a nonpejorative way.

5. *Lakes and toners.* Formerly a widely used term but now seldom encountered is the term "lake"—yellow lake, madder lake, scarlet lake, and so on. To make a synthetic pigment, a dye in water solu-

tion was chemically precipitated onto a base, which was one of the inert pigments (page 30). Depending on the proportion of inert pigment used, a lake could be concentrated or weak. A toner is a synthetic pigment in its most concentrated form, with little or no inert material, or else a dyestuff that is naturally insoluble; the latter is the modern definition of a toner. One of the most serious defects of the old-fashioned organic pigment was its tendency to bleed, or become soluble in the paint and seep into or permeate the surrounding oil paint. Or if such a scarlet lake was used in an underpainting and a white oil paint layer was painted over it, the white would soon become tinged with pink. Modern synthetic pigments seldom have this property, but it is not impossible for a bleeder to be used instead of being rejected.

A number of colors of exceptional brilliancy of hue, made with the older, impermanent dyestuff lakes, are still on the market; these are intended for use by artists who work for reproduction, as in illustration and commercial art where the original painting has no particular value as a unique work of art. These colors, which bear names that will not be found in the lists of pigments approved for fine-arts purposes, such as scarlet lake, peacock blue, and geranium red, are valuable for the purposes for which they are intended but should never be used for permanent easel painting. There is more on the subject of this class of artists' materials in Chapter 7.

THE PERMANENT PALETTE

In the following list, the *hue designations* in the left-hand column comprise a complete palette such as the average painter customarily uses. The right-hand column lists all the completely approved pigments used in oil painting. Painters in watercolor, gouache, tempera, pastel, and fresco have a somewhat smaller choice of pigments available in some of these categories because some of the pigments that are entirely acceptable for use in oil paints have properties or shortcomings that make them undesirable for use in the other methods of painting. References to such exceptions will be found in the chapters that deal with these techniques.

Asterisks indicate synthetic organic pigments introduced in recent years. They are the author's selection from a larger number of pigments of somewhat lesser permanence. Not all of them are currently in use by paint manufacturers, mostly because the established palette is quite satisfactory and a new pigment has to possess extraordinary color characteristics to be welcomed as an addition or replacement.

White. Flake white
Zinc white
Titanium dioxide

 Titanium-barium white
Black............. Ivory black
 Lampblack
 Carbon black
 Mars black
Dull red.......... Indian red
 Light red
 Mars red
 Burnt sienna (also listed as a brown)
Bright red......... Cadmium or cadmium-barium light,
 medium, and deep (maroon)
 Alizarin crimson
 Quinacridone reds*
 Pyranthrone red*
 Perylene scarlet*
 Permanent carmine*
 Acridone red*
Blue............. Ultramarine blues
 Cobalt blue
Greenish blue....... Phthalocyanine blue
 Pale greenish blues:
 Cerulean blue (opaque)
 Manganese blue (transparent)
Middle blue........ Indanthrone blue*
Dull yellow.........Mars yellows
 Yellow ochres
 Transparent ochres
 Raw sienna
Pale bright yellow....Cadmium or cadmium-barium yellow,
 pale
 Strontium yellow
 Hansa yellow*
 Green gold (nickel azo yellow)*
Deep bright yellow...Cadmium or cadmium-barium yellow,
 medium, deep, and orange
 Naples yellow
 Transparent bright yellow:
 Cobalt yellow
Orange........... Cadmium orange
 Brominated anthanthrone orange*
Green............. *Bright greens:*
 Viridian
 Phthalocyanine green
 Permanent green
 Dull greens:
 Chromium oxide

35

```
                    Cobalt green
                    Green earth
                    Ultramarine green
Brown............Burnt umber
                    Raw umber
                    Burnt sienna (also listed as a red)
                    Transparent brown:
                    Burnt green earth
Violet............Mars violet
                    Cobalt violet
                    Manganese violet
                    Ultramarine red
                    Isoviolanthrone violet*
                    Quinacridone violet*
                    Thio-indigo violet*
```

A painter seldom uses more than one pigment from each category in the same picture, but when he needs them he has a sufficient variety and choice to fulfill all his color requirements among the permanent pigments. His choice and the number of colors he uses depend on his personal preferences and on the requirements of the particular work at hand. A working palette that contains less than a dozen colors can be considered a simplified palette, whereas one in which more colors are used would be a full or elaborate palette.

Restricted palettes. Successful painting can be done with a palette limited to a very few colors, and on some occasions a simplified palette can be employed to considerable advantage, for there can be several valid reasons for using a small number of colors. However, in the majority of cases it is most advantageous technically to have a full range of pigments available. Single pigments are invariably purer, more brilliant or vivid than mixtures of pigments made to imitate them. Uniformity of effects and an economy of effort are a few of the other advantages of using colors whose hues are close to those wanted in the final effect.

Painters receive training with simplified palettes as a matter of discipline; sometimes circumstances compel the use of a small assortment of colors, and often a painter will deliberately adopt a limited palette because he finds it best serves certain aesthetic reasons, aims, or principles. But even in this case it is not wise for the mature painter to exclude too rigidly from his palette pigments which he does not habitually use but which on occasion can be introduced into a painting with good results.

The pigments that comprise our modern approved list are the survivors of a process of elimination that has been going on for a long time—actually, for thousands of years. They remain in popular use not only because they fulfill the necessary chemical and physical requirements but also because a long development has established their status

as good and useful tools of coloring and because each has individual characteristics sufficient to warrant its perpetuation. Neither artist nor colorman wishes to include or perpetuate an excessively large number of unessential items, and therefore it can be assumed that the colors on the approved list are all valuable.

DESCRIPTIONS OF ARTISTS' PIGMENTS

White pigments

Flake white. Artists' quality white lead is sold under the name of flake white. Cremnitz white is the same basic lead carbonate, but made by a different process; the practical differences between them are so small and the genuine Cremnitz white so scarce in America that in 1962 its name was removed from the Standard list (see page 188). White lead, one of the first artificially manufactured inorganic pigments, has been used since the earliest recorded days and until comparatively recent times was the sole white pigment used in oil painting. It is a dense, heavy, opaque pigment and, when mixed with black or with the chromatic pigments to make pale tints, imparts a more generally pleasing tone than do other whites. When used in oil paint, it has perhaps the finest mechanical or physical properties of all the pigments. It absorbs less oil, it brushes out better, it dries rapidly, and it produces paint layers of superior permanence and durability. Its two defects are: its poisonous nature and a tendency of its surface to turn brown when exposed to sulphur-bearing fumes. Lead poisoning can be avoided by observing the simple precautions of cleansing the hands and fingernails after its use, by refraining from smoking and eating during use and from breathing the dust from the dry powder. My advice is never to use powdered white lead and to avoid recipes that call for it. White lead is poisonous only when swallowed or inhaled—its danger has been somewhat overrated in the recent past. The same precautions should be observed with all paints, as there are other pigments which are undoubtedly harmful when taken internally. Examples of well-painted oil paintings darkening because the white lead was affected by sulphur are extremely rare; works of art are seldom exposed to such conditions. Although some lead-bearing pigments are good oil colors, they are never used in pastel, watercolor, fresco, or any other purely water medium, because in these techniques the two disadvantages mentioned are more serious considerations. They are, however, sometimes used in tempera painting when the picture is overpainted, glazed, or varnished, but not in straight tempera that is unprotected by an oil or varnish coating. White lead will brush out poorly in water mediums as compared with the other whites. The commercial white lead in oil, sold in paint stores, is not suitable for easel painting but may be used in grounds. The U.S. government restrictions against interstate commerce in paints that contain more than a trace of lead apply to ready-mixed wall paints. Artists' concerted efforts in

1972 resulted in a ruling that exempts artists' paints from the ban. Flake white is freely available in top-quality oil colors, seldom, if ever, in cheap lines. Commercial white lead in oil in cans is a raw material rather than a "paint" and is available in paint and hardware stores unless there is a state or local law prohibiting its sale. Until such time as the artists'-material manufacturers make white lead in oil available in one- and five-pound cans, one could use their regular flake white oil color, which, I believe, most of them will ship direct to artists on request in five-pound cans. It would contain a small bit of stearate, as do all artists' colors, and consequently a small bit more oil than the industrial white lead, and the oil would be the refined grade used in artists' colors instead of raw linseed oil.

Zinc white. Zinc oxide has been used since the beginning of the nineteenth century and under the name of Chinese white has long been the principal white pigment for watercolor and gouache, but it was not widely used as an artists' oil color much before the twentieth century. It is a snow-white pigment, and when tinted with black or other dark colors it yields cold tones, as compared with the comparatively warmer, generally more pleasing tones obtained with flake white. When ground in oil, it loses a great deal of its hiding power, and the artists' zinc white oil color is generally rated as semi-opaque. Sometimes this property is advantageous, but it is usually to be considered a disadvantage as compared with flake white. In physical properties zinc white in oil is distinctly inferior to flake white. It brushes out with difficulty, it dries very slowly, and its film tends to become brittle. However, it is free from white lead's two defects. It is not poisonous, and if exposed to the action of sulphur fumes no darkening takes place because the products of any such reactions would in themselves be white.

Titanium whites. Pure titanium dioxide and titanium-barium pigment have been sold as artists' materials since about 1920. Both kinds have approximately the same physical properties and are equally acceptable as chemically permanent pigments, but the pure oxide is more opaque and has greater tinctorial power than the titanium-barium pigment—so much so that its great tinting strength in relation to its bulk is likely to cause it to be awkward to handle. The titanium pigments are dense and heavy and have great hiding power. They are absolutely permanent and chemically inert. They do not react with oil; for that reason they do not form such intimately mixed pastes with oils, and so are less likely than lead or zinc whites to mask any after-yellowing or darkening of the film. When used alone, titanium does not produce the most permanent or durable of oil films; in industrial paints it is usual to mix 40 per cent to 60 per cent of zinc oxide with titanium, thereby producing a film that has more durability than either one alone. Titanium pigments give their best results in water mediums. Their greater inertness to oil may cause fluid paints to settle out more rapidly than when white lead or zinc is used.

Composite whites. Mixtures of zinc and titanium whites ground in oil, intended to combine the best properties of each, are sold in pound tubes under trademark names. They are liked by some painters for the way they handle. Because some of these whites may contain undesirable additions, a brand which conforms to the Commercial Standard should be selected. The pigment components of such paint will be stated on the label.

Red pigments

Red iron oxides. The red iron oxides are among the basic, original pigments usually considered indispensable; one seldom sees a palette discussed that does not include at least one of them. There are two distinct kinds: (1) the bluish variety, usually known as *Indian red,* which produces rose pinks when mixed with white; (2) the scarlet type, known as *light red,* which produces salmon pinks when mixed with white. These pure iron oxides, artificially made in furnaces, are absolutely permanent for all techniques. They are dense, opaque, and have good tinting strength and pigment properties. Many special shades of pure iron oxides, from bright reds to deep crimson and maroon tones, are also made under the name of *Mars reds.*

The pure red oxides have their counterparts in a large number of native red earths produced in various parts of the world. These contain varying amounts of inert material, and for artists' use they are now almost entirely replaced by the modern pure oxides.

Vermilion (mercuric sulphide). Vermilion is a dense, opaque bright red, the heaviest pigment in use. In Greek and Roman times a native ore called cinnabar was used, but later, when processes for chemically manufactured vermilion became available, the duller, inferior native product was discarded. Vermilion is usually considered one of the oldest chemically produced pigments on the artist's palette.

For centuries vermilion has been accepted as a permanent pigment for easel paintings, but in recent years some doubt has been expressed as to its permanence to light under all conditions because of an inexplicable tendency in some instances to turn dark or revert to the black form of mercuric sulphide. Although these occurrences are not frequent, they have happened often enough so that careful painters have long since replaced vermilion with the completely reliable cadmium reds.

Cadmium reds. The cadmium reds have been available for paint use only since 1919, but their pigment properties were well known; they are identical with those of the century-old cadmium yellows, and the cadmium reds are universally accepted as being completely reliable for all easel painting purposes. The light shade is a perfect replacement for vermilion; the medium, dark, and maroon shades are also valuable, but, as a general rule, painters make less frequent use of them. Two types of cadmium reds are on the market, the CP or pure cadmium sulphoselenides and the cadmium-barium reds. The latter grade is considerably

less expensive, although it is the equal of the CP grade in permanence and in all other properties except tinting strength, in which respect it is considerably weaker. The cadmium reds are brilliant in the dry state and are densely opaque.

Alizarin crimson. A bright, transparent lake made in a limited range of tones, all with a characteristic crimson mass-tone and a bluish undertone. It yields clear rose pinks. Although not absolutely permanent under drastic test conditions, this red is sufficiently stable to be accepted as a permanent pigment for easel paintings. Its performance serves as a minimum standard to which other pigments must conform. It is superior to the old rose madder lakes which have lasted for centuries when not exposed to extremely destructive conditions. Alizarin red or crimson is a synthetic organic pigment made from anthracene. It superseded madder lake and rose madder about a hundred years ago; these were made from the root of the madder plant, which contains alizarin. Modern improved alizarin may be freely combined with any of the other pigments on the approved lists without harmful effect. By mixture with other pigments or dilution with glazing mediums, it can be made to match any desired color effect that could be produced by the older, less satisfactory red lakes of vegetal or animal origin.

Quinacridone red and maroon. These are brilliant, intense colors with bluish undertones, producing bright rose pinks. Modern synthetic pigments of high stability, recommended in the 1962 Commercial Standard (see page 188), they are likely to be sold under "fancy" names; if so the words "linear quinacridone" should also be found on the label.

Inferior and obsolete red pigments

Harrison red, lithol red, scarlet lake, geranium lake, para red, and American vermilion are names for lakes which may fade on exposure to light and which are likely to bleed in oil.

Cochineal, carmine, lac, and crimson lakes are products of insect origin. All are fugitive; they have long been discarded, and alizarin replaces them.

Venetian red, originally a native earth but now a deliberate mixture of iron oxide with various percentages of calcium sulphate (a substance harmful to the durability of oil paints), is replaced by Indian red, light red, and the Mars reds.

Dragon's blood, logwood, and Brazil wood are antiquated lakes of vegetal origin, replaced by alizarin.

Bole or Armenian bole is a red earth of the clay type, now used only to make grounds such as are used for water-gilding on panels and picture frames.

Blue pigments

Ultramarine blue. This is now the principal blue pigment used in all paints; it is of absolute permanence in all techniques except fresco. Before 1828 the rare and costly native ultramarine, which is refined with

great difficulty from lapis lazuli, a semiprecious stone, was in use. Ultramarine is a furnace product made in a number of grades and in a variety of tones, but the usual kinds sold as artists' material are more or less uniformly characteristic. The special types of ultramarine that have distinctly different tones are always designated by different names, such as "Imitation Cobalt Blue" and "Ultramarine Violet."

Cobalt blue. True cobalt blue (Thenard's blue), a furnace product, is absolutely permanent for all uses. Its hue is of the same general type as ultramarine, but in paints its top-tone is considerably lighter and brighter, while its undertone is greenish compared with the purplish undertone of ultramarine blue.

A dried layer of true cobalt blue ground in oil has one color peculiarity which it displays only in unvarnished oil paintings after they have been exposed or aged. The color becomes whitened, losing its depth of tone, as though it had faded. When such a whitened cobalt blue is varnished, the color is immediately brought out again in all its original tones. None of the other permanent pigments has this action to such a degree—it is a sort of exaggerated "sinking in."

Cerulean blue. A furnace product, this is absolutely permanent for all uses. Unlike the other permanent blues, cerulean blue has a solid or earthly quality. Other blues owe their opacity or hiding power to their deep, dark hues, rather than to their solidity. Cerulean blue has a distinctive deep azure or sky-blue top-tone and is quite greenish in undertone. It is expensive, and therefore a cheap paint that is labeled "cerulean blue" is likely to be either an imitation or an adulterated product.

Manganese blue. Although long known and appreciated as a reliable permanent pigment, economic or practical considerations have confined this color until recently to the status of a laboratory rarity. Its mass-tone is similar to cerulean blue but considerably cleaner and brighter; it is transparent and its undertone is very greenish.

Phthalocyanine blue. After alizarin, the earliest of the permanent synthetic organic pigments (1935), this intense and powerful blue differs greatly from the above-mentioned blues; its color duplicates that of Prussian blue exactly and so can be substituted for it in all mixtures. It has been entirely approved for use in all easel painting methods. Because of its coppery bronze sheen and poor pigment properties, also because of its unusually high tinting strength, a grade reduced to about 25 per cent with inert pigment is preferable for most uses to the CP grade. The pigment is a complex organic compound (copper phthalocyanate), a product of modern synthetic chemistry.

Indanthrone blue. A modern pigment that has been used by a few makers, this is a middle blue without the distinctive greenish or bluish undertones that characterize most other blues.

Inferior and obsolete blue pigments

Smalt. Replaced by cobalt blue.

Egyptian blue. Permanent but not available. Replaced by cobalt

blue, cerulean, and various mixtures of permanent pigments.

Bice. Copper carbonate, replaced by cerulean and cobalt blues.

Azurite. This was formerly an expensive water-medium pigment made by pulverizing the precious stone. It was also blended with malachite for a greenish blue and a bluish green. It was used in Egyptian, classical, and Oriental art.

Indigo. As an artists' pigment, an obsolete and unreliable vegetal color, now made synthetically. It can be matched by a mixture of ultramarine and phthalocyanine blues.

Prussian blue. Long included in artists' lists as a "borderline pigment," which meant not entirely or reliably permanent but reasonably so, it was considered indispensable because of its distinctive color effect. It has now been replaced by phthalocyanine blue.

Yellow pigments

Ochre. An earth of the clay type which contains varying proportions of hydrated iron oxide. Ochres occur all over the world, but the best are mined and refined in France. Ochre is permanent for all uses, and it is one of the oldest traditional artists' pigments, used in all techniques. When strongly heated in a furnace, yellow ochre turns red, but the burnt ochres and light reds thus produced are no longer used to any great extent, having been replaced by the more intense red oxides. The usual ochre is very opaque.

Transparent gold ochre is refined from a rather rare species of ochre. It is permanent, and suitable for all painting uses.

Raw sienna is a purified and refined native earth similar to ochre but semitransparent and of a deeper and more subtle tone. It contains small amounts of manganese in addition to the iron. It takes its name from Siena in Italy, where the early supplies were obtained. It is produced in various parts of the world, but the best grades still come from Italy.

Mars yellow. This pigment is a permanent artificial iron hydroxide which bears the same relation to the ochres and raw siennas as the pure Indian reds and light reds do to the native red earths. Brighter, clearer, and several times stronger in tinctorial power than ochre or sienna, it is preferred by many painters for these reasons, while others prefer the more subtle tones of the traditional earth colors.

Mars yellow, yellow ochre, raw sienna, all have distinctive color characteristics that make one preferable to another for certain uses, but an artist will seldom require more than one yellow of this type in the same palette.

Cadmium yellows are produced in a wide assortment of shades, from a pale primrose to a deep orange. They are permanent for all artists' techniques except fresco and are dense, opaque, smooth pigments. The modern grade, labeled "cadmium-barium" yellow or orange, is just as permanent and satisfactory but is definitely less powerful in tinting strength than the more expensive CP or pure cadmium sulphide yellow.

Further remarks descriptive of cadmium yellows can be found on page 39 under *cadmium reds,* with which they are identical insofar as pigment properties and permanence are concerned.

Naples yellow is lead antimoniate, a permanent, opaque pigment used only for artists' oil painting and having the same attributes and defects as white lead. By itself, and in mixtures, it gives pleasing tones that cannot easily be duplicated by substitution. Like white lead, it has fine brushing qualities, produces paint films of superior durability, and is well liked by painters. It should not be used in watercolor, gouache, pastel, or fresco, or in straight tempera; however, Naples yellow is used in tempera if protected by oil glazes or varnish. The same restrictions that govern the use of white lead (page 37) also limit the use of Naples yellow.

Its hue is a subtle yellow of medium shade and brightness; sometimes variations either toward the pinkish or greenish are available. Much Naples yellow is not genuine; check the label. Naturally an imitation composed of zinc white and cadmium yellow will have none of the properties of the genuine pigment except its light yellow hue.

Strontium yellow is a pigment of clear, very pale, rather greenish shade, permanent in all techniques except fresco. It is sometimes useful to produce the palest lemon or primrose hues, as well as light greens of a different quality from those that can be made with other yellows. It has a fair degree of opacity, but in comparison with the cadmiums it must be rated as semi-opaque.

Cobalt yellow (aureolin) is permanent for all uses except fresco. Used transparently as a glaze, it has a bright, clear golden tone, and it is also useful as a tinting color, but it is never applied in an opaque manner because its top-tone is a dull muddy tan. It replaces all such antiquated, fugitive pigments as Indian yellow, yellow lake, gamboge, Dutch pink, stil-de-grain.

Hansa yellow. This brilliant, powerful light yellow of the pale or canary type is made from a modern synthetic dyestuff. Although most specimens are transparent, it does not replace the warmer, more golden tone of cobalt yellow.

Nickel-azo yellow (green gold) is one of the modern synthetic organic pigments referred to on page 33. It has a greenish-yellow undertone and produces hard-to-match brilliant greens when mixed with phthalocyanine blue.

Inferior and obsolete yellow pigments

Chrome yellows and oranges. These heavy, opaque pigments are made in a great variety of shades and are produced in large quantities for industrial use. The chrome yellows are not lightproof, turning dark or greenish on exposure. They are replaced perfectly by the cadmiums. Chrome yellows contain lead; they must not be used in pastel, watercolors, or children's paints.

Indian yellow, gamboge, yellow lakes, Dutch pink, stil-de-grain, and other obsolete transparent yellows made from natural dyestuffs are

not permanent. They are replaced by cobalt yellow, plus a bit of tinting color where required.

Zinc yellow and barium yellow are "twins" of strontium yellow as far as color is concerned. Although of a fair degree of permanence, zinc yellow has been excluded from most modern lists of artists' pigments both because it is slightly water soluble and because it is likely to turn greenish on exposure. Barium yellow is an acceptable pigment, as permanent as strontium yellow but so pale in tone that strontium yellow is universally preferred. It can be matched perfectly by adding white to strontium yellow.

Green pigments

Viridian. Introduced in the middle of the nineteenth century, this pigment has become the chief green on the artist's palette. It is a furnace product (chromium tetrahydroxide) and absolutely permanent for all artists' techniques. It has a clear, transparent emerald hue, but heavy impasto layers in full strength are likely to appear blackish and dull when dry.

Its principal uses are for clear, transparent oil glazes and watercolor washes, and for producing all sorts of greens and blues through mixing with other transparent or opaque pigments in all techniques. It serves well as the sole green on a limited or restricted palette. In oil painting it is safer not to use it full strength in undercoats, because such layers are not particularly strong and contain a large percentage of surplus oil. It is a bright green in oil only when mixed with paler pigments or applied thinly over them.

Green earth. A clean, clear pale green pigment, it is permanent for all paint purposes, but so transparent, and so low in hiding and tinctorial power when ground in oil, that its usefulness is confined to glazes and transparent painting of a rather olive hue. In opaque water mediums such as gouache, its body-color or top-tone is a pale hue of the celadon or willow green type. It was used traditionally in Italian fresco and tempera for underpainting flesh tones; in aqueous mediums its color effect has always been a favorite with artists.

Chromium oxide green. A rather dull, cool willow green and a high-temperature furnace product, it is absolutely permanent for all pigment purposes. It is a heavy, dense pigment with fair opacity but rather low tinting strength. Although it is somewhat limited in usefulness and range of effects, chromium oxide is well liked by artists.

Cobalt green. This pigment is a furnace product, absolutely permanent for all techniques. It is somewhat brighter, clearer, and more bluish than chromium oxide green, but similar in general properties. Not widely available.

Phthalocyanine green. See phthalocyanine blue. The green is a chlorinated variant of the blue, and its pigment properties are identical. Its hue is close to that of viridian but more intense and brilliant. Its

44

tinting strength in the pure state is enormous, and therefore it is customary (and permissible) to use a grade that has been reduced to about 25 per cent.

Permanent green. A composite pigment sold in oil and in water-color, composed of a permanent green, such as viridian, and cadmium yellow in various proportions. Useful as a convenience to save mixing operations.

Ultramarine green. A permanent green variant of ultramarine, which has the same properties as ultramarine blue, it is extremely weak in color and tinting strength, resembling green earth in this respect, and consequently has very limited uses.

Inferior and obsolete green pigments

Emerald green. A brilliant, bright, rather light green which cannot easily be duplicated by mixtures of other pigments. Permanent only when used in oil by itself and when well varnished. It is likely to turn black when mixed with most other pigments except titanium or zinc whites. A highly poisonous material, it is sold as an insecticide under the name of Paris green. It must not be used in pastel, in water paints, or in children's paints. The name has sometimes been confused with *vert emeraude,* French for viridian. Its color can be approximated by mixtures of phthalocyanine green and Hansa yellow.

Verdigris and green bice are obsolete copper pigments of doubtful permanence easily matched by mixtures of other colors.

Malachite. This precious pigment of antiquity and Oriental painting is made by pulverizing the native stone. It is often blended with azurite for a bluish green.

Chrome green is an intimate mixture of Prussian blue and chrome yellow. Large amounts are used in industry, and many different shades are produced, but the pigment is not permanent for artists' use. Chrome yellows are perfectly replaced by cadmium yellows, and when various shades of the cadmiums are mixed with the various blues or greens, permanent colors can be obtained to match the hue of any variety of chrome green.

Brown pigments

Umber. The best-quality umbers are mined in Cyprus and are known as Turkey umber. They are permanent, opaque enough for most purposes, and at the same time sufficiently transparent when spread out in thin layers to serve in all techniques of painting. Burnt umber is more reddish in mass-tone than raw umber, which—in direct comparison with it—seems greenish.

In oil painting, both raw and burnt umber act as powerful driers and yield tough, flexible films. They absorb large amounts of oil and therefore, in conformance with the recommendations and precautions against the cracking of oil paints (page 89), should not be used full

strength or approximately full strength in underpaintings; whites or other pigments of lower oil content may crack if laid over them. The umbers are not entirely satisfactory in those mixtures where the very deepest or darkest colors are attempted, because of their tendency to impart chalky or whitish effects to such mixtures.

Burnt sienna is one of the most useful and versatile pigments on the artist's list, as an opaque pigment for its top- or mass-tone, as a tinting color, or as a glaze color for transparent effects. Its color effect is clearer and less chalky than that of most other earths and it serves well in dark or deep-toned mixtures; in selecting a burnt sienna, the deepest or "mahogany" type will be found more useful than the paler, more opaque type. In a palette strictly limited to a very few colors, some painters employ it as a red, and it is sometimes classified as a red rather than as a brown.

The color effects of burnt sienna are illustrated in the front end-paper, which shows its characteristics in actual paint swatches (D) when applied as an opaque or body color and displays its mass-tone; (E) as a transparent or glaze color over a white surface; and (F) as a tinting color mixed with white, revealing its opaque undertone.

The differences between burnt sienna's body-color hue, its transparent or glaze effect, and the hue of its tints and mixtures with white pigments are very definite. As a tinting color with white, it produces a salmon pink; as a transparent glaze in oil or a watercolor wash, it is a bright, fiery orange; used as a body color it is a reddish brown. The umbers and burnt sienna have been in general use for a sufficient number of centuries to establish them as permanent and trustworthy pigments.

Transparent brown or burnt green earth is produced in a variety of shades, all quite intense, transparent, and valuable as glaze colors in oil painting. They are of lesser value, however, in techniques that require opaque effects, as they have very little hiding or tinting power. Transparent brown is permanent in all techniques and, although not so well known and widely used as the other earth pigments, is a useful addition to the artist's palette.

Inferior and obsolete brown pigments

Vandyke brown, no longer in general use, is an earth containing undecomposed or partially decomposed vegetal matter. Oil paintings on which it has been used almost invariably turn dark and crack badly, although a few of the highest grades are permanent to light. Its popularity during the nineteenth century was due to the clear and deep tones it produces in mixtures of dark colors.

Sepia, obtained from the ink sacs of the cuttlefish, octopus, and other cephalopods, has been known and used as an ink and watercolor brown since Roman times. On exposure to daylight it fades too badly

to make it acceptable as an artist's pigment.

Bistre, obtained from the tarry mass resulting from incompletely burned beechwood, has properties and defects similar to those of sepia. The hue of sepia is approximated by burnt umber; that of bistre by raw umber.

Asphaltum, or bitumen, is not a true pigment, but a resinous or pitchy substance soluble in oils, yielding a blackish brown mass that is opaque when applied thickly and a transparent brown when applied thinly.

No longer in general use as an artist's pigment, asphaltum was one of the most destructive materials ever introduced into oil painting. Paintings in which it was employed—whether as a solid film, as a tinting color, or as a glaze—have invariably turned dark and cracked in wide-open seams or fissures. Dug from deposits in the earth, it has been valued as a preservative or waterproofing material since prehistoric times. The blemishes and defects that develop on its surface with age, and that are ruinous to artists' paintings, do not affect its high performance in its other uses.

Mummy, supposedly an improved quality, was simply asphaltum recovered from Egyptian tombs.

Violet pigments

Cobalt violet. A furnace product, permanent for all uses, except that some samples are not limeproof and must be tested in lime plaster for six months before being used in fresco. It must also be excluded from pastels and from children's paints, because one variety of it contains arsenic; but, in oil paints and in adults' watercolors, it is a useful, bright, clear pigment. Two shades are sold, reddish or light, and bluish or deep.

Manganese violet. This is almost identical with the bluish shade of cobalt violet and is less expensive, nonpoisonous, permanent.

Mars violet. A pure iron oxide of the Indian red type, but much more bluish in mass-tone and in undertone; permanent, and suitable for all painting techniques. Compared with the brilliant cobalt and manganese violets, it is dull and muddy, but in many instances it is useful for violet and lavender effects.

Thio-indigo violet, isoviolanthrone violet, and *quinacridone violet* are among the modern synthetic pigments discussed on page 33. Reliably permanent and lightfast, the choice of any violet is a matter of how well its particular characteristics suit the artist's requirements.

Black pigments

Ivory black. This is the principal black pigment used by artists in all techniques. Originally made by burning ivory scraps, now made by carbonizing selected bones, it is superior to the ordinary bone black

47

because it is made with greatest care from the best materials.

Lampblack and carbon black, made from the soot of burning petroleum products, are also permanent forms of pure or nearly pure carbon and can be used, but they are not so well adapted to artists' needs. They are extremely lightweight, fluffy powders; lampblack has a greasy nature, and carbon black—the most intense, jet-black of all—mixes poorly with other colors, its streaks persisting after much stirring and rubbing.

Drop black, vine black, and other varieties of carbon made by burning vegetal materials are also permanent forms of carbon, but they are inferior in color and pigment properties to the best ivory black.

Mars black is an artificially produced form of iron oxide. Unlike the other blacks, which are lightweight, fluffy, water-repellent powders composed of pure or nearly pure carbon, it is a heavy, dense material of the same physical or pigment properties as the other Mars colors. Although it has a rather reddish cast when compared with the more intense jet-black carbon pigments, most artists find it entirely satisfactory for all uses and some prefer it to the carbon blacks, especially in the water mediums. Formerly it was sold in few makes of tube colors, but its popularity has increased so that now most brands have it.

Mixed pigments

Most of the tube paints that contain a mixture of pigments but that are labeled with a single name, such as "Hooker's green," contain impermanent or doubtful materials and have been discarded or relegated to the status of obsolete or inferior colors. Careful painters will not accept such vaguely described materials unless the maker also indicates the exact components on the label or in his literature.

Payne's gray. This is one of the few mixed pigments regularly accepted as permanent, if offered by a reliable maker. It is supposed to contain ultramarine blue, black, and ochre. Most mixed colors are rejected by the experienced artist as unnecessary, because they increase the number of tubes of paint he must harbor and because he can easily mix the desired shades himself. However, many painters consider Payne's gray an exception to this, because of the convenience of having this particularly useful combination on hand in ready-mixed form. This applies especially to watercolor, where it seems to fill a gap in the list of colors and to be such a useful addition to the palette that it has survived for more than a century—long after similar mixtures have been abandoned.

Permanent green. See page 45.

Inert pigments

Inert pigments constitute a group of powders that are white or nearly white in the dry state, but, when ground in oil, have little or no opacity and will impart no color effect to the chromatic pigments other than to detract somewhat from their clarity. Some of them retain their

whiteness, however, in water mediums. The tinting strength of pigments or prepared artists' colors that contain appreciable amounts of such fillers or extenders will obviously be greatly weakened.

The pigment properties of the inert pigments and the qualities they will impart to paints vary considerably. Some of them are not just cheap extenders but are valuable and useful materials for certain purposes; as such they are used more often in industrial products than in artists' paints. The following are some of the more common inert pigments:

Alumina hydrate (aluminum hydroxide). A light, fluffy, pure-white powder that becomes transparent and nearly colorless when ground in oil. Although a very slow drier in oil, it imparts excellent brushing qualities and desirable smoothness to colors and can be used as an extender in students' grade and other cheap colors. It is the principal *base* or inert pigment used in making clear, transparent lakes; the alizarin and madder reds contain it.

Blanc fixe (precipitated barium sulphate). This very dense, fine white powder is used as a base for opaque lakes, as an extender or filler, and as a reinforcing or strengthening pigment in house paints. Native barium sulphate (barytes) is an exceptionally heavy material used only as a loader or cheapener of paints. Blanc fixe and alumina hydrate are the highest-grade inert materials used to reduce the strength of pigments.

Chalk. Known in its purest form as precipitated chalk, this inert pigment is artificially manufactured and is used in several artists' materials, such as gesso grounds, pastels, and water paints. In the dry state it is a pure, snow-white, smooth powder which retains its whiteness in water mixtures but becomes muddy and yellowish when mixed with oil. Chalk has a high "bulking value" and contributes bulk or volume to paints. It is widely available in a standard U.S.P. grade at supply houses and drugstores and, although more expensive than whiting, is still of sufficiently low cost for large-scale use.

Whiting. Whiting is native or natural chalk, mined, ground, washed, and refined. Many industrial grades exist, but the average retail buyer at the paint stores is generally limited to the grade called Extra Gilder's; this is adequate for paint and gesso use but inferior in whiteness and uniformity to precipitated chalk, although it shares its general properties. When mixed with raw linseed oil, whiting forms the familiar putty, commonly used as a window cement.

Silica or silex (powdered quartz). This is made in a variety of grades, depending on its degree of coarseness, and is used in some paints and grounds to impart roughness or "tooth" to surfaces, because even the more finely powdered grades retain their sharpness of particle form and produce this result in coatings.

GROUNDS 4

Definition. The ground is the surface upon which an artist paints. In most painting techniques, a distinction is made between two elements: the *ground* itself, or the surface layer upon which the paint is applied, and the *support* or carrier of the ground; for example, linen or cotton canvas, wood or composition board or metal. Thus, the usual oil painting is executed on a ground made of two coats of white oil paint applied to a support, which is a piece of linen cloth stretched on a wooden frame—the whole commonly referred to as a canvas.

Importance of grounds. From a purely artistic viewpoint, the ground on which an oil or tempera painting is executed or the wall which provides the background for a mural painting is just a blank area upon which the artist projects his ideas. For this reason, the ground and its support are likely to be considered as the elements furthest removed from the creative part of painting; in fact, in many instances they are taken for granted to such an extent that the considerations which govern their technical requirements are ignored or at least not given sufficient thought.

The permanence or durability of a painting, its optical or visual effect, and the excellence or successful execution of the artist's personal technique, all depend to quite a degree on the nature of the ground; therefore, far apart though it is from the artist's principal concern, these considerations are of extreme importance, and attention given to their correct preparation or selection will repay the painter in many ways.

Rule of gradation of layers. The ground is not merely a pleasant white surface applied to conceal the color of the support, but it is also a necessary and important part of the structure of a painting. A painting with its multiple layers of support, ground, coats of paint and varnish is a structure, and as such must conform with the age-old rules of construction, which follow:

1. Never apply a brittle layer over a more flexible layer.
2. Never apply a layer containing strong binder over a weaker layer.

Disregarding the above precautions will invariably lead to cracking or distintegration of the coating. The opposite terms, "brittle" and "flexible," are used in a relative sense, meaning simply that some layers or films will bend or stretch more readily than others.

3. Coarser layers should lie under finer layers; the first coat of a plaster, for example, always contains coarse ingredients, whereas the final coat is made up of more finely divided particles.

2. Heavyweight, square-weave Belgian linen.

4. In thin coatings, layers of identical or nearly equal degree of strength, flexibility, and texture can ordinarily be used safely over each other.
5. Layers must have good or adequate adhesion or anchorage to each other. Roughness of texture (tooth), absorbency, or mutual cohesiveness is necessary to accomplish this. Any one of these conditions is normally sufficient to create good adhesion when the coating is acceptably strong, tough, and flexible. Ideally, all three should be present. The adhesion of paint to grounds is discussed on page 92.

GROUNDS FOR OIL PAINTING

Artists' canvas

Although the term "canvas" is sometimes applied to plain, coarsely woven cloth of vegetable origin, it is normally used among artists to denote a completely finished ground ready to paint on. Sometimes a completed oil painting is also referred to as a canvas, especially when someone is commenting on an artist's works. The application of a ground to cloth is called priming; sometimes this word is also used as a noun to indicate the coating itself.

3. Same high-quality Belgian linen, square-weave and average good middleweight.

4. Backlit photograph showing open weave of flimsy lightweight linen.

Linen canvas. Linen has been the standard material used as a support for canvas over the past five centuries, and no other textile fabric equals its combination of good properties. Finely woven or coarse, its boldness of texture persists through several coatings of primer and paint, imparting a distinctive quality to oil paintings that the less characterful weaves of cotton do not approach. The best linens are imported, mainly from Belgium and Ireland, where they are made especially for the purpose. There is quite a variety of weaves and weights to select from, but artists' linen is not too widely available. Not too many firms specialize in it, but the well-established art supply shops usually stock a few rolls or bolts.

Cotton canvas. The cheapest canvas in the shops is made of cotton sheeting, has a smooth texture, and can be distinguished from linen by the pale color of the rear or unprimed side, instead of the color of linen. Selected for its low price rather than its quality, it is a cheap product throughout. Compared to linen, cotton materials stretch poorly, do not take priming well, and are more susceptible to injury and to atmospheric changes. Cotton's lack of boldness of texture can often be discerned in the finished work; if a painting on cheap cotton canvas is hung among works on linen, the difference is usually apparent.

Cotton duck. Because real linen is expensive, substitutes became available in the mid-twentieth century—artists' canvas made of heavy,

53

5. Lightweight but good close-weave linen.

6. There are many varieties of pure linen available for artists' canvas.

7. And many varieties of prepared canvas.

close-woven cotton duck, and heavy cotton duck by the yard for preparing canvas in the studio. Cotton duck does not share most of the shortcomings of the cheap cotton canvas described in the foregoing paragraph, and although cotton duck is distinctly second choice compared with linen, it is acceptable, especially when it is used in paintings of great size, where the saving over linen would be appreciable. Its chief points of inferiority are that primings are prone to lie on the surface rather than to penetrate and grasp the fibers, and that the character of the weave is mechanical. Some painters have no objection to the cotton texture; others paint in styles in which it may be objectionable.

Cotton-linen mixtures. Oil grounds "take" better on mixed weaves than they do on straight cotton, but such canvases have the serious fault of unequal tension. The two separate materials are affected differently by atmosphere and stretching; thus the ground is subject to surface inequalities and its use is avoided by careful painters.

Jute, burlap, and similar coarse vegetal fibers are entirely unsuitable for permanent painting; they become extremely weak and brittle on short aging and are never used by conscientious painters.

Artists' canvas should be made of strong, stout material. The flimsiness and openness of weave of some of the cloth used at present, and in the recent past, are the direct causes of many failures, such as cracking and flaking of the paint and ground, because of the inability of such canvas to withstand mild, mechanical shocks and wear. The most desirable weave is a close, square one in which the threads of the warp and filling are identical or equal.

All vegetal textile fabrics are harmfully affected when they are impregnated with oils; they rot and become brittle and powdery with age. This action is prevented or minimized by sizing the cloth with a weak glue or gelatin solution before coating it with oil paint.

A nearly flawless, even weave is desired by most artists; irregular spots, knots, or nubbles are likely to be most annoying. The fine, uniform, flawless weave known as portrait linen is best for small works, and a more pronounced, bolder weave for larger paintings. Fine weaves are most suitable for precise, sharply painted styles, and coarse weaves for the heavier, more robust type of brushstroking.

The best-quality, ready-for-use artists' canvas is ordinarily sold in the shops in two grades, coated with either one or two coats of white oil paint, and known respectively as "single-prime" or "double-prime." Double-prime is more rigid, single-prime more limber; which one is preferable is a matter for the artist to decide; each has its adherents who hold that their choice is the more permanent and durable. Double-primed canvas is more expensive than single-primed. Because the cost of high-grade linen is such a large item, the maker will seldom skimp on these priming coats, and so the primings found on good, stout linen are generally of high quality. On cotton canvas and on the cheaper grades of linen, however, the priming itself may also be inferior. Before

8. A very thick stiff cotton duck, and a lighter, more pliable one that makes good, strong canvas for use in huge canvas sizes when linen would be too expensive.

the canvas is purchased, the priming should be inspected closely and its adhesion to the linen tested by a vigorous bending and rolling of a small corner between the fingers. It should be remembered that any textile coating can be made to crack or break under such treatment, but a good indication of its quality can be obtained by observing the tenacity of the ground's adhesion to the linen and the manner in which the coating suffers. It should not dust or chalk away weakly; it should not be over-brittle and crack too easily. The average oil-painting canvas is semi-absorbent, made to suit the average straight oil-painting technique.

It is practical to prepare commercial canvas with a slightly grayish tone, for uniformity and to counteract any slight yellowing. However, when the artist prepares his own canvas, he usually wants it to be as brilliant a white as possible, for the greatest reflection of light. If it is desired for any reason to use a colored ground, better results are obtained when a glaze or veil of color is put over a white ground than when colors are mixed into the ground itself. However, no structural or chemical disadvantage occurs when the priming is tinted by mixing colored paints with it.

Much canvas nowadays is prepared for use with acrylic polymer colors (see Chapter 10) and has an acrylic instead of an oil priming. Although such canvas is frequently offered as "all-purpose" canvas, suitable for use with either oil or acrylic colors, it should be borne in mind that a dual or multipurpose ground is apt to be inferior to one

57

designed for a specific purpose and also that permanence of adhesion between two disparate layers is inferior to the adhesion between like substances. Another disadvantage is that painting oil over acrylic goes against one of the primary guiding principles for permanent painting— never paint a layer over one that is more flexible. The acrylic colors form very flexible films; they retain their flexibility for a long time. Oil paint is less flexible to begin with and becomes more brittle as it ages (see number 5 on page 116). The best practice is to use oil colors on an oil ground and acrylic colors on an acrylic ground.

Making an oil canvas. Sometimes an artist finds that it is desirable or necessary to make his own canvas. For this purpose, a piece of linen, preferably of a closely woven, even-textured material (see Figure 3), is stretched making sure that the threads run parallel to the stretcher bars, and the surface is given a thorough coating of *weak* glue size as described on pages 73–74.

First priming. When the linen is dry, it is restretched tightly if necesary and given a thin, uniform coating of white lead in oil thinned down with turpentine or mineral spirits to a consistency that allows an even coating. The proportion is two or three fluid ounces of turpentine to each pound of white lead in oil, varying somewhat according to circumstances. The consistency is not that of a conventional free-flowing or fluid paint, but the mixture is soft enough to be brushed out and distributed evenly. Too much turpentine yields a weak or insufficient coating; too little produces a film that is too glossy or too nonabsorbent for the average painting technique. A flat varnishing brush is most convenient for applying grounds.

White lead in oil is sold in paint stores. It comes in one-, five-, twenty-five-, and hundred-pound containers; the best kinds bear the names of well-known, nationally distributed brands and have the contents on the labels–90 to 91 per cent basic lead carbonate plus 9 to 10 per cent raw linseed oil (see notes on its availability on page 37).

Second priming. After a day or two, the surface of the cloth, although still tender, will be dry enough to receive the second and final coat. Before applying it, the surface is tried by passing the palm of the hand lightly over it, and if there is any fuzz or hairy roughness, it is removed by a *very light* sandpapering, the sandpaper held loosely in the fingers, just so as to shave away the fuzz without grinding away the coating. The second coat is applied in the same way as the first, the priming being exactly the same as that of the first coat. It may contain slightly less turpentine but never any more than the first coat, as that would be likely to produce a somewhat less flexible layer which would be contrary to the rule forbidding application of a coat of paint over a more flexible coat. This kind of ground may be used as soon as it is completely hard and firm, which should be in about two weeks.

Effect of daylight. Grounds made of this type of industrial white lead in oil require exposure to daylight for about ten days during the

initial period of drying in order to prevent their turning yellowish. Should this occur, several days' exposure to daylight will restore them to their original creamy whiteness again. The raw linseed oil and the grinding methods employed in the manufacture of commercial white lead in oil seem to make this product more susceptible to the presence and absence of light than the finer-quality artists' flake or Cremnitz white oil paints.

Other white pigments as oil grounds. Zinc white, titanium white, lithopone, and mixtures of these materials have been used as grounds for oil canvases because purer or more brilliant white coatings can be produced with them than with straight white lead in oil, which by comparison produces relatively creamy whites. Because of the inferior film or structural properties which these pigments impart to coatings, as compared with the good characteristics of a white-lead-in-oil film, they are not recommended for homemade canvases. Commercial makers of artists' canvas, who have many more grades of materials and means of manufacture than are available to retail consumers, achieve good results with mixtures of zinc and titanium whites. A very important consideration to the retailer is whiteness; such canvases are far more attractive than those with a creamy-toned white lead priming. However, the straight white lead in oil ground, as used for centuries, is still standard for studio-made canvas. The properties of these other pigments have been described under **White pigments** (pages 37–39). The value of mixtures of white lead and zinc or titanium whites has been proved largely in house paints, which are ordinarily painted on rigid surfaces such as wood rather than on canvas. Since satisfactory grades of ready-prepared zinc and titanium whites of the same degree of quality and suitability as white lead are not ordinarily available in retail paint stores, the more expensive artists' material must be used when zinc or titanium is introduced into homemade grounds.

Utilization of old canvases. From the standpoint of permanence of effects and structural permanence, there are so many bad results when an oil painting is done over a completed old canvas that none of the makeshift methods of utilizing old paintings can be recommended. For temporary sketch or students' purposes, the old paint can be scraped or sandpapered down to an acceptable smoothness and given a coat of flat-white oil paint such as is sold for painting interior walls. Panels can be salvaged for professional use by sandpapering down the entire coating. The linen of a canvas can sometimes be salvaged, if it is of good, stout quality, by removing it from the stretchers and soaking it in a tub of water; this may, in many cases, make the entire paint and oil ground easily detachable from the cloth by dissolving the glue size. Few important, successful paintings of past art periods have come down to us on reused canvases, and the practice always leads to disagreeable or distastrous blemishes. There are some more remarks on this subject, in relation to painting with oil colors, on page 103.

9. Materials for stretching canvas.

Stretching canvas. The *stretcher strips* or stretcher bars sold universally in art-supply shops have tongue-and-groove corners (Figure 9) and are formed by automatic machinery so that they can be assembled to an accurate rectangle, capable of being expanded at the corners to tighten the canvas in case it should sag because of atmospheric changes —a not-infrequent occurrence. The outer edges of the strips are flanged so that the canvas does not come into contact with the inner edges; should this occur, the painting would be disfigured by marks caused by the contact; this would certainly happen if the stretcher were not flanged or beveled. The assembled stretcher frame is known as a *chassis*. The chassis is expanded by driving small flat wedges called keys into slots

10 & 11. Assembling stretcher bars.

12. Assembled stretcher frame or chassis being pushed into a doorway to true it.

which are provided at the inner corners of the assembled chassis. A chassis made of simple wood strips that could not be expanded at the corners is entirely substandard and would not be tolerated by a museum; its correct name is a *strainer,* not a stretcher. A strainer may be used as a support for a wallboard panel or a work on paper mounted on cardboard. Heavier stretchers are required for large canvases (see pages 65–66).

It is not difficult to tack canvas to a chassis, but unless it is done *systematically* the results may be erratic. The important points are to make sure that:

1. The stretcher strips are assembled tightly and the corners are true right angles.
2. The weave of the canvas is exactly parallel to the frame.
3. The tacks are placed at regular intervals.
4. The pull or tension used with the stretching pliers is uniform at each tack. Otherwise the canvas may very likely have the following faults:
 a. Distortion of its rectangular shape so that it might not fit a picture frame.
 b. Distortion and irregularity of weave.
 c. Lack of tautness resulting in wrinkly or slack spots.
 d. Bad warping of the frame from unequal tension, especially in the larger sizes.

Check the accuracy of the assembled chassis with a try square, or by fitting each corner firmly into a corner of a door or window frame, and by measuring both dimensions with a steel tape. Adjust any differences by tapping with a hammer.

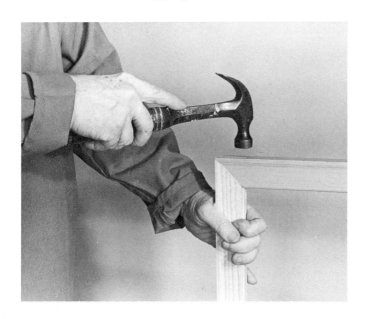
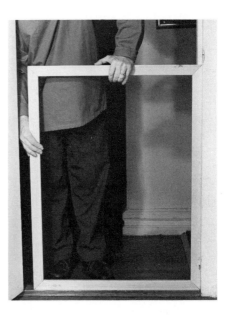

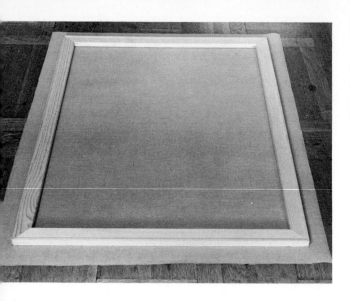

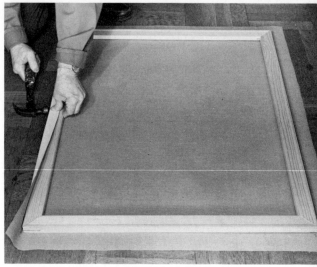

13. Chassis centered on back side of canvas which has been cut 1½ inches larger all around.

14. First tack driven into middle of a long side.

Cut the canvas from the roll, allowing a margin of 1½ inches more than the exact size, so as to be able to grasp the edges while stretching. It is, of course, most economical to cut the shorter dimension from the roll, but in some instances it may pay to take the longer dimension so as to have a usable remnant left over, instead of a wasteful scrap. Lay the piece of canvas face down on table or floor and center the chassis on it, trying to keep it parallel to the weave of the canvas as much as possible. Then fold the canvas back over one of the long sides, drive in a tack at the center of the strip and another tack opposite it at the center of the other long side, stretching it very tightly. An acceptable

17. Note that with tacks on all sides, the wrinkles tend to assume a diamond-shaped pattern.

18. Canvas is pulled taut toward the corner during tacking to help avoid wrinkles.

19. The left corner (facing the rear) has a tack or two in its upper corner, which is its wider portion.

15. Second tack placed opposite the first.

16. Third tack goes in the middle of a short side.

job can be done with the fingers, but the stretching pliers are much more efficient and have been standard equipment for many years. Repeat with the other two sides, stretching very tightly and maintaining the parallel alignment of the weave. At this point it is normal for the canvas to have a diamond-shaped wrinkle, running from tack to tack.

Now, beginning at the center tack of one of the *long* sides, drive in a row of tacks toward the corner, placing them evenly and stretching tightly at each point. Don't go beyond the point where the bars join; the corners are to be tacked last, after all the other tacks are in. Before placing each tack, take up any horizontal slack by pulling the canvas to

20. With the canvas standing on edge and facing its rear, the right corner is tucked in and then folded down, placing the tack or tacks in the lower portion of the right-hand corner.

21. This is the wrong way to tack a corner, with canvas folded over instead of tucked in; the resulting flap is a hindrance to framing and susceptible to damage.

the right or left with the fingers. Should a wrinkle occur at any point, ease up on the tension until the canvas at that point is smooth and flat before placing the tack. Turn the canvas around and do half of the other long side (diagonally opposite), then finish the first side, and back to the final section. Then do the short sides.

To do the corners, face the rear of the canvas, and start by stretching and tacking the left-hand end near the *front* edge (Figure 19); next, the right-hand end at the same corner by first folding the corner of the canvas and tucking it *in* neatly (Figure 20). Then with the aid of the stretching pliers drive in the tacks near the *rear* edge. The reason for these left-hand-front-edge and right-hand-rear-edge instructions and for always tucking the canvas in over the right-hand ends will be seen im-

22. Surplus canvas fastened down with staples.

23. A canvas stretched with staples may be strengthened with middle and corner tacks.

mediately on examining the construction of a stretcher strip at these points: the idea is to drive the tacks into the center of the widest portion of the wood; this is always toward the front edge or face of the canvas at the left-hand end of each strip and toward the rear edge at the right-hand end. The little triangular wooden wedges or keys are lightly hammered into the slots, two in each corner, after all the tacks are in. Normally the wedges should not be driven in very far, but they are best held in reserve in case tightening of the canvas is subsequently required. When a hammer is used, a piece of cardboard should always be inserted between canvas and stretcher, because glancing hammer blows can cause future cracking of the canvas. Small brads will keep the keys from falling out (Figure 25).

There are a great many other systems of the order in which stretching is done; this one has been selected as most universally successful. Some will be found in books and canvas dealers' pamphlets; others may be learned through contact with other workers. Select the one you like best. Do not trim the surplus margin but tack or staple enough of it down for use in possible future restretching.

In recent years some painters have substituted the use of thin wire staples and a lightweight staple gun for hammer and tacks. The only advantage of this procedure is ease and speed of operation; in every one of the more important long-term considerations it is completely inferior. For permanent stretching use ordinary carpet tacks (number 4 is average). When staples have been used, a canvas can be greatly improved by adding a few tacks, or at least one at the center of each strip and at the wide part of each corner.

Special extra-heavy, rigid stretchers with two crossbars are made to order by the firms which manufacture the regular stock strips (Figure 26). These can be ordered from any complete artists' supply shop, on reasonably short notice, and they can be made to any exact dimensions or with any desired number or arrangement of crossbars. Many careful

24. A piece of cardboard slipped behind the chassis before hammering in the keys prevents a common damage—cracking of the paint by hammer blows and scrapes.

25. Brads hammered into the stretcher prevent keys from falling out.

26. An extra heavy (2½-inch bar) stretcher with two crossbars, assembled for use.

27. Hardboard panel braced by gluing to a wooden framework.

artists prefer them, especially in large sizes, as they decrease the painting's fragility and its tendency to warp, and they should be used for all paintings that are longer than 40 inches. These special strips are 2½ inches wide, are beveled on one side only, and their crossbars are keyed as well as their corners. Ordinary stretcher strips can also be ordered in fractional lengths or with crossbars, but these will not have slots for keys as in the heavier ones.

Warping of canvases. The modern lightweight, interchangeable stretcher made by automatic machinery was first introduced around the turn of the century as an improvement over the earlier custom-made chassis that was similar to our present extra-heavy stretcher. They have the advantages of cheapness, universal availability, and light weight, and so they soon became popular. However, they were adopted in a day when no painting was ever hung without being securely braced in a sturdy frame. The warping of unframed canvases or those with simple stripping is fairly common, especially when they are hung on exterior walls. The answer to the problem of warped canvases is simple; when a picture is to be hung without a strong, bracing frame the canvas

should be put on heavy stretchers with crossbars placed wherever they are deemed necessary.

Wood panels. Wood panels have been used for easel paintings by European artists from the earliest days. They present a more rigid support for painting grounds than do canvases; they are therefore far superior for brittle and inflexible coatings, such as gesso, and they are also more satisfactory than woven textiles when smooth, textureless surfaces are preferred.

Wood panels, however, suffer from as many defects and ills as do linen canvases and, judging from the practical test of time, it cannot be said that one is more permanent than the other; in general, old oil paintings on canvas have survived in good condition as often as those painted on wood. Wood panels are subject to warping, cracking, and rotting, more rapidly in some climates than in others.

Wood panels may be classified in two types: (1) solid wood and (2) plywood, which is composed of relatively thin laminations or layers of wood glued together under pressure. Solid wood panels are principally of historical interest, because for many years the finest woodwork of all kinds has employed plywood or veneer, which is even more durable for paintings than panels made from one piece of wood. The early Italian easel paintings were largely done on very thick solid panels; the typical or usual wood employed was poplar. The Northern schools preferred thinner panels as a rule, and the wood was usually solid oak or mahogany.

Plywoods. The results of years of experience, corroborated by scientifically controlled tests, now show that a plywood or veneered wood panel is far less subject than a solid panel of equivalent dimension to cracking, warping, splitting, and other forms of decay. The following commercially available standard stock varieties are in use:

> Five-ply maple, ¾ inch thick, generally called die boards; all five plies are of equal thickness. This kind is made for technical use rather than for furniture purposes.
>
> Five-ply birch or maple, $1\frac{3}{16}$ inch; the inner core is the thickest and is made of softer wood, such as gum, and the two outer plies on each side are thin.
>
> Five-ply maple, birch, walnut, or mahogany approximately ¼ inch thick; this type is less desirable than the heavier ones, especially in larger sizes.

The four above-named species of wood are believed to be of equal value, and no superiority of one over another has been established. Birch and maple, said to be least sensitive of the durable hardwoods to moisture, are likely to be the most available and least expensive. Panels with one-piece faces or the least number of joins are preferable.

Fiberboards. During the first half of the present century there was an active search for a convenient and economical panel for easel painting in place of the traditional high-grade, expensive, heavy hardwood

boards and plywoods—a board that could be handled like the common-place cardboards and composition boards that were employed for less exacting purposes, but that would have additional properties, providing durability and longevity, that would put the panel in a class with a slab of veneered wood or a stretch of canvas. As various boards developed for the building trades, both solid and laminated were tried out; finally, in the early 1930s, artists had adopted as an ideal board that met all their requirements the compact fibrous material known as *hardboard*.

Hardboard. A dense, strong, durable board, light-tan to chocolate-brown in color and with one perfectly smooth side, the other slightly irregular and indented with a wire-screen pattern. Hardboard comes in several thicknesses; the panels generally in use by artists are $\frac{1}{8}$- or occasionally $\frac{3}{16}$-inch thick. The sheets usually found in lumberyards are four feet wide in several lengths up to sixteen feet. From the time it was first introduced as a building board in the early 1930s, artists have used a superior brand called Masonite or Masonite Presdwood (to distinguish it from other products of that company). Currently there are a number of good, honestly made brands.

Hardboard is an excellent material to use as a support for painting-grounds for both oil and tempera painting; it has several advantages over plywood and hardwood; it saws easily, it is a homogeneous material without wood's grains and cellular structure, therefore will not crack or split, and if correctly prepared will not warp. Pieces larger than 24 inches, however, will sometimes curve or bend of their own weight when stored standing on edge. To avoid this, a panel should either be well-braced in a substantial frame or it should be glued to a wooden framework made of 1½-inch strips, preferably carpenter-made with mitered corners and with crossbars for the large sizes. For panels 50 inches or more, some careful workers use 2½-inch strips, and some recommend this practice of "cradling" panels for even the smaller sizes. I put the word in quotation marks because although painters use the term to describe this simple bracing, it really defines a more complex type of hardwood bracing with movable slats, used by conservators to repair old panels that have become split and warped. Recommended glues are full-strength rabbitskin glue (with all the soaking water poured off and heated in a double boiler), casein glue (for a rigid join), or one of several popular synthetic adhesives, such as Weldwood. Since hardboard is so much cheaper than linen canvas, it does not make sense to skimp on the quality of the bracing.

A hardboard panel should be lightly rubbed with extra-fine sandpaper or garnet paper until a fuzz is raised, and then scrubbed with a cloth dipped in denatured alcohol to which a little *clear* ammonia has been added. This will overcome any tendency to repel wetting, and when these fluids have evaporated, a gesso or oil ground is brushed on as outlined later in this chapter.

Sometimes there is a tendency of the board to warp while the priming is applied, especially when it is water-based (gesso). This can usually be avoided or corrected by coating the rear in order to compensate

for the tension of the gesso priming. Sometimes a high-quality exterior oil or alkyd house paint is employed for this purpose. Technically, either the smooth or the rough side may be used, but I think that, when painted, the rough side looks like an unsuccessful attempt at imitating a canvas weave. One may glue cloth on a braced hardboard panel if it is desired.

Manufacture of hardboard. In the manufacture of hardboard, the bark is removed from the logs and machines chop the wood into small chips which are screened to uniform size. In the exclusive process introduced by Masonite the chips are placed in a chamber where steam under high pressure is gradually introduced, then suddenly released, which "explodes" the wood into a mass of fibers. Pressed into sheets under heat and high pressure, the fibers interlock to form a solid material again, bound and cemented permanently by the natural lignins within the wood. Unlike any other type of manufactured board, hardboard does not need added binders or glues; a small amount of paraffin size is added to provide a moisture-resistant quality. In another process the chips are first steamed and softened under pressure and then reduced to fiber form by a machine which avoids breaking them, retaining their long fiber shape. In a wet process water is introduced to put the material into pulp form. According to the process used, the fibers go through a series of treatments before going into hydraulic presses under heat (380 to 550 degrees Fahrenheit) and a pressure of 500 to 1500 pounds per square inch. The sheets are usually pressed between a smooth plate and a wire mesh screen which imprints the familiar marks on one side. The heat and pressure welds the fibers back together into what some have called an improvement on wood.

Some hardboards are sold as "tempered," which means they have been treated with linseed or tung oil and baked. This increases the board's strength against wear and tear and also increases its moisture resistance—but interferes greatly with the permanence of adhesion of coatings, especially those that contain water. Tempered hardboard is never recommended for artists' panels for which purpose the regular hardboard is amply strong and durable.

There are more than a dozen companies that make or are capable of making hardboard in the United States; most of them have several plants. In addition, hardboard is made throughout the world, and a great deal of what is available in the lumberyard is imported from Europe, Africa, Asia, and South America. One would expect properties to vary, at least somewhat, with so many different species of wood in use, together with variations in process, workmanship, and management.

It is quite difficult to distinguish between unbranded hardboard and other boards such as particleboard. Some kinds are identified; others are not. Masonite has always been branded.

As yet, no research has been done on hardboard from the artist's standpoint, although the industry has standards and tests for hardboard as a building material. Some of the points to check would be the reaction of a panel to priming and its ability to age without change.

69

There is a tendency among American manufacturers to concentrate their domestic plants on the production of specialty items such as wall paneling and siding, importing their basic hardboard from foreign sources, sometimes from affiliated factories. If a board is branded on the rear, it is advantageous, as it insures a supply of material that will behave in a uniform way. The hardboard makers and the American Hardboard Association have united in the establishment of a Voluntary Project Standard (under the U.S. Department of Commerce) Number PS58-73. This has substantially the same function as our own Paint Standard CS98-62, which is described on page 188. Boards that comply with all of its requirements may indicate adherence to the standard by vertical colored stripes painted on each of the four sides of a stack of boards, three inches from the corner. The code for Basic Hardboard is one green stripe, which results in a short green line on the edges of each board. There is a special form of standard hardboard which is smooth on both sides. It is called Underlayment and is available only in sheets four feet square. The rough side has been sanded down to a uniform thickness of 0.215 inch.

Particleboard. Particleboard is another class of homogeneous hot-pressed board, produced both in flat sheets and molded components, and is made for construction work and furniture, not only from wood but also other lignocellulosic materials—from dried grasses to peanut shells. Particleboards differ from the hardboards in that their manufacture does not depend on their natural ingredients to bind them, but they owe their strength and cohesion to added synthetic-resin adhesives such as phenol-formaldehyde, urea-formaldehyde, and melamine-formaldehyde combinations, thermosetting resins that are polymerized by the hot press. The great technical difference between the two is that particleboard has none of the interlocking fiber, welded, or "reconstituted wood" character of hardboard but is composed of discrete particles glued together. In general, the run of particleboard and weaker boards with added glues and adhesives is definitely inferior to hardboard in meeting the requirements for durable easel painting. All kinds of modern particleboards, as well as the old-fashioned lightweight fiberboards, are sometimes made up to resemble hardboard, so that it is not always possible to distinguish between them unless they are accompanied by identification. They are made the world over.

Other wallboards. Several cheaper and less durable kinds of wallboard, such as the Upson board type and others of paper or cardboard origin, are suitable for preparing panels for students' work and for temporary purposes. They should never be used, however, for permanent painting as they are not durable enough to resist the decay of aging or the wear of handling. Originally some artist painters were rather dubious on the subject of the permanence of the adhesion of paint or glue coatings on hardboard because it was a relatively new material and lacked the test of time that wood and linen had undergone. When apply-

28. Canvas glued to Masonite with gesso-strength rabbitskin glue. Upper panel had a thin coating of oil paint; when pulled away, canvas came off clean. Lower panel was glued directly to untreated board; when canvas was pulled away, a layer of Masonite came away with it.

ing either oil or gesso grounds to hardboard panels, some cautious painters, following the old procedure for linen and wooden supports, apply a coat of thin, hot glue size as recommended for these supports on page 74. However, careful tests for adhesion and ease of coating with either oil or gesso grounds indicate that this is not entirely necessary. Figure 28 illustrates the adhesion of the gesso glue to unprepared hardboard; on the lower panel, a piece of fine linen was attached with a solution of rabbitskin glue. When this is pulled away from the surface by force, a whole layer of Masonite fibers comes away with it, showing complete and efficient adhesion; on the upper panel the same test was repeated on Masonite that had been given a thin coat of oil paint. Here the linen pulls off very easily and cleanly, indicating a superficial and perhaps impermanent adhesion.

Oil grounds on panels. Panels may be prepared with white lead in oil in much the same manner as canvas. When the panel is not abnormally or unevenly absorbent, the glue size may be omitted. It is customary to roughen the surface of the panel with sandpaper before applying the first coat. For very smooth surfaces the ground may be sandpapered with very fine abrasive paper. In order to produce a surface that has a coarse texture or tooth, powdered pumice or silica may be stirred into the final coating.

Metal grounds. In former times copper sheets have been used as supports for small paintings, but the practice never achieved much success; lack of adhesion and the development of blistering and flaking of the coating are common in these old works. The use of stainless steel and aluminum sheets is a modern development and shows much prom-

71

29. A sheet of French rabbitskin glue.

30. American granulated rabbitskin glue.

ise, but until there have been further research and standardization of artists' grounds on metals, they must be considered experimental.

The vast experience in applying coatings on aluminum gained in recent years, especially by the airplane industry, has shown that the production of durable grounds with permanent anchorage to this metal is by no means the simple procedure that was supposed when aluminum sheets first came into use. The natural oxide that forms on aluminum surfaces does not supply a good bond; aluminum panels require an electrolytic treatment and a corrosion-inhibiting primer before the ground or finishing coating is applied.

Student and sketching panels.

Oil ground. The ready-made canvas boards and academy boards that are sold for temporary sketch purposes are usually adequate but should not be used for permanent, serious works of art, as their materials and workmanship are usually of an inferior nature. For larger sizes such panels are usually made by the artist, by applying two thin coats of ready-mixed flat white oil paint, such as is available for interior house use, to hardboard panels. Lighter-weight and cheaper panels can be made by using common wallboard (paperboards and fiberboards). When a less absorbent coating is required, the panel is sized with a thin coat of shellac before the paint is applied. A coat of any sort of paint or varnish on the back side will prevent excessive curving or warping of the board.

Substitute gesso grounds. Gesso is such a simple, basic product that there is little one can do but cheapen it by using the least expensive board, fiberboard, or paperboard. For large quantities, one could also effect a saving by using cheaper glue, but this would require tests to arrive at the proper strength.

72

31. Sheets of gelatin made for laboratory use.

32. Consistency of dilute rabbitskin glue for sizing linen after cooling to room temperature.

GLUES

A glue is used for the following purposes:

1. As an adhesive to join various materials, such as wood and canvases.
2. As a size or sealer for porous surfaces.
3. As a binder for some types of grounds (gesso).
4. As a binder or vehicle for coarse or cheap paints (poster colors, scenic colors, and so on).

The best glues are those made from the hides or skins of animals; the more delicate and tender the skin, the better the glue. The European craftsmen in medieval and Renaissance times prepared a homemade glue by boiling parchment scraps and clippings, for which the modern equivalent is a very high-grade glue made from rabbitskins. Some calfskin glues are also good. French rabbitskin glue comes in sheets about 7 inches square (Figure 29). American kinds come in coarse granules or flakes. Hide glue is also sold in powder form, which I believe is less desirable; it cannot be dissolved by the presoak method, and there is no certainty of its purity or freedom from adulterants.

Bone glue, fish glue, and other types are seldom desirable. Gelatin (Figure 31) is a highly purified material made from the same sources as the hide glues and is used to a limited extent in painting techniques, mainly as a sizing material rather than as a binder or adhesive.

A well-balanced glue has both high adhesive strength and high viscosity or jelling power; the rabbitskin and calfskin glues fill these requirements, but gelatin is second choice because it is not so good as a binder or adhesive, although it is an excellent sizing material. The most powerful glues are also the cleanest and purest and will produce the best results in every respect.

What a size is. A fluid material used as a size is distinctly different from a binder or an adhesive or a film-forming material. A size is employed to fill up pores in a porous surface, to render a surface less absorbent to subsequent applications of paints, and to isolate the fibers of a material from the action of some other material. When a weak glue solution or a weak shellac solution is recommended as a size, it is intended to accomplish one of these purposes without forming a definite or appreciable layer or skin after it has dried. If the solution is too strong or is applied too thickly, the result will not be that of a size; rather, it is likely to form a continuous layer or film, thus adding an element to the structure of the coating which is almost always undesirable. In the case of the weak glue or gelatin size recommended for linen, a thick layer is to be avoided as it would be a weak element in the structure of the canvas. It is very important to observe this precaution: to avoid, whenever a size is required, the formation of a continuous film of any appreciable thickness.

Approximately 1½ ounces of rabbitskin glue dissolved in a quart of water (in the manner described on page 76) will yield a size of the proper strength for treating linen canvas prior to priming with oil paint. When cool, this solution should not solidify at normal room temperature beyond the point of the weakest sort of semi-jelly, as shown in Figure 32.

Gesso Grounds *

The word "gesso" (from the Italian, pronounced "jesso") means a white coating composed of hide glue mixed with an inert pigment such as chalk or whiting. It is applied to flat panels, picture frames, and other objects, plain or carved, in order to produce a smooth, level surface for decoration with paint or gold leaf. The term dates back beyond the fourteenth century. Cennino Cennini (see page 123) made a distinction between two kinds, *gesso sottile* or finishing gesso, which is equivalent to the modern gesso described here, and *gesso grosso,* formerly used as an underlayer for the finishing gesso, especially on rough or heavily ornamented surfaces such as carved frames, furniture, and the like. *Gesso grosso* was raw plaster of Paris used either alone or mixed with glue or *gesso sottile.* Giotto's *gesso sottile* was made of parchment glue and slaked plaster of Paris (artificial gypsum).

Gesso and its application are simple, and perfect results are easy to obtain; complicating the simple instructions merely leads to compli-

* Gesso and the preparation of gesso panels are gone into in such detail here not because the subject is of greater significance than the others, but because the material is more often prepared by the artist than it is purchased ready-made, and also because it demonstrates a set of instructions typical of the kind of procedure an artist is called upon to perform when he prepares his own materials.

33. Left: dry French rabbitskin glue. Right: swollen after an overnight soaking.

cations in results. If the glue is too weak, the gesso will be too soft; if the glue is too strong, the gesso will be too hard and probably will crack. Cracking also occurs when a stronger gesso is applied over a weaker layer, and sometimes when the panels are made in a damp or unheated room. Pinholes are caused mostly by air bubbles or foamy gesso; they appear most frequently when the gesso is too weak and when the under-layers were too dry. The defects of simple gesso show up immediately upon the complete drying-out of the surface, and if the gesso surface is good at that time it is almost certain to remain so indefinitely.

The average gesso surface for modern use should be hard and strong; it should not be too easy to dent, scratch, or chip off with the thumbnail, but it should not be so hard that it will present too much difficulty in the smoothing or finishing operations.

Acrylic polymer "gesso." After more than five centuries of use as a specific term for glue-and-chalk mixtures, the word "gesso" was used by the first American marketers of polymer colors to label their polymer primer, and all other producers have followed suit. The user of real gesso now has to be wary of confusing the two; look for the words "acrylic" or "polymer" in small type, or a brand name, above the word "gesso." European brands are labeled acrylic polymer primer (see the remarks under polymer paints on page 168). The acrylic "gesso" is not absorbent and will not serve the same purposes as real gesso.

The art-supply people do sell a packaged gesso, chalk and glue. It is a dry powder and needs to be mixed with water before using. The product is perfectly acceptable for average purposes.

Composition of gesso. The classic recipe for gesso as recorded by Cennino Cennini employs parchment glue and an inert white powder (calcium sulphate) made by slaking plaster of Paris. Precipitated chalk and a fine grade of purified whiting (these powders are described under **Inert Pigments** on page 48) soon came into use as improvements, when

75

34. Thin brushing-consistency of heated gesso.

these materials became available. Modern gesso is made of a solution of rabbit- or calfskin glue and chalk. The best modern gesso recipes do not differ appreciably from the earliest ones and, although some care and skill are necessary to make good gesso panels, ability to prepare them is quickly acquired without too much trouble.

Typical recipe for gesso. Soak 3 ounces of French or American rabbitskin glue in 28 fluid ounces of cold water overnight, or until it has swollen and absorbed its full capacity of water. It should then be of a uniform pale color and of soft consistency throughout, without any dark or tough spots (Figure 33). If the glue comes in large sheets, it should first be wrapped in a cloth and broken into small pieces.

Place in a double boiler and heat, with occasional stirring, until dissolved. No glue solutions should ever be boiled, overheated, or scorched as this would immediately throw off its properties in an erratic manner and destroy all accuracy and control of recipes; that is why a double boiler is necessary. Pour the glue into a quart measure and add the few ounces of water necessary to bring its volume up to one quart. Replace in the double boiler, heat thoroughly, and it will be ready for use.

The hot glue solution is mixed with precipitated chalk to a *thin* cream consistency as demonstrated in Figure 34. Water and glue are measured accurately, and the consistency is varied according to the amount of chalk added; about a pound or a little less to a quart of glue solution is average. It is customary to replace two ounces or so with zinc or titanium white in order to increase opacity. If, instead of being

76

used, the glue is allowed to cool in the pot overnight at normal room temperature, it will set to a jelly, as illustrated in Figure 35. One way to test the glue for strength is by an inspection of this jelly. When the smooth surface of the jelly in the pot is parted with the fingers, it should break as it does in the illustration, a rather clean break at the surface and a rough granular break through its mass. A clean, sharp break all the way down shows it to be too strong, whereas a soft, ragged break on the surface indicates that it is too weak.

Supports for gesso grounds. Gesso is usually applied to rigid panels of wood or a durable wallboard (see page 67) by brushing on the liquid gesso in several coats as uniformly and evenly as possible. When the coating is dry, the brushmarks are rubbed down so that the surface is smooth and flawless. Gesso is not well adapted for coating canvas. The cloth is too flexible and too susceptible to the access of atmospheric moisture from the rear to be considered safely permanent. When special precautions are observed, a fairly durable but very thin ground is sometimes made on canvas—especially on the reverse side of a prepared oil canvas where the oil priming acts as a stiffener or rein-forcement as well as a moisture resister—but, in general, this practice is not to be recommended. Canvas is of principal value as a support for oil grounds. If a canvas or canvas-like texture is preferred to the stan-dard ivory-smooth gesso finish, it can be obtained either by gluing coarse linen on the panel before applying the gesso or by impressing the weave

35. The consistency of rabbitskin glue of the proper strength for gesso, after cooling to room temperature.

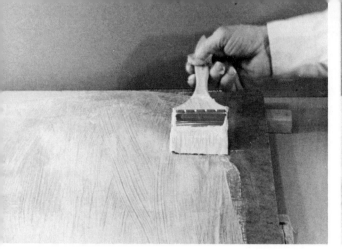

36. Applying gesso to a hardboard panel: first coat.

37. Applying gesso: removing air bubbles by stroking the wet gesso with the fingertips.

of cloth on the final coating of gesso while it is drying, at the moment when it is dry enough to resist being picked up and, at the same time, soft enough to receive the impression.

Before applying gesso, the panels must be prepared in accordance with the instructions mentioned at the end of the section on hardboard panels on page 68.

Artists who use wood or plywood panels like to glue a piece of thin muslin to the board as a safeguard against cracking from shrinkage or other separation of the grain of the wood. Dip the cloth in gesso-strength glue, stretch over the panel tightly, rub over the surface with the fingertips to make smooth. If necessary, fasten with thumbtacks to the edges of the board, but the wet cloth need not be stretched; it tightens as it dries.

Application of gesso. The gesso must be applied in several thin layers or coats, and in order to insure uniformity of the whole coating, it is important to use liquid gesso of the same strength throughout the application. It is also important to remember that glue gesso must be at the same uniform heat when its consistency is judged. Some careful

38. Alternate method of applying first coat of hot gesso by scrubbing it in to break up pinholes.

39. Applying gesso: brushing out a solid coat.

40. Applying gesso: smoothing out a coating.

workers will use a thermometer to maintain a constant temperature, but with a little experience this should not be necessary as there is some leeway. The first coat should be applied as hot as possible, and manipulations will be easier in subsequent coats if the liquid is kept warm, but continual heating in the double boiler while in use sometimes causes pinholes to form. The cooler the glue mixture, the thicker and less brushable will be the coatings.

Enough gesso must be put on the panel so that the final dried coating may be sandpapered to a smooth finish, free from the rather heavy brushmarks that are normally present, without the sandpaper going through and exposing the panel at any point. This will take four or more coats.

First coat. After the first coat has been brushed onto the panel (Figure 36), any air bubbles are smoothed away with the fingertips (Figure 37). This results in a rather thin and not very opaque layer. Any roughness or fingermarks will be concealed by the next coat and can be disregarded.

Subsequent coats. Each coat is applied as soon as the previous coat is dry enough to withstand it and not be picked up by the brushing. Each coat will take longer to dry than the preceding coat because of the greater moisture-retention of the built-up layers. The gesso is applied with a thin flat brush (a varnish brush or artists' extra-wide, flat, bristle brush is best). A full brushstroke is drawn rapidly across one edge of the panel, with a waggling wrist motion such as house painters use (Figure 39); then with straight, light strokes (Figure 40) it is smoothed *in one direction only* until the brush begins to drag and the gesso begins its initial set; the brushing is stopped immediately at this point and the next stroke commenced.

The same method of brushstroking is repeated on the rest of the coats, but each time the panel is turned so that the strokes are at right angles to those of the previous coat. This is most important if a level, smooth layer is to be produced.

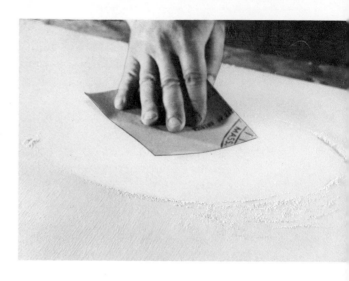

41. Applying gesso: removing brushstrokes with garnet paper.

42. Applying gesso: sanding with a block.

43. Applying gesso: the final polishing with a wet pad.

Finishing the panels. At any time after the final coat has become thoroughly dry, the panels may be brought to a smooth, level surface by rubbing them down to remove brushmarks and other irregularities. The most widely used method is to rub the surface with fine-grain abrasive paper (Figure 41), several varieties of which are useful. The 4/0 grain (150) is usually considered best, as it will take down the irregularities of surface rapidly enough and not scar the finish too deeply. A finer grain, 6/0, is preferred by some. Garnet paper and some of the synthetic aluminum oxide abrasives work well. Ordinary or common sandpapers are not satisfactory; they stain the surface and are not sharp enough for use on gesso of the required hardness. For a mechanically perfect, level surface a sandpaper block can be used (Figure 42).

Any fine abrasive scratches may be smoothed (or the entire finishing operation may be accomplished) by another method—rubbing with a soft cotton cloth dipped in water, well wrung out, and smoothly folded to a wad (Figure 43). This method dissolves a tiny surface layer and distributes it evenly over the surface, creating a smooth, ivory polish.

Another means of producing a smooth surface is to use a soaking-wet block or lump of pumice which has been brought to a smooth flat surface by rubbing it on fine sandpaper. Experience and practice will develop a good technique, and personal preferences for these various methods of smoothing gesso panels will be established. If powdered pumice is used in connection with a wet rubbing method, sufficient pumice will remain embedded in the surface after drying to produce a finish with a considerable degree of tooth.

Defects of gesso panels.

Pinholes may be caused by careless application, by air bubbles (especially in the first coat), by the preceding coat being too dry or the gesso being too foamy.

Paint will seldom conceal pinholes; as shown in Figure 45, thin layers of color will accentuate them.

Cracking (Figure 46) may occur if the glue is too strong or stronger than the preceding coats; if a single coat is too thick; or when the room is cold and damp. Cracks occurring long after the panel is finished are usually the fault of the support.

Preparation for painting. A gesso panel may be, and ordinarily is, painted on directly, without further preparation, when tempera, watercolor, or gouache paints are used. For normal oil painting it is necessary to reduce its absorbency or porosity by sizing lightly with very much thinned-out shellac or a very dilute gelatin solution; this will cut down (but not eliminate entirely) the absorbency of the surface so that painting manipulations may be properly carried out. The reasons for desiring this condition are discussed on pages 92 and 93. If too much size is applied, the panel will become so nonabsorbent that the painting will not take well or have good anchorage to the surface. Some painters apply the size after an outline drawing, thus combining its function with that of a fixative for the drawing.

Casein gesso. Casein is a material from which adhesive and binder solutions can be made; its properties and the methods of handling it are described on page 135.

Some painters and some commercial firms have used casein in painting grounds, where it serves fairly well, but such grounds are distinctly second-rate compared to those made with glue. Casein is a "cold glue"; that is, after making the solution, whether for adhesive, gesso, or paint-binder use, it may be applied cold, whereas glue solutions must be kept at a fairly high and uniform temperature during their use. In making grounds, this is its sole advantage. Casein gesso is more difficult to handle and apply than glue gesso; it is more readily subject to decay and defects; its texture and behavior toward paints are liked less by expert painters; it is also subject to increasing embrittlement on aging. When making gesso panels from casein mixtures, the procedures to be followed are the same as those given for glue gesso, except that the

81

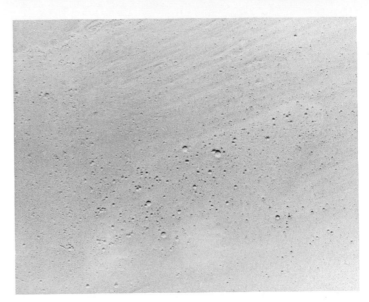

44. Air bubbles in the wet coating cause pinholes in the gesso surface.

45. Thin color accentuates pinholes rather than conceals them.

46. Cracks in gesso caused by glue being too strong.

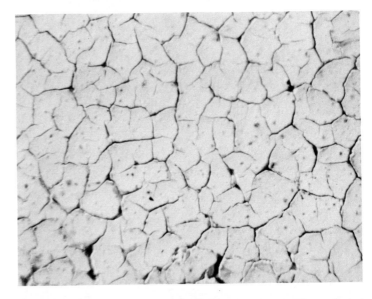

casein coating is used at room temperature. Because it can be applied cold it may also be used in spray guns.

Perhaps the greatest drawback to the use of casein in any home-made product is the difficulty of maintaining uniformity of binding strength, due not only to the variation in different lots of the raw material, but also to the changes it undergoes on aging. A few months' storage will alter its properties erratically, so that a different formula must be used from the one employed on fresh material.

All in all, casein has proved more successful in the case of professional workers in shops where continuous processes and systematic controls are in operation than when used occasionally by artists.

Emulsion grounds. The use of grounds made with emulsion binders or part oil paint and part water-adhesive (casein, glue, egg) has little or no precedent beyond comparatively recent times, with the exception of a few obscure references to the addition of starch or flour to oils in some ancient manuscripts.

Most authorities do not favor such mixtures in grounds for permanent painting on canvas because they do not have sufficient qualities of flexibility, toughness, adhesion, or resistance to moisture. Like gesso grounds and tempera paints they are best adapted for use on panels, but even there they are sometimes inferior to simple gesso grounds. They are relatively spongy and porous, which imparts to them a deceptive flexibility when fresh—the sort of flexibilty a slice of fresh bread has—but they become very brittle with age. Casein and oil mixtures are especially bad in this respect; casein coatings embrittle with age, and all casein-oil mixtures eventually turn yellow.

OIL PAINTING 5

Painting in oil is by far the most important and popular method of easel painting. As a method or technique, it has been completely and thoroughly studied and recorded from every viewpoint. This means that the present-day painter has at his command—if he is conscientious enough to learn and apply them—all the details necessary for successful manipulation of effects, as well as safeguards for the longevity of the painting and the variations for creating styles to suit individual requirements. The positive data we have concerning these matters have been gained from several different sources: from the records and examples of more than six centuries of European development; from the researches of scholars and scientists into past practices; from laboratory investigations, analyses, and reconstructions; and from adapting results of similar modern research on the same materials, which is always being carried on by workers in related fields—for instance, scientific work on industrial paints.

Linseed oil. Linseed oil is expressed from the seed of flax plants. When used in paints it dries to form an adequately durable film which performs all four functions of a paint vehicle, as outlined on page 12. Linseed oil does not "dry" in the same sense as does water, turpentine, or benzine. It is not volatile and does not evaporate and disappear into the air; instead, when it is spread out in a thin layer and exposed to the air, it jells and then hardens. After going through a series of chemical changes, it becomes converted to a new substance; if it has been properly combined with the right pigments, in the correct proportions, it forms an adequately tough, leathery, adherent film, resistant to solvents and capable of surviving for centuries on works of art. There are two principal chemical changes undergone by vegetable drying oils in their conversion from the fluid to the insoluble, solid form—absorption of oxygen from the air (oxidation) and an internal or structural change (polymerization) in which the molecules of the oil become rearranged.

There are, of course, numerous grades, varieties, and degrees of refinement of linseed oil, and small differences or variations in the raw materials and processing methods will produce oils of extremely varying characteristics—something which is also true of other products refined or processed from vegetal sources. Some linseed oils, although excellent for the purposes for which they are produced, make poor artists' colors. Some specially refined linseed oils are useful in artists' mediums and are discussed further on in this chapter.

The best oil for artists' oil colors, and the one used by American makers for their best grades prior to the 1930s, would be cold-pressed linseed oil. It is no longer available in commercial quantities, but sometimes small bottles of imported CP linseed oil may be found in art-supply

stores. Industrial linseed oil is pressed with the aid of steam (which increases the yield) and then subjected to chemical treatments to refine or purify it. The best one for artists' oil colors is called alkali-refined oil (varnish oil); its color is known as "pale straw." It is the kind usually sold in the art-supply stores. There are other kinds of refined linseed that are less desirable because they tend to revert toward the dark color of raw linseed oil.

Other drying oils. Although not all vegetable oils are drying oils, about fifty can be expressed from various seeds and nuts and could be utilized as drying oils for one purpose or another. However, because of their shortcomings and defects, none of these has ever been used extensively in artists' paints, with the exception of walnut, poppy, and safflower oils. Walnut oil has long been discarded from the lists of approved artists' materials because of its inferiority to linseed and poppy oils. Poppy oil is valuable as an ingredient to improve the smoothness of some linseed oil colors, but it is better not to use it in amounts greater than 25 per cent, preferably about 15 per cent. Poppy oil alone forms a film that is weaker and less permanent than linseed oil, it does not dry so well, and it cannot be used with the same freedom or for the same number of varied purposes. In the liquid state, poppy oil is much paler than raw or cold-pressed linseed oil, but this advantage is outweighed by more important disadvantages. Poppy oil is in second place to linseed oil as an ingredient of permanent paints, its chief use being as an addition to linseed oil colors. It is never employed as an ingredient of clear varnishes or glaze mediums, or used in complicated techniques. At the present time few brands of artists' paints use poppy oil as the sole or principal paint vehicle. Colors ground in poppy oil can be distinguished from linseed oil colors by their lack of odor, since linseed oil has a characteristic odor.

Safflower oil began to be employed in artists' colors in the late 1950s; it is a satisfactory and acceptable replacement for linseed oil although it can be rated a little bit below linseed in all-around properties. The results of accelerated laboratory tests show it to be slightly inferior to alkali-refined linseed oil in color retention, in retention of flexibility, and in toughness and durability of film, but for practical purposes these small differences should not disqualify it for use in high-quality oil colors. Safflower oil has a reputation in industry for being one of the best non-yellowing oils—better than linseed oil in this respect—but this is true only of its use as an ingredient of mediums like the oil-modified alkyd resins rather than of its use as a vehicle for artists' oil colors.

MANUFACTURE OF ARTISTS' OIL COLORS

Modern dry pigments are put on the market in fine, uniform powder form; care is usually taken to have the particle size of each individual pigment correct, so that its color characteristics and its physical

47. First step in homemade oil color—mixing dry pigment and oil to a stiff paste consistency.

48. A glass muller for grinding colors.

or mechanical behavior in paints will conform to the highest standards. Consequently, the grinding of paints is necessary, not so much for making the pigment particles smaller as for breaking up the lumps and producing an intimate mixture in which each little particle or grain is completely surrounded by the liquid vehicle. No mixture of pigment and oil which has simply been stirred together or lightly rubbed (as with a spatula or palette knife) is a paint; it is merely a paste, which will contain a great excess of vehicle, will be made up largely of microscopic clumps of semi-dry pigment, and will be full of air bubbles. A real paint, having plastic qualities and which will flow and manipulate properly and form a durable, permanent film when dry, must be ground by *strong friction* in order to break up the little clumps and to insure that the particles are completely wet or surrounded by the oil. The same is true of the water paints described in following chapters. Paint technologists refer to the process as *dispersion* rather than grinding, since the main result is the scattering of pigment particles throughout the liquid, rather than the grinding down in size of the pigment particles.

The paint manufacturer stirs dry pigment and oil in a very powerful mechanical mixer until a smooth, stiff paste is obtained. The paste is then run through roller mills which grind it into paint, doing a much more efficient job of dispersing the pigment particles than is possible by hand methods of grinding, and turning out a product that is seldom equaled by hand grinding.

Homemade oil colors. The painter of old used freshly made hand-ground oil colors, since no way of preserving them and retarding their hardening had been devised. The frontispiece illustration is by no means exceptional; there are also other pictures (woodcuts, drawings, and paintings) of medieval and Renaissance workshops which show a

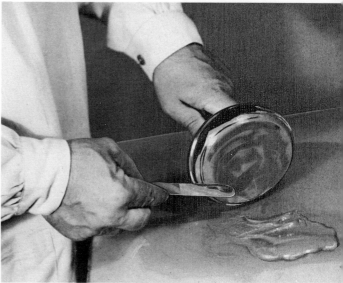

49. Grinding the oil and pigment paste to a smooth dispersion.

50. Gathering the batch during grinding.

studio boy grinding up the day's supply of colors.

The necessary equipment is simple: a strong, flexible, but not too limber spatula or palette knife, a slab made of plate glass with a roughened or ground surface (some workers prefer a slab of marble or some harder stone), and a muller made of stone or glass. The grinding surface of the muller should have a roughened, ground-glass finish, and it should be not less than 2½ inches in diameter. The grain or tooth of the grinding surfaces of muller and slab can be produced or sharpened by grinding with an abrasive powder such as Carborundum mixed with water or turpentine. The slab can be of large size and permanently attached to the table top, or it can be as small as 12 inches square. It can be kept from shifting about during the grinding by strips of wood or molding, flush with its surface and nailed or screwed to the table along three or four sides.

The mulling of paints. In grinding paints, pigment and oil are first rubbed together with the spatula (Figure 47), using the smallest amount of oil to produce the stiffest workable paste. This paste, which is not yet a *paint* (because it does not have the required consistency or plasticity) is spread on the slab and ground thoroughly with the muller (Figure 49) until it is a smooth, glossy paint, free from grittiness and specks that are evidence of undispersed clumps of dry pigment. After from 25 to 50 rubs the paste must be scraped from the slab and from the edges and bottom of the muller (Figure 50). It is gathered together and given another 25 to 50 rubs, and this procedure is continued until the entire batch is thoroughly and smoothly ground. If the grinding makes the paint too thin, more pigment is added and the grinding continued. There are other systems of handling the paste during grinding, but these instructions are typical.

87

Fluid coatings—basic principles. A fluid such as a paint vehicle, a varnish, or a priming contains an ingredient or combination of ingredients that the paint technologists call the film former. Most coatings also contain a volatile liquid or thinner that evaporates and disappears when the coating dries. In oil painting, the film former is linseed oil and the volatile thinner is turpentine or mineral spirits. In watercolor the film former is gum arabic; the volatile solvent or thinner is water.

In painting, we encounter two kinds of film formers; one becomes solid (dries) by simple evaporation of its volatile ingredient. After watercolor or gouache paint dries, you can dissolve it again with water; after a simple-solution varnish dries, you can dissolve it away from the surface with fresh solvent. But the drying action of the other group is more complex.

When linseed oil dries (see page 84), it undergoes an irreversible reaction: it solidifies to a new material that cannot be changed back to the liquid oil state by any means. Other paints with irreversible solidifying or drying reactions are egg tempera, casein paint, and acrylic polymer colors. The paint technologist characterizes the simple evaporators as "thermoplastic film formers" and the ones that undergo chemical or molecular changes as "convertible film formers."

Consistency of paint. All pigments do not react with oil in the same manner. Some, such as white lead, will produce very good paints, smooth and short (buttery); others, such as ultramarine, have a tendency to be long and stringy; still others, like cobalt yellow, are inclined to become grainy or crystalline. Artists can accommodate their painting manipulations to the various natural characteristics of the individual pigments, as was done to some extent in the past. However, today the manufacturer has learned from long experience how to turn out a whole set of colors, all of which come out of their tubes in much the same consistency, with a close similarity of handling properties, and within a reasonably close range of drying speeds. The manufacturer gets these results by proper manipulation of mixing and grinding operations and by the addition of modifying ingredients. These added materials should be chosen from time-tested ingredients known not to be detrimental to the permanence of the finished painting. It is permissible to adjust the properties of paints with them, provided that they are *not used in excessive amounts.*

Plasticizers. This term is applied to modifying ingredients that are added to paints in order to make them more controllable in manipulations and to increase or prolong their flexibility. It is also applied to materials used for the same purposes in all other mixtures and compounds, such as water paints, glues, lacquers, and plastics.

A much-used and generally approved plasticizer and stabilizer for tube colors is white refined beeswax, which aids in making the paint smoother, tends to prevent separating of the oil, and helps keep the dried paint film supple and flexible.

A waxlike, fluffy, lightweight powder called aluminum stearate is

almost universally employed by commercial paint manufacturers to give a smooth consistency to the paint and as a stabilizer to keep pigment and oil from settling in the tubes during storage. Because use of this powder demands considerable knowledge and experience, and because so many types and varieties are employed, beeswax is preferred for amateur paint grinding. Provided the amount of stearate or wax is kept to a minimum—that is, no more than the small amount usually necessary to improve the consistency—it is not considered harmful.

The use of poppy oil as an addition to linseed oil colors has already been noted; if, instead of pure linseed oil, a mixture is used which contains four parts of cold-pressed or alkali-refined linseed oil and one part of poppy oil, the consistency of those pigments which naturally tend to make stringy or sticky paint will be considerably improved.

Small amounts of water or of emulsions that contain water are generally condemned by all competent authorities for this purpose. Adding water is an easy way to stiffen and improve the consistency of some oil paints and also to preserve consistency in the tubes, but paints containing it will eventually harden in the tubes, and their dried paint films will be likely to fail in several respects.

Adding too much of these modifying ingredients may lower a paint's quality in three ways:

1. By lessening its tinting strength, brilliance, clarity, or hiding power.
2. By causing rapid yellowing of the paint film.
3. By decreasing its toughness or flexibility, thus leading to cracking or other failures.

Normal oil content of paints. There is sufficient oil in a well-made oil color to insure the permanence and durability of the paint film; in fact, it contains a surplus over the amount which is actually required to bind the pigment and anchor it to the ground. This surplus is necessary in order to grind the pigment to a smooth paste and to give the paint the right brushing properties.

Some pigments require a greater amount of oil than others in order to make a smooth plastic paint; the degree, in relation to the pigment's volume or weight, is called its "oil absorption." Naturally, most oil paints made with pigments which have a high oil absorption will yield rather flexible oil films, while those of low oil absorption will tend to give more brittle results. Thus it is of some importance for the painter to learn into which class the various pigments fall, if he is to avoid possible cracking of paint films through superimposing brittle coatings over flexible ones.* An exaggerated example would be a layer of zinc white over a solid coating of burnt umber—which would mean cracking within a very short time.

* Oil absorption data may be studied in the author's *The Artist's Handbook of Materials and Techniques,* The Viking Press, New York, 1970.

Excessive oil in paints. An excessive amount of oil beyond the normal surplus—sometimes found in poorly ground colors—or additional oil added to paint may cause after-yellowing and also wrinkling of the film. Obviously, then, it is important for the artist to use colors containing the lowest percentage of oil, with which smooth-working, well-ground paints can be made, and to refrain from adding linseed oil to paints except when it is a component of a well-balanced painting or glaze medium. Such mediums (see page 95) are made with selected

51–56. Filling paint tubes by hand: Scrape the pigment into the tube with a palette knife; settle the color by pounding the fist, not the tube directly, on the table while protecting the tube's neck and shoulder from damage; pinch the open end; press a palette knife on the pinched end; flip the tube over the palette knife to seal; complete the process by crimping the sealed end firmly with a pair of stretching pliers.

non-yellowing oils, and their varnish content prevents their weakening or softening the paint film. Excess oil which has separated from paint in the tube may be drained off by allowing the paint to stand for a few minutes on a sheet of writing paper; if the remainder of the paint is too stiff or overpigmented to work well, it should be discarded. When paint becomes useless through hardening or "livering" in the tube, it means either that it was made of inferior materials poorly ground, or else that it contained too large an amount of drier or other modifying ingredient.

Unlike hardened watercolors which can be reworked, hardened oil paints or those that have become thickened cannot be reclaimed because the setting of a drying oil is not a reversible process.

Filling of tubes by hand. Homemade paints can be packed in collapsible tubes, as shown in Figures 51 to 56. Originally, the best paint tubes were pure tin, but since tin is in short supply, lead, alloy, and aluminum tubes are to be found.

BASIC PRINCIPLES APPLIED TO OIL PAINTING

In Chapter 1 the nature of paint is described, and the basic principles or mechanics of painting are summarized on page 19. An oil painting must be considered as a structure. Therefore, just as a building, a highway, or a bridge must conform to age-old principles of engineering, so an oil painting must conform to long-established rules which govern the building-up of layers or coatings, superimposed one over the other. Since the ground, the paint layers, and the individual ingredients of these are all elements of the whole painting, they must be built up in relation to each other and to the whole in order to obtain satisfactory results.

One of the most important of these rules is the previously mentioned (page 50) admonition never to paint coats over more flexible layers, or else cracking will occur. When painting on an oil canvas, you should remember that the ground itself has some degree of flexibility, which limits the use of paints to those that are at least as flexible as the priming on the canvas.

Adhesion or anchorage of coatings. Paint (and, for that matter, gesso, oil grounds, plaster, and any other coating as well) must adhere permanently to the surfaces to which it is applied; flaking, peeling, blistering, and similar defects are most frequently caused by simple lack of adhesion. Aside from the adhesive or gluelike action of the coating itself, permanent adherence depends largely on the nature of the surface to which it is applied. There are two kinds of surfaces which are satisfactory for promoting and assisting permanent adherence on coatings.

1. An absorbent or porous surface which will partially imbibe the paint vehicle.
2. A rough, textural surface (granular, fibrous, weblike, or scored) which will hold the dried paint in a mechanical grip or bond.

A slick, shiny, completely nonabsorbent surface is the least likely to offer permanent adhesion. A coating that is too absorbent is generally not desirable; for example, an unsized gesso coating with full absorbency may take watercolor and tempera very well, but it will absorb so much of the oil vehicle as to leave the paint in a weak condition, a development more likely with heavy, thick coatings than with thin or very thin coats. Extreme absorbency can be reduced by the use of a size, as

previously mentioned.

As a general rule, a combination of the proper degree of tooth plus the proper degree of absorbency is desirable. However, for some painting methods the coarseness of texture of a nonabsorbent ground or the absorbency of a smooth ground will alone suffice to promote good adhesion of the surface coating to the support.

A common cause of poor adhesion and of the development of various defects through weakening of the paint film is the use of stale oil colors—blobs of color that have been too long exposed to air on the palette, where they have begun to go through their drying action and have thickened. The painter who "freshens" such colors by adding turpentine to them deludes himself; the thickened oils have aleady gone through their sticky, adhesive stage either partially or wholly while on the palette, and they have little or no chance of equaling the adhesive power or film strength of fresh colors.

Role of the ground in painting manipulations. The very same qualities that make for permanent *adhesion* between paint and ground or between layers of paint are also desirable for assisting the *manipulation* of paint in most oil-painting techniques. The worst surface on which to attempt manipulating oil paint would be a slick, shiny one, such as a sheet of glass. Ordinary brush or painting-knife strokes could not be used with any control or precision, and the result would almost certainly be smeary and undesirable. If the surface has the proper degree of tooth (coarseness of grain) or roughness, or if it is somewhat absorbent, the color is taken from the brush in a satisfactory way and subsequent manipulations can be carried out well. On the other hand, if a surface is too fully absorbent and takes in too much of the oil vehicle, it may cause extreme difficulty in handling or manipulation and hamper free stroking since the brush becomes exhausted immediately.

The use of turpentine. In order to brush out oil paints and to spread them around or thin them so that they can be smoothly brushed out to thin layers—*and for no other reason*—turpentine or mineral spirits is added to the colors during the painting. Practice in painting is the only way to learn how much thinner to use. Most painters work it in by occasionally dipping the brush into a small cupful of the thinner and mixing it with the paint on the palette. The object is to add just enough thinner to serve the purpose, but not to introduce so much into the paint that it becomes runny or that a weakened paint film results. Naturally, a thin layer of paint will dry more rapidly than a heavier coating; therefore a paint which contains a volatile solvent or diluent will dry faster, because its oil content is more exposed to the oxygen of the air. The paint will also *set up;* that is, it will assume a gelatinous rather than a fluid condition, as soon as the volatile portion of the vehicle evaporates. Other than by these mechanical aids, volatile diluents or thinners do not promote the drying action or the chemical hardening of oil.

Mineral spirits is a petroleum distillate made especially for paint

use and is sold in bulk in house-paint stores. It is also known as "turpentine substitute," "odorless paint thinner," and a number of trade names such as Varnolene. As a paint thinner, a brush and palette cleaner, and all-around studio solvent, its action is about the same as turpentine with one exception—it is not a good solvent for damar resin, as noted below. It costs something like one-fifth as much as turpentine and is free from the sticky residue that turpentine sometimes has. Both of them are considered safe solvents, and because of their low volatility they are not detrimental to health in normal studio operations.

Mineral spirits and turpentine, which is distilled from pine-tree balsam, serve most studio purposes, but many other solvents are used for various industrial and craft purposes (see *Thinners and solvents,* page 104).

Mat and gloss finishes in oil painting. One of the striking features that appealed most strongly to the first generations of painters who used oily paint vehicles was the fact that full-toned glossy paintings could be painted more directly than was possible with the use of aqueous paints. For hundreds of years thereafter oil painting was supposed to be glossy; it was not until quite recent times that any attempts were made to imitate with it the lusterless finishes of fresco, watercolor, and gouache paints.

A normal oil painting is intended to have some degree of gloss; results of all the experience in technical work on industrial coatings show a very definite inferiority in the permanence of coatings when they are made lusterless. Gloss can be dulled in several ways, such as by decreasing the percentage of binder or by adding waxes or other ingredients, all of which weaken the paint film, make it more susceptible to the development of defects, and lower its resistance to wear.

Reliance on excessive use of turpentine or on the absorption of paint by an overabsorbent ground is not only likely to produce a weak and faulty coating, but the paint quality so produced will generally be unsuccessful.

The best flattener for oil paintings would probably be the use of a reliable mat varnish that would produce an over-all, uniform dull finish and permit the retention of a full paint quality and a depth of color —but unfortunately the mat varnishes on the market at the present time leave much to be desired. They either contain materials which will turn yellow on short aging or have large percentages of wax (or waxy ingredients) which do not form a sufficiently durable coating to withstand normal wear; or else they will quickly polish to a glossy finish when rubbed. Waxes are among the most permanent and moisture-resistant of our materials and are useful ingredients of various painting materials, but they are not ideal additions to picture varnish. A wax paste—made by melting white refined beeswax, removing it from the stove, and thinning it to the consistency of floor wax by stirring in some turpentine or mineral spirits—makes a fine preservative and finish for paintings *which*

have previously been varnished. Damar varnish is considered the very best picture varnish when a bright finish is desired, and clear acrylic (methacrylate) varnish the best for a dull, satiny gloss; both are described a little further on in this chapter.

PAINTING MEDIUMS

When more complex methods of oil painting are used, especially those which employ thin coats of paint, glazes (thin, transparent films of paint, applied over dried underpaintings), and the like, it sometimes becomes necessary to make the paint very thin and fluid. This is accomplished by using a liquid which not only dilutes the vehicle but also contains "fixed" or solid ingredients with film-forming properties in themselves. These leave behind them, when dry, substances which reinforce or assist in the film-forming action of the original paint vehicle instead of evaporating completely like the volatile thinners. Such liquids are called painting mediums, or glaze mediums. A good definition of a paint medium, then, is a liquid which, when added to a fluid paint, will contribute desirable properties to its workability and also, because of its film-forming or plasticizing ingredients, to the final paint coating. Much opaque painting of average or above-average thickness is done without the use of mediums.

There are many oil-painting mediums in use by artists, the best of them being simple mixtures of time-tested ingredients which have been generally approved because of the permanent results observed over long periods of time. There are also some overcomplicated mixtures, as well as concoctions of undesirable ingredients. The harmful effects of many of these were known a long time ago, but their recipes occasionally survive or are revived from time to time and hailed as inventions.

Oil-painting mediums are usually mixtures of specially refined linseed oils and varnishes; they are generally prepared with turpentine or petroleum thinners, in thin, ready-to-use form. The mixture of oil and varnish is used rather than a single oil or varnish because the balance of properties (see page 13) makes it necessary for the medium to meet a number of requirements, and no single ingredient can comply with the various functions that a painting or glazing medium is called on to perform. Mediums must mix perfectly with oil paint; they must not alter the character of the painting too far from that of plain oil paint; they must allow easy manipulation, without flaws or blemishes; they must leave the final paint layer at least as strong, in terms of permanence and durability, as though plain oil colors had been used.

Driers. Some mediums and oil paints require the addition of driers. The artist should look upon a drier as an occasionally necessary additive that must be used sparingly, just enough to accomplish its purpose— that is, to make the paint dry in a normal manner. Thin layers and glazes that are to be overpainted or overglazed when dry may be made

to dry overnight, average or thicker oil paint in two days or so. Such amounts are not detrimental to the life of the paint film; excessive amounts may be.

Driers are substances that have a powerful chemical or catalytic effect on the drying of linseed oil. They promote and accelerate the initial drying of the oil film; they counteract the slow-drying effect certain pigments have on linseed oil, also the slow-drying or anti-drying effect produced by some varnish-oil mixtures.

Cobalt drier, made of cobalt naphthenate, cobalt octoate, or cobalt linoleate and thinned to usable fluid consistency with turpentine or mineral spirits, is the only artists' drier approved by modern authorities. Its use is best limited to normal or very thin paint films; it should not be used in thick, impasto painting; when it is necessary, it should be added in minimum amounts—just the fewest number of drops that will produce the effect. Excessive amounts of drier will detract from the permanence of the paint and lead to cracking, darkening, and other defects. Instead of adding a set amount of drier to a recipe it is well to make trials and reduce the amount to the minimum quantity that will dry the mixture satisfactorily.

The pigments themselves exert a drying or retarding effect on linseed oil, although this varies to a considerable degree—for example, the umbers and white lead will dry rapidly, whereas cadmium yellow and zinc white dry slowly. Most manufacturers of oil colors add minute amounts of cobalt drier to the very slow-drying colors in order to bring them a little closer to the average drying time of the rest of the palette.

NOTES ON OIL-PAINTING METHODS

Preliminary drawings or outline sketches on the canvas are generally done with light pencil strokes or with charcoal, the excess grains of which are tapped away or flicked off with a cloth. It is often desirable to have these guidelines rather strong and resistant to the paint; in this case they are gone over with a pointed brush and a very much thinned-down oil color, which dries rapidly (for example, burnt umber plus about an equal amount of thinner), and allowed to dry.

When methods used are more complicated than the simple direct oil-painting technique, such as a first underpainting which is allowed to set, or the use of thin glazes, or any multiple-layer technique, there is sometimes doubt as to the advisability of unrestricted free painting into or over surfaces that are wet, semidry, or completely dry. Investigators have suspected that some of these manipulations might lead to eventual cracking of the paint, because of interference with the normal drying action of the oil and the slowness of its conversion from the fluid stage to the tough hard film of dried paint. However, with well-made oil colors, correctly ground with the best linseed oil, it seems safe to paint freely in any of these ways, provided that the simple rules as

96

outlined on page 116 are observed. There has been no objection on the part of chemists on the score of painting into or over wet or semidry or sticky paint, but the statement has been made—on the basis of some laboratory tests—that it is inadvisable to paint over recently or freshly dry coatings, and that once a paint film has become surface-dry it is better to wait until the layer is thoroughly dry before overpainting, usually several weeks.

This thorough drying is undoubtedly necessary with poppy oil colors, which should be used only for simple, direct, *alla prima* painting. However, the best grades of linseed oil colors, which are less critical in this respect, will withstand this departure from theoretically correct treatment, and unless very heavy, enormously exaggerated impasto is freely used, artists find that they can paint over recently dried underpainting without bad results.

Use of medium. No painting medium is required for simple, direct oil painting, and it is a mistake to use complicated mixtures or techniques either to make up for a lack of skill in manipulations or to make special effects easier to obtain. It is for this reason that the mediums mentioned in this chapter have been called glaze mediums rather than painting mediums; they are more useful in thin layers of paint than in more solid, average, or heavy painting, which more often requires little else than occasional thinning with turpentine or mineral spirits. Mediums are necessary in thin, transparent glazing and in thin paints in general to manipulate and control them successfully.

The majority of experienced painters prefer to mix their own glaze mediums because so many of the ready-made mediums of the shops are put out as secret formulas without a clear statement of all their ingredients. Variation or adjustment of homemade mixtures to suit individual requirements is easy; with ready-prepared mediums it is dangerous.

Ingredients of glaze mediums. Among the approved materials for use in painting or glaze materials are two specially refined linseed oils—stand oil and sun-refined oil.

Stand oil is a pale, very viscous product of honey-like consistency, made by a high temperature process and also known as polymerized oil. Stand oil is non-yellowing, and when thinned down to usable consistency works well in mediums. It has a tendency to flow out smoothly to an enamel effect.

Sun-refined oil is made by exposing linseed oil to sunlight until it is clarified, bleached, and somewhat thickened. If desired, it can be thickened to a heavy viscosity. Sun-refined oil has always been employed by artists for use in mediums, and sometimes oil colors have been made with it, but the specially treated oils of this type are ordinarily not well adapted to color grinding. Sun-refined oil is a fairly quick drier, whereas stand oil dries very slowly and usually requires an addition of a little cobalt drier when used in mediums. Stand oil is more

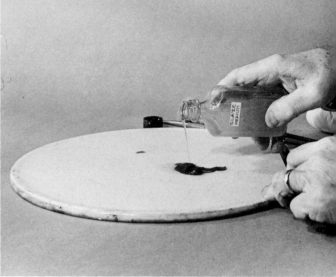

reliable than sun-refined oil in non-yellowing properties; some samples of sun-refined oil have been observed to revert to a deeper color when stored in bottles.

The following resinous ingredients are in approved use for glaze mediums:

Damar varnish, a solution of damar resin in turpentine, described later in this chapter.

Venice turpentine, an extremely thick, viscous fluid resin or oleoresin. It is the exudation of a certain species of European larch, which throughout the centuries has been found to be one of the few oleoresins of its kind that give good results and comply with all the requirements for use in permanent oil-painting mediums.

Some typical recipes for glaze mediums are as follows (the first one gives good results for all-round purposes and is in wide use):

(1)	Stand oil	1 fluid ounce
	Damar varnish (5-pound cut)	1 fluid ounce
	Pure gum spirits of turpentine	5 fluid ounces
	Cobalt drier	15 drops
(2)	Damar varnish	4 fluid ounces
	Sun-refined linseed oil	2 fluid ounces
	Venice turpentine	1 fluid ounce
	Pure gum spirits of turpentine	4 fluid ounces

The manipulative properties of such mediums can be altered to meet individual requirements by slight changes in the proportion of oily and resinous ingredients. Increasing the varnish content will give a more sticky or tacky quality, and decreasing it will make it handle in a more oily way.

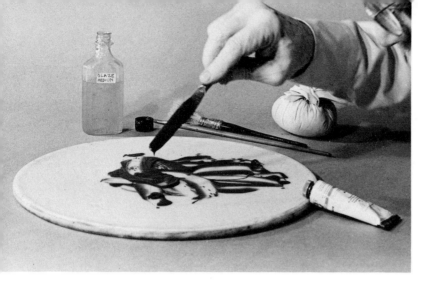

57. Glazing: mixing oil colors.

58. Glazing: adding glaze medium to mixed colors.

59. Glazing: average "syrupy" consistency of glaze.

Glazing and scumbling. Glazing is a method of imparting color effects to a painting by superimposing a thin layer of transparent or nearly transparent color over a dried, colored, or monochrome painting. The glaze heightens and increases the color and brightness of the underpainting rather than obscures it. The blended effect of this kind of coloring is entirely different from that in which two colors are mixed or scrambled into each other, and one can hardly be imitated by the other. Note the enormous variation in color effect between the transparent and opaque methods of handling burnt sienna in the front endpapers. The effect of the transparent E cannot be matched by mixing the color with white, as in F.

Formerly there was much difference of opinion as to the relative advantages of glazing versus solid painting as a regular technique, but today glazing is generally recognized as a legitimate tool or technique to be employed whenever the artist wishes to obtain its special effect. It may be used either to produce smooth, blended effects or to enliven the color of more casual or roughly stroked areas of paint. Objection to glazing has come mostly from artists who teach straight, direct painting or the bold brushstroke and who do not wish beginners to acquire "picky" habits.

Fundamentally, glazes should follow the rule for brightness as applied to grounds on page 22—that is, applying them over brilliant, reflective undercoats. However, there are so many variations and effects in which glazing may be used to advantage that no generalized instructions can be given in this respect.

Oil colors may be squeezed out of their tubes onto ordinary writing paper and allowed to remain there for a short while. This will absorb some of the surplus oil. Then they can be removed with the palette knife and mixed thoroughly with the glaze medium on a dish or palette to the desired consistency; for average use it should be quite fluid.

60. Glazing: applying the glaze.

61. Glazing: spreading and reducing the thickness of the coating with a badger blender.

62. Glazing: using a dabber instead of the blender to spread the glaze.

 The mixed glaze in a syrupy consistency is sparingly applied to the areas of the underpainting to be glazed, and then patted or tapped with the tip of a clean, dry, soft brush held vertically, using a stippling or pouncing motion. This not only spreads the color uniformly over the surface but also picks up the glaze, diminishing the thickness of the layer. A small cloth pad or dabber may also be used. Repeated pouncing with a *clean, dry* implement will diminish the thickness of the glaze still more. Making up a thin, fluid glaze doesn't work as well; it is very difficult to coat over a surface satisfactorily. Brushes must be continually changed for clean, dry ones as they clog. A method for cleaning and instantly drying a brush consists of rinsing it in mineral spirits or turpentine, wiping, and rinsing with acetone, a solvent which evaporates very rapidly and which is very flammable. Keep it away from flame.

 Scumbling means coating a dried painting by rubbing over it with a little straight oil paint, usually but not necessarily smearing or rubbing off the surplus with a soft cloth or the fingers. Scumbling implies the use of light or pale tints over darker ones, the use of opaque instead of transparent pigments, and sometimes a rather wholesale, overall toning rather than the carefully controlled, more delicately applied glazes.

 Special effects. The best way to insure permanence in oil painting is to keep the process simple, not to stray too far from the simple rules and regulations when painting with linseed oil colors, and to obey them very carefully when using poppy oil colors. The attempt to duplicate some of the effects of the seventeenth-century Flemish artists has

led some painters into complex and troublesome procedures, when, as modern investigators have so often pointed out, the materials of these older users of the oily mediums were not so very different from ours. Their oil paints were perhaps somewhat more fluid and less stiff or plastic than ours; resinous painting or glazing mediums were added to them only when the thin glazes and other special manipulations were involved. Sometimes, however, an effect created in certain areas, especially where white lead and flesh tones and other pale tints made with white lead were used, displays crisp linear or impasto definition which defies reproduction when we use the more softly blending whites which we now buy in tubes.

One way to make flake white crisp and useful for sharply textured effects for under- or overpainting is to mix in a little egg yolk by working it into the paint thoroughly with the palette knife. The egg yolk must be added a little at a time, until the desired manipulative properties are obtained, avoiding an excess which might produce tempera or water-soluble paint. For the same reason, neither turpentine nor water should be added during the mixing, although the paint may be freely diluted with turpentine during its use. This mixture is a dual emulsion in which oil is the surrounding medium or external phase, and it can be handled and thinned like any other opaque oil paint except that it dries or sets up more rapidly. It tends to dry to a mat and somewhat coarse finish.

Another means of achieving this crisp handling quality is to grind titanium or zinc white to paste consistency in whole egg and mix two

63 & 64. Glazing: two methods of removing excess glaze with dry absorbent cotton.

parts of it thoroughly with two to three parts of flake white tube oil color. Some artists use an egg-and-oil tempera emulsion, such as the one mentioned on page 128, instead of straight egg; the entire procedure requires a little experimentation to suit the individual's personal requirements, and the resulting dried paint films have to be carefully examined to see whether or not they are tough and flexible enough before adopting any such mixture of materials for continual use, especially on canvas. Casein paints will also mix with oil colors in the same way, but the combination of casein and linseed oil is not recommended because of rapid after-yellowing and embrittlement of such mixtures on aging. Ready-made textural whites of this nature are sold in tubes under proprietary names; these are believed to be of synthetic-resin origin.

Throughout the nineteenth century a number of complex painting mediums were added to oil paints in order to alter their brushing qualities, and virtually all these have been discarded because of the rapid decay of the paintings in which they were used. Chief among these offenders was a jelly-like substance with a curious name, *megilp*. Made by mixing heavy mastic varnish with a linseed oil that had been cooked to blackness with litharge or white lead, this material was used with oil paints to impart a brushing quality that overcame many difficulties, at the almost certain cost of the eventual disintegration of the painting. History teaches us that the wisest course is to adhere to the simple oil-paint technique as much as possible, to use oleoresinous painting mediums with restraint, and to avoid complex jelly mediums.

Overpainting. The technical term *pentimento* refers to a peculiar effect, examples of which are to be seen in galleries, where, because thin top coatings of paint have become more transparent with age, the underpainting or drawing originally concealed has become visible.

102

Notable or striking examples of pentimento are seen in some of the works of De Hooch, where the bold black-and-white checkerboard of floor tiles occasionally shows through the figures and furnishings in the room. They are found also in early Italian paintings where the architectural lines of buildings may sometimes be discerned running through the figures that have been superimposed on them.

Such effects also are commonly seen in more recent pictures where the artist has made changes during the painting and, in obliterating unwanted brushwork or altering contours by overpainting, has been so careless in making these changes that, on relatively short aging, the colors underneath have become visible or the texture of underlying brushstrokes has become more pronounced.

Although it may take such notable examples to bring home the fact that paint is likely to become literally transparent with the years—because of the increase of the refractive index of linseed oil film with age or for other reasons—the general effect of transparency exists in all old paintings. The lessons that careful painters have learned from this are several: that multiple layers of paint must be planned with this effect in mind; that when underpainting is to be concealed or obliterated, the top coat must be sufficiently opaque for the purpose; that distinctly dark or outstanding areas should be scraped away before overpainting them with paler tones; and that disturbing textures and brushstrokes should be taken down, using a sharp blade if the paint is too hard to be cut with a palette knife. The underpainting and the ground will always have some degree of influence on the final painting except when the paint is applied in an extremely thick impasto layer.

65. Glazing: gradation of tones or colors applied separately.

66. Glazing: first scrambling of tones.

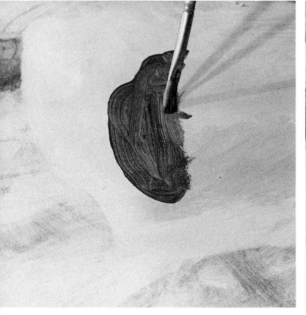

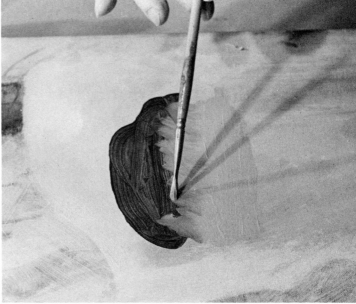

Overpainting of old canvases. As mentioned on page 59, artists are often tempted to paint new pictures on top of old ones, and some are continually searching for a means to prepare an old surface for that purpose, either for the sake of economy or because of remoteness or shortage of supplies. The answer to this problem is "don't." Although drastic changes can be made during the painting of a picture by careful planning or the scraping down of paint (while still fresh enough to remove heavy brushstrokes easily), a completely dried painting—which bears forms, colors, and especially irregularities of thickness that have no relation to the overpainting—cannot be used as a foundation for permanent and successful results; the original design will soon strike through the newer work. However, if the film is fresh enough to be removable with a palette knife, scraping down will give good textural or structural finish on which to paint, provided that color effect is satisfactory.

Prepared paint removers will deposit paraffin wax on the surface, and their powerful solvents will weaken the supporting oil film or ground. When, despite its disadvantages, an old canvas is used for a new painting, perhaps the use of a high-grade flat paint, as mentioned on page 59, is as good a coating as any to obliterate the old work, since the complex coating structure of the finished work will, at best, not be permanent or stable.

Oil painting on paper. Oil paintings, especially those of small size, are sometimes attempted on paper or paper that has received some sort of coating to render its surface less absorbent or more adaptable to the medium. Paper is a completely unsuitable material for oil paint from almost any viewpoint—it lacks structural strength and stability, it is alien and inappropriate to the oil medium, and the resulting works are usually very fragile. Almost every oil painting on paper that subsequently becomes of value has had to receive extensive restoring treatment. But pure rag paper or wood-fiber paper certified to be neutral (pH 6.5 to 8.5), mounted on 4-ply rag board (some dealers call it museum board), would seem to have an excellent chance for survival.

Thinners and solvents. The thin, colorless liquids that are used to dilute viscous oils, oil paints, and other oily, resinous, and waxy materials are called volatile solvents. They contribute no binding action and evaporate while the paint is drying.

The two most familiar and most useful of these materials to the painter are turpentine, which is distilled from pine tree balsam, and mineral spirits, a petroleum distillate which is produced specifically for use as a paint thinner and turpentine substitute. Both are used more frequently as thinners than as actual solvents.

Many other solvents are used for various industrial and craft purposes, but few of these are employed by the painter, and then only for an occasional special use. For example, alcohol is the solvent in shellac and a few other resin varnishes. Benzol is the solvent in rubber cement;

for prolonged use, the less toxic xylol should be used. Most of the powerful special solvents for lacquers and synthetic resins are rejected for painting because of their obnoxious odors and their poisonous vapors. Vapors from solvents are not supposed to be breathed continuously or used for long periods in unventilated rooms. This warning is the same as the precaution concerning powders, on page 153, and for further remarks on toxicity of solvent vapors see page 190. This warning applies even to the most harmless and nontoxic solvents. But the more toxic ones should be avoided entirely. When a special powerful solvent of the lacquer-solvent or paint-remover type is required, acetone is recommended. It is one of the most powerful, it is nontoxic, and it has no disagreeable or residual odor. But it does have a special precaution; it is highly flammable at all temperatures and must be kept from fire.

Many painters use mineral spirits in preference to turpentine. It is a perfect substitute in every case except with damar, for which pure turpentine must be used as the waxes in the damar are imperfectly soluble in it. Once dissolved, however, fairly large amounts of mineral spirits can be added to the solution before these white waxy ingredients fall out of solution. It is free from the sticky, resinous remnant that turpentine leaves. The relatively low volatility of both turpentine and mineral spirits makes them safe in terms of both toxicity and fire risk.

VARNISHES AND VARNISHING

A varnish is a clear solution of a resin in a volatile solvent; a typical example is damar varnish, which is a solution of damar resin in turpentine. Four kinds of varnish are used by artists: picture varnish, retouch varnish, isolating varnish, and mixing varnishes used as ingredients of painting mediums.

Resins are insoluble in water but will dissolve and mix with various organic solvents and oils. There are many commercially useful resins that are hardened exudations from many sorts of forest and crop-grown trees, as well as a number of treated or modified natural resins and several different types of synthetic or man-made resins.

Resins vary greatly in properties such as appearance, hardness, durability, and solubility in various solvents. Only a small number of them have been used in artists' materials, and only a few of these have survived the test of time, remaining in current, approved use. Chief among those satisfactory for use in picture varnishes are damar and the methacrylate (acrylic) resins, from which simple solutions are made with turpentine and mineral spirits respectively. Damar, Venice turpentine, Strasbourg turpentine, and the non-yellowing alkyds may be used in glaze mediums.

The outmoded resins, which have long since been discarded because they do not conform closely enough to the requirements of an ideal material for artists' varnishes, include materials one may read of

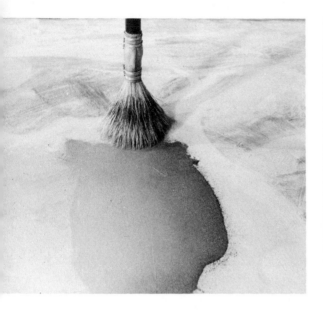
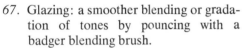

67. Glazing: a smoother blending or grada-
tion of tones by pouncing with a
badger blending brush.

68. Quick method of cleaning and drying a brush
to continue its use. 1. Rinse in mineral
spirits.

in older books, such as: rosin, burgundy pitch, sandarac, elemi, kauri, amber, and the various copals, hard and soft. Many of these resins, as well as a number of more modern synthetic resins, have been rejected because they will not dissolve in turpentine, or they cannot be made into varnish unless cooked with oils, plasticizers, and driers, or because they will eventually turn yellow or crack. Most of them, however, have other good properties which make them valuable for certain uses in industrial varnishes and enamels. In industry, the copals and other natural resins have largely been superseded by modern synthetic resins with superior properties. Damar is the only tree resin that retains the universal approval of scientific museum technical experts.

Picture varnish. A picture varnish is a necessary final coating for the preservation and uniform appearance of an oil painting. In order to make certain that the normal drying process of oil paint is not hampered, it has been the custom to wait six months or a year, depending on how heavily the paint was applied, before varnishing, but with a painting of thin or average thickness of layers, it would be less harmful to varnish a little too soon than to chance the picture's remaining unvarnished for too long a period.

This question of premature varnishing is not nearly so serious or important as artists have been given to believe; a picture does not run very much risk of damage if it is varnished soon after it has become thoroughly dry to the touch or surface-dry. It was a more serious consideration in the past, when copal or very thick glassy coatings of mastic varnish were applied; these were quite capable of injuring a tender or soft paint layer by the great strain that was put upon the surface by the

69. 2. Wipe to remove excess solvent.

70. 3. Rinse with acetone.

contraction or compression of their drying. Nowadays a thinly brushed-out varnish is the rule; those smooth, glassy finishes are considered less desirable than the normal oil-paint gloss that a more thinly applied varnish gives.

My own recommendation has always been to varnish as soon as the paint appears to be completely dry—in the case of thin paintings a few weeks, heavier paintings a month or two. In an emergency, when a painting has to leave the artist's hands soon after being finished, I would say that it would be less risky to varnish as soon as the painting will take it than to allow it to leave unvarnished. Thin glazes may be varnished as soon as the coating is dry enough to resist damage by the wet varnish.

An unvarnished painting, even if it is uniform in sheen when first dried, will frequently become spotty within a few months; its color effect will suffer not only from the dull, sunken-in spots but also from the distorted color relationship between the various areas, some of which will retain their gloss longer than others.

Dirt will settle into the surface of an unvarnished painting and, with the passage of time, will become so embedded that cleaning becomes difficult and sometimes impossible. A varnished painting is easily kept clean by occasional dusting and, if the varnish becomes seriously encrusted with dirt after an accumulation of years, it may be cleaned and the dirt removed. Methods for the cleaning of paintings are described on page 112. Varnish prolongs the life of paintings by preserving them not only against dirt but also against the ravages of time, moisture, mold, and wear.

A picture varnish should be freely soluble in turpentine or mineral spirits. Varnishes which require stronger solvents are likely to attack the oil film while being applied; also they will usually evaporate too rapidly to allow satisfactory brush manipulations. If it ever becomes necesary to remove a varnish that requires a strong solvent or some other drastic means, the painting will be endangered. Turpentine or mild petroleum solvent will not harm well-dried paint if applied by approved picture-cleaning methods and preferably by a professional conservator. Good picture varnish must be composed of non-yellowing resins, not too hard or brittle in nature, and it must present a uniform gloss when properly applied.

Kinds of picture varnish. The two best picture varnishes are a simple solution of damar resin in turpentine, and a simple solution of acrylic (methacrylate) resin in mineral spirits. The next best is a simple solution of mastic resin in turpentine. Mastic is rated definitely below the other two because of its tendency to turn somewhat yellow with age, its greater tendency to crack and to bloom (the formation of a white or bluish-white fogginess), and also because of the more glassy effect of its finish. Mastic varnish is seldom used at present; the only reason it has been permitted to remain in circulation is its relative harmlessness, as it is easily removed with mild solvents.

Damar varnish is a pale straw-colored liquid, seldom absolutely clear in the bottle. Mastic is perfectly clear in the bottle, but it has a more amber tinge. Pure methacrylate or acrylic varnish is water-white, clear, fast-drying, and yields a more uniform surface with a duller gloss than do the others. It is extremely soluble, so much so that one cannot brush on a second coat without picking up the first. Successive coats, however, may be sprayed on.

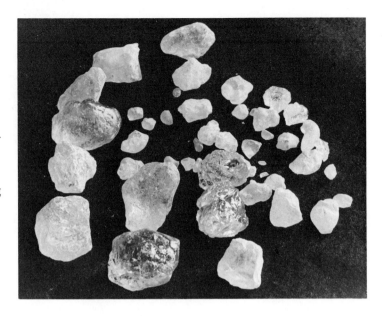

71. 4. Evaporate the acetone by twirling.

72. 5. Evaporate the acetone by flicking on sleeve.

73. Number 1 Singapore damar resin.

In addition to picture varnish, artists use three other kinds of varnishes: retouch varnish, isolating varnish, and mixing varnish.

Homemade varnish. No cooked oil varnishes or heat-treated oils should ever be attempted by amateur varnish makers, but some of the cold-cut or simple solution types can be made easily. The synthetic resin varnishes, with the exception of clear acrylic (methacrylate) varnish, which is simply a dilution of the concentrated solution, are best left to the expert varnish technicians. An exception, perhaps, is the clear acrylic solution which may sometimes be obtained from its manufacturer in concentrated form and diluted with its solvent somewhere in the neighborhood of 50–50, depending on requirements.

Damar and mastic varnishes may, however, be advantageously made by suspending a cheesecloth bag of the crushed resin in a container of pure gum spirit turpentine (Figure 74) for from 24 to 36 hours (Figure 75), removing it (Figure 76), and if necessary straining it through cotton sheeting, and keeping it in tightly capped bottles. If accuracy of recipe is important, the container can be a more tightly closed kind, to minimize evaporation of the solvent. The usual proportion for damar is 6¼ ounces of resin to 10 fluid ounces of pure gum turpentine. This is known as a "5-pound cut," being the equivalent of 5 pounds to 1 gallon. For mastic, 8 ounces to 10 fluid ounces of turpentine is customary. A 5-pound cut is standard, and a good grade of damar varnish sold in the shops will approximate this consistency. For brushing, it will need to be thinned a little; for spraying, thinned a bit more. The correct consistency for use is best determined by trial rather than by reliance on exact recipes.

It must always be borne in mind that the color of oils or varnishes cannot be judged or compared to each other unless they are viewed in

109

75. Making damar varnish: dissolving the resin.

74. Making damar varnish: placing the bag of resin in turpentine.

110 76. The resin dissolved.

identical bottles, because the greater bulk or volume of the liquid in a large bottle will make it seem darker than the same liquid in a smaller one. Figure 77 shows a test for comparing the *viscosity* of two oils or varnishes. By inverting the two cylindrical bottles and observing the speed with which the bubbles travel to the top, an accurate comparison can be obtained. Identical bottles, filled to the same level, must be used.

Retouch varnish. Retouch varnishes are intended to be used during painting or when retouching a dried painting. This is necessary in order to bring the dry areas or any sunken-in places up to the normal gloss of a wet, freshly painted surface, so that colors can be accurately matched or manipulated. The gloss and color effects in dry oil paint are almost always somewhat different from those of fresh, wet paint (see pages 24–26), and the two must be brought to the same degree of gloss in order to have the final color effects of the new paint the same as that which has already dried.

Retouch varnish is made of non-yellowing resins, similar to picture varnish, but it contains very much more turpentine or petroleum solvent and is much thinner, because a retouch varnish should act more as a size (see page 74) than as a film-producing varnish coat. For example, a full-bodied picture varnish creates a definite continuous layer of resin on the picture; this would add complications to its structure, besides making a doubtful anchorage for the new paint and introducing undesirable glossy areas. A high-grade retouch varnish should have no more effect on a picture than its function of supplying a temporary gloss; the amount of resin it deposits on the picture is inconsequential and will have no harmful effects.

Retouch varnish can be either sprayed or applied with a soft brush; the paint surface must be absolutely dry or the retouch may remain sticky for a long time. At the present time the most widely used retouch is damar retouch, sold in spray cans. In the absence of the regular, prepared product, regular damar varnish thinned with two to three parts of turpentine may be used.

Isolating varnish. This is a thin, non-yellowing varnish that is insoluble in turpentine or mineral spirits. It can be thinly sprayed over a dried coat of paint to protect it against being disturbed by overpainting manipulations; for example, in precise or intricate work, the artist frequently needs to remove a first attempt with turpentine. He can do this repeatedly if his undercoat has been protected with isolating varnish. One of the most widely used isolating varnishes is a solution of vinyl resin in isopropyl alcohol, sold for use with straight acrylic colors; it can be thinned with denatured alcohol. It is called Magna varnish.

Varnishing paintings. A wide, flat bristle brush (varnish brushes are described on page 180) is usually employed to varnish paintings. The painting and brush must be completely free from moisture; painting, brush, and varnish must all be at room temperature. All varnishing must be done with the picture lying flat, never in a sloping or vertical position. The varnish must be well worked into the surface and spread

77. The rising-bubble system of comparing the viscosity of heavy-bodied oils.

78. Varnish brushes.

out thinly and uniformly. The brushing-out and smoothing operations must be done with dispatch, so that the varnish does not set up or dry irregularly, but not so rapidly or violently as to whip up air bubbles.

Picture varnish is generally sold ready to use, but before varnishing, the consistency or viscosity is tested to make sure that it is not too sticky or thick for easy brushing; if it is, turpentine is stirred in cautiously and in small amounts until it is just right. A too-thin consistency is not desirable either, as a sufficient body is necessary to retain uniformity of gloss and to avoid dripping and other surface defects.

After varnishing, the work is allowed to dry in a level, horizontal position until the varnish sets up and becomes tacky (from 10 to 15 minutes), after which it can be leaned against the wall, face in, to dry out completely.

Using a mouth blower (Figure 79) to apply varnish introduces moisture into the film and causes bloom. A power spray gun with a moisture trap can give a flawless coat of picture varnish but is not easily available. An inexpensive sprayer (Figure 80) consists of a plastic top that holds a 4-ounce jar and a replaceable can of propellant. This small hand-held sprayer is excellent for general studio use.

Cleaning paintings. The cleaning of paintings is, in general, more a matter of skill and experience than a simple knowledge of the right and wrong materials to use, and all complex operations are better left to the professional conservator or restorer.

Contrary to popular notions, water or a damp cloth is not always a safe material for cleaning oil paintings. It should not be used on old, dry, cracked paint surfaces because of the likelihood of moisture seeping through and loosening the glue sizing in the ground. When water must be used, little balls of absorbent cotton should be well squeezed

112

79. Folding mouth blowers or atomizers.

80. "Jet-spray" or "spray-pak" sprayer with refillable jar and replaceable can of propellant.

so that they are just damp. After cleaning, the painting must be thoroughly and completely dried before varnishing. Soap is often destructive and should not be used by nonprofessionals on paintings.

The safest cleaning fluids are turpentine, mineral spirits, naphtha, or benzine, which will not harm completely dried, sufficiently aged oil paintings. No liquids should be allowed to flood a painting; they are applied by moistening wads of absorbent cotton as described in the preceding paragraph. Simple, soft-resin picture varnishes, such as methacrylate and damar varnishes, can be removed with turpentine or mineral spirits to the point where the painting will be sufficiently bright and clean; it is neither necessary nor desirable to remove every trace of old varnish. Removal of hard varnishes such as copal, as well as other difficult surface conditions, requires alcohol or other stronger solvents. These should not be used by inexperienced persons. Spots, spatters of paint, unwanted brushstrokes, and encrusted foreign matter, however, are usually easy to remove by scraping with a sharp blade, such as a small scalpel or surgeon's knife.

Freshly painted or recently dried paintings often will not resist the action even of the mild solvents; such canvases can usually be cleaned with balls of white bread kneaded from the center of a fresh loaf and used like an art eraser; care must be taken to remove all traces of bread from the surface so that it does not encourage the growth of mold.

Defects of oil paintings. Properly executed oil paintings that have been properly cared for will survive hundreds of years without cracking, peeling, flaking, blistering, or exhibiting any of those defects or failures that sometimes occur in cases where the rules for correct execution and care have been ignored.

Cracking is caused by (1) painting brittle layers over flexible layers; 113

(2) use of inferior materials; (3) long storage in bad atmospheric conditions (too cold or too hot, too damp or too dry); (4) sharp or sudden bending or rolling of canvas or warping of panels; and (5) hammer scrapes near keys (see page 65).

Flaking, peeling, and blistering (usually preceded by cracking) is caused by (1) lack of sufficient adhesion between layers or between paint and ground (see page 92); (2) moisture attacking from front or rear of paint.

Yellowing of oil paintings. Good oil paintings do not become yellowed with age; some linseed oils will actually bleach on long exposure to daylight. A slight degree of yellowing which may be observed in dried *clear* linseed oil films is masked by the pigment when the same oil is made up into a paint. When the oil is improperly used, however, or when the wrong grade of oil is selected, a definite after-yellowing can occur.

The outmoded practice of "oiling out" a dried painting with linseed or poppy oils by rubbing the clear oil over the painting with a cloth has been responsible for much yellowing of old paintings; no clear coatings of oil or oil varnishes should be used in permanent painting techniques. The yellowed or brown appearance of old pictures is most frequently caused by dirt and by discoloration from old varnish; after these are removed the oil paint is generally found to be in its original bright condition.

Oil paint will sometimes turn yellow if the freshly painted work is allowed to dry in total or nearly total darkness. A painting should be exposed to normal daylight (but not in the direct rays of hot sunlight) during the two or three weeks of its initial drying time, after which it can be safely stored in a darker place. If a painting has yellowed because of absence of light while drying, it may be brought back to its original state by a period of exposure to normal daylight. This reversible photogenic behavior of linseed oil was known to artists at least as far back as the seventeenth century. Some kinds of linseed oil are more sensitive in this respect than others; the common industrial white lead in oil is quite susceptible to the action, and painting grounds made with it *always* should be allowed to dry in daylight.

Highly bleached, straw-colored paint-grinding oils (acid-refined) will revert to an amber color on aging, whereas the normal golden-amber, cold-pressed oil will not change. Stand oil and the modern alkali-refined or varnish-refined oils of low acid number are also non-yellowing. A warm, humid atmosphere promotes the tendency of linseed oils to yellow when drying in the dark.

Care of oil paintings. Oil paintings should be preserved under the same normal indoor surroundings generally considered comfortable, average living conditions; an excessively cold, dry, or humid atmosphere and sudden changes in temperature and humidity should be avoided.

The best way to protect a canvas from the rear is to tack a piece of cardboard of the same size to the stretcher frame. This is better than coating the canvas, and it also protects the painting from mechanical

81. Cardboard backing attached to framed oil painting by artist. Small squares of thick cardboard under the middle side tacks supply air vents.

82. A conservator's job, circulation of air supplied by the two round holes.

damage; it insulates it from sudden atmospheric changes, and keeps out most of the dust and dirt. (See Figures 81 and 82.) Very tight or hermetic sealing of the cardboard is not advisable.

The practice of rolling canvases and repeated removal and restretching puts a great strain on paintings; it is likely to lead to cracking and should be avoided as much as possible. It is much better to store and transport unstretched canvases flat than to roll them. When circumstances require rolling a painting, as in transporting a large canvas, roll it *face out* on a cylinder of as large a diameter as is practical.

Repairing damages. The first remarks under *Cleaning paintings* on page 112 apply especially to repairing paintings of any value. Patching, relining, filling-in of missing areas, and all other treatments made necessary through aging under bad conditions or mishap require experience plus knowledge gained through instruction. Those who want to read up on the subject, including more details on cleaning, will find a section in my book *The Artist's Handbook of Materials and Tech-*

niques (see bibliography, page 194), which was written with the non-professional in view. About all that can readily be righted by the painter are those dents and bumps that frequently disfigure a painting when it receives an accidental poke. Place the painting on the easel and wet the area of the canvas at the rear with a sponge—just wet it, don't drench it. Tap the keys in to be sure the canvas is taut, and the bump or dent will flatten as the canvas dries. Small punctures, slits, or tears may be *temporarily* fixed and protected by sticking a piece of cloth adhesive tape to the rear, to be more thoroughly repaired later.

SIMPLE RULES FOR PAINTING IN OIL

The following concise outline touches on the more important points to be observed:

1. Use a white ground which is firmly anchored to its support.

2. Canvas should be prepared with oil grounds; emulsion or gesso grounds belong on panels.

3. Be sure there is good adhesion between paint and ground.

4. Use sufficient paint to produce a full, normal paint coating so that the final picture has the desired paint quality, but do not overload the work with extremely thick or exaggerated impasto. Avoid, at all costs, a continuous, thick, pasty layer of paint; heavy or thick impasto strokes are best used in isolated spots.

5. Remember the basic rule for all paint coatings and layers—that is, always paint flexible coats over less flexible layers, and never use brittle coatings over flexible ones.

6. The degree of absorbency and texture of the ground should be suited to the type of painting. Control of paint and its permanence are greatly influenced thereby.

7. Thin the paint with a little turpentine when desired; avoid the excessive use of painting mediums and emulsion-stiffened whites except when the occasion calls for glazing and work that requires precise control.

8. Remember that previous painting or underpainting has some effect on the final results and that careless overpainting may lead to unwanted effects.

9. Oil paintings must be varnished eventually. It is desirable to wait from 3 to 6 weeks before varnishing, but it is better to varnish them too soon than to put them into circulation or exhibit them unvarnished.

10. Use fresh colors that have not thickened on the palette.

HISTORICAL

The practice of easel painting in oil paint on canvas has been universal since the seventeenth century; it did not arise as a sudden invention but was the result of a long development. Scholars have traced this

development in considerable detail through the various schools of art, and the subject can be studied by reference to the books listed in the bibliography. There are several milestones or turning points in the history of European easel painting which can be noted briefly as follows:

The early tempera paintings, notably those of Italy, were done on gesso grounds on wood panels. Working under the patronage of the Church or the reigning families, the artists reflected the artistic tastes of their times. The results achieved were exactly what the painter desired; the rather limited effects and the rather intractable materials were manipulated by developing superior skill and craftsmanship rather than by adopting more fluent or easily handled materials. Giotto is an outstanding example of the early Italian painters in this tradition; the works of Botticelli and Fra Angelico exemplify the high point of technical achievement in pure egg tempera.

A subtle change then followed; as small amounts of waxy, oily, or resinous materials began to be introduced into the tempera in various ways, paintings showed a definite degree of technical change. These were characterized by a somewhat more fluent command of brushwork and a trace of softening or blending of colors, but for the most part they retained the same dry, linear quality of the earlier type. The culmination of this later type of tempera painting may be seen in the work of the Venetian painters of the fifteenth century—such as Antonello, Domenico Veneziano, and Andrea del Castagno—who refined their tempera paintings throughout with oily or resinous transparent glazes. Also, in the Northern countries, following the innovations of the Van Eycks and others at Bruges, the works of van der Weyden, van der Goes, and Memling show the use of oil glazes over tempera and sometimes oil underpaintings carried on to the highest degree of jewel-like perfection.

The artist has two instruments which he uses to express his intentions in paint; they are line and color or tonal masses. In their importance to painting techniques neither one can be rated above the other, and when discussing them the same general terms are applied to each. Two completely different technical approaches may thus be distinguished.

In the first, line predominates and the painters cited above always retained completely and meticulously their original draftsmanship. Underpainting was never entirely obscured by the final painting; its effect had a strong and direct influence on the finished work. The pictures are by no means colored drawings; they are veritable paintings, but the color or tonal element is subordinate to the linear quality.

The next great change was the tendency to techniques in which the tonal masses could be made to contribute a greater influence toward the final effect so that they might be used to play a part equal to that of the linear draftsmanship, or if desired, to dominate the total effect. This change, which came about through the demands and requirements of changing times and conditions and a preference for more "painterly"

styles, rather than through the "discovery" of new materials or methods, was made possible by the adoption of oily mediums as opposed to the aqueous tempera, which is more suited to the linear or "drier" kind of painting. The oily paints, which dry more slowly and which are adapted to a more plastic handling, are more versatile. Blending of tones and also a looser, more fluent stroking may be used if desired, and the final coats of paint can be made to contribute the major part of the total effect, whereas in the earlier method, the underpainting or drawing predominates.

Because of the gradual and irregular state of development of the oil-painting process and the varying requirements and conditions of schools and individuals in different localities during the fifteenth and sixteenth centuries, one cannot assign exact dates or chronological precedence to these changes.

However, the development of the oil-painting technique can be conveniently studied by observing the development of the painters whom we classify as belonging to the Venetian school and those who followed or came under its influence.

Giovanni Bellini, who started his career by painting in the traditional tempera manner, became a user of the oily materials later in his life and produced a more blended, painterly type of work. Following the previously mentioned painters, the works of Tintoretto and Titian display all the above-mentioned characteristics brought out by the increasing use of oily materials; although the disciplined and systematic training of the tempera painters is not wholly discarded, the fluency of oil paints creates a different type of picture. It is carried on still further by the technique of El Greco and finally that of Velázquez, whose effects can be duplicated by the simple direct method we know today as straight oil painting.

In citing the names of some of the great masters of the past, we do not intend to imply that these men were necessarily the sole innovators or that only they possessed rare technical secrets; they are mentioned simply as convenient landmarks because they are universally known and represent the culmination of the technical advances of their times.

In the work of Rubens, who had a prodigious command of technical facility, we find the culmination of all the developments of Flemish and Italian techniques. Here the linear elements and tonal masses are combined and played against each other to bring one or the other into prominence at will. His paints were not of a complicated nature, differing in no major respect from our own except that they were perhaps more fluid. He is one of the most successful individuals of all time, both in setting down his exact intentions and in securing lasting, permanent results. That he was not possessed of mysterious, technical secrets is amply shown by his writings and by those of his associates; in addition, by the fact that large numbers of his students, assistants, and contemporaries used the same methods and materials.

However, as an example of the culmination of a technique, his work is most interesting in marking another important change or landmark in the development of easel painting—that is, the deliberately planned and consistent use of comparatively thick or loaded opaque whites and pale colors combined with thinly painted or transparent darks and shadows. This makes for a distinct change or advance over the earlier type of work, in which for the most part all color masses were painted in equal bulk or thickness. The use of this procedure can be discerned in the work of earlier painters, but its adoption as a deliberate basic principle begins with this period.

In his choice of techniques, the present-day painter is guided by the experiences of the past, as to appropriateness of effects, permanence of results, and the various materials that have proved themselves by the test of time, but he is no longer limited or confined to any single method or technique as were the painters of the past. All the accepted methods are available, and each is appreciated as a means of creating acceptable works of art; the styles of every age and every country now have their influences on our art, and their materials and techniques as well can be applied to our own purposes.

The use of entirely new materials or of any innovations that can be applied to our modern developments in art proceeds rather slowly; we are still dependent on the traditional or time-tested methods of the past, and only a few of the modern innovations have been admitted to the lists of materials in widespread use. New processes that employ radically new materials and procedures have remained in the experimental stage and, at the present writing, our artists' materials, although supplemented by vastly improved grades of raw materials and a few new resins and pigments, have not progressed to any very considerable extent since Rembrandt's time. Recent developments in paints with binders composed of synthetic resins are discussed in the section beginning on page 167.

TEMPERA PAINTING 6

Description. Tempera paintings are done with paints which can be diluted freely with water, but which when dry become insoluble in water to the extent that they may be gone over with more tempera paints without being picked up. They yield pleasing textural and visual (optical) effects and are capable of much delicacy of control.

Tempera painting is capable of being applied to nearly any type of pictorial, decorative, or abstract work, but it is particularly suited to high-keyed or blond effects rather than to the deep-toned, intense, or somber tones for which the straight oil-painting method is more appropriate. Tempera paint can be applied in a completely opaque manner, and one may also get transparent results with it, but the special effect that distinguishes it from the other methods is a translucent, semi-opaque paint quality. Its handling is productive of a crisp, linear character which, combined with the luminosity and clarity of the color effect, gives results that cannot very well be duplicated by the use of any of our other standard methods.

Appropriate use of tempera. In general, tempera is more adaptable to a systematic, deliberately planned method of painting than it is to the casual or impulsive style. The advance preparation that goes into a successful work in tempera, both as to the painting procedure and the materials themselves, while not particularly onerous, appeals more often to the methodical painter than to one who prefers the more direct or immediate production of effects. If the control of a translucent quality in the paint and brushwork is maintained, the brilliant ground, the original modeling, and the various colors of the underpainting all combine to contribute their effects to the final results.

Unlike watercolor and the usual direct oil techniques where color effect, draftsmanship, and other elements of the work are simultaneous concerns of the painter, true tempera is a division-of-labor method. The original drawing on paper should be complete and well finished in detail, so that it may be used as a reference during painting. Either direct from life or assembled from notes and sketches, it should, like a mural cartoon, have all problems of design, composition, draftsmanship, and modeling worked out to their final degree so that painting, or the application of color, will be unhampered by these considerations later on. This drawing is then transferred to or traced on a smooth gesso panel, made according to the methods outlined in Chapter 4, "Grounds." Although the later stages of painting and overpainting can then be carried on calmly and without being complicated by decisions and alterations, it is not mechanical work; complete alertness is necessary to subdue and intensify color effect; one is freed only from decisions

on the other elements. When it comes to the final layers or washes of color, much bold, spontaneous stroking can be used, thus overcoming any pickiness or labored effects that may have been introduced by the rigid control of the start.

Emulsions. Tempera paints owe their special characteristics to the fact that their vehicles are emulsions. A normal or customary emulsion is a homogeneous, stable mixture of an oily ingredient and an aqueous (dissolved in water) ingredient. In our general practical concept of materials, we say that oil and water won't mix, and this is perfectly true in the handling and mixing of the general run of fluids. However, under the proper circumstances, many oily (and this term includes fats, waxes, and resins as well as oils) materials can be combined with water solutions if one or more of the ingredients is a good *emulsifier* or *stabilizer*. These emulsifiers are, for the most part, colloidal solutions of gums or gumlike materials.*

How emulsions are made. Some emulsions occur in nature and others may be made. The conditions for making an emulsion are: (1) the presence of an emulsifier or stabilizer of the correct type, and (2) a thorough and vigorous agitation of the watery and oily ingredients. If, for example, a fairly viscous solution of a water-soluble gum is mixed with linseed oil and shaken or stirred together vigorously, the result will be a milky fluid in which the oil is uniformly suspended in myriads of minute droplets. The emulsion of oil and gum solution appears milky because of the diffuse reflection of light between the surfaces of all the little oil particles. For a similar reason snow appears white, as explained in the section on light (page 26). Upon drying, a film of this material will be as clear, or nearly as clear, as the original gum solution.

The little droplets in a good emulsion do not easily separate out and unite with each other, but remain dispersed during long storage. However, some of the approved emulsions, made in the necessary proportions for good tempera paints, may—on long standing in a bottle—show some degree of creaming. This is merely a heavy layer of emulsion on top of a thinner layer which contains surplus water, and this separation should mix in promptly when the bottle is shaken, exactly as does the cream on a bottle of fresh milk.

Milk is an example of a natural emulsion, in which the oily ingredient (butterfat) is suspended in a solution containing casein and other materials which are good emulsifiers.

Emulsion types. There is another type of emulsion with which artists' paints are rarely involved, and that is a sort of reverse type in which the aqueous solution gets dispersed in the form of droplets and

* Gums are water-soluble substances mostly obtained as natural exudations from trees and shrubs; others are processed from various natural sources. The water-soluble gums should be distinguished from resins (page 105), which are insoluble in water and which are used in varnishes. Some confusion exists because of the practice in the varnish trade of applying the term "gum" to varnish resins.

the oily ingredient acts as the surrounding medium. Butter is an example of such an emulsion, being composed principally of butterfat and water with small amounts of other ingredients. The usual or water-soluble emulsion is called an *oil-in-water emulsion,* and the oil-soluble type is called *water-in-oil* emulsion. Although not frequently encountered, it is well to know that these oil-soluble emulsions exist, because under certain conditions they are likely to be formed, or one type is likely to invert over to the other type.

About the word "tempera." Some artists and commentators apply the word "tempera" to any opaque water paint such as the cheap poster colors, gouache colors, and simple casein paints, but this is incorrect. Such simple materials are not true tempera paints and will not behave in the same manner. The original meaning of the Italian word *tempera*—in the days when it was virtually the only method in use on artistic easel painting—came from the verb "to temper" and meant any liquid which could be mixed with pigments for binding and adhesive purposes, as distinguished from fresco painting, in which the vehicle (pure water) has no binding or adhesive functions. In other words, the pigments were "tempered." At that time, oil paints were used only for coarser work, not for artists' easel paintings. After oil painting became the principal method in use by artists, the word began to be applied exclusively to emulsion paints. Some remarks concerning the historical development of tempera and its use in past ages will be found on page 117. The British term "distemper," which is not in general use in America, is applied to coarser water paints of the glue-size type; it denotes paints and painting for walls and other large-scale decorative purposes rather than artists' paints. The French equivalent of this word, *détrempe,* is also the word for tempera; this has caused errors in the translation of French accounts into English by persons with a theoretical rather than a practical acquaintance with the subject.

True tempera emulsion paints are not common in the shops, and the carefully made ones are put up in tubes, never in jars. The use of the word "tempera" by manufacturers of poster colors in jars is misleading. Almost every type of tempera emulsion has been used to produce commercial tempera paints, particularly in the European brands. They have been made of emulsions based on egg, gum, casein-wax mixtures, and combinations of various other ingredients; sometimes the materials or types are stated on the labels, but more often they are not. Each kind of tempera paint has its own special properties, and some are more suitable for some purposes than others.

EGG TEMPERA

The original European tempera paintings were made on gesso

panels with pigments ground in pure egg yolk diluted with water. Egg yolk is a perfect tempera-paint vehicle; it is a natural emulsion of an oily or fatty ingredient, called egg oil, with a water solution of a gummy ingredient called egg albumen, plus several lesser ingredients, chief of which is lecithin, a powerful emulsion stabilizer. The method of painting tempera pictures completely by means of colors mixed with egg yolk and water is of considerable antiquity; by Giotto's time in the fourteenth century it had become well established, and we have many surviving examples as well as contemporary writings on the subject. It is one of the best documented of all the Italian Renaissance techniques that have come down to us. The most complete and interesting early manuscript on the subject is that of Cennino Cennini,* who painted in the fourteenth century and whose treatise is available in modern translations. It is familiar to all artists who have made any study of painting materials and, besides the technical information it contains, it affords glimpses into the character of the painter and the spirit of his times.

In connection with books of past ages, even up to works of the comparatively recent past, it is most important to remember to be very cautious in adopting these accounts as completely reliable, detailed guides for modern practice. Unless one is thoroughly grounded in the subject and can modify or discriminate between the finer points of good and bad, exhumations of old recipes and "secrets" are generally disappointing.

The pure-egg-yolk technique, although limited in its manipulative properties and visual effects, appeals to many present-day painters who find that its special characteristics are adaptable to many modern requirements. The finished paintings have a luminosity and paint quality which cannot easily be matched precisely by other means.

The following account of the traditional or classic pure-egg-yolk technique is a basic instruction in tempera painting; all other tempera methods were developed from this method. Although modern painters frequently use other forms of tempera emulsions, its mastery is usually considered a necessary background for the practice and study of all tempera painting.

PREPARATION OF EGG TEMPERA PAINTS

Separating the yolk. Yolk of egg is considered an ideal tempera emulsion. Its ingredients are combined in proportions which, when well diluted with pure water, are well balanced for the purpose. The painter, therefore, wants the pure yolk, uncontaminated by any of the white,

* Available in paperback in *The Craftsman's Handbook,* by Daniel V. Thompson, Jr. New York: Dover Publications, 1954.

which is all albumen and would throw the properties off balance.*

The illustrations above and below show a traditional method of extracting the pure yolk; after it is separated from the white (Figure

* With the exception of a few minor and highly specialized uses in the distant past, straight egg white has no place in the list of paint vehicles. In the egg-and-oil emulsions however, whole egg is commonly employed.

86. The yolk ready to puncture.

87. The yolk run into a jar.

88. Measuring proportion of pigment and egg yolk.

83. Separating the yolk from the white.

84. Removing the rest of the egg white from the yolk.

85. A method of handling the yolk.

83), it is rolled dry on a towel (Figure 84), picked up (Figure 85) and held between the fingers of the right hand (Figure 86), then punctured by stabbing with a sharp point (Figure 87). Another method is simply to drop the yolks, after drying them, into a wire-mesh strainer to remove their skins. The yolk is easier to handle if the egg has been chilled.

The colors. Painting with egg yolk on gesso requires a careful grinding of pigments and the use of at least as much water as egg in the

final paint. Fresh egg yolk must be used in tempera painting; therefore, to avoid the tedious task of grinding fresh paints every day, tempera colors are ground in water instead of in the yolk. The pigments are well ground to a paste or a syrupy consistency, either on a slab with a muller or in a mortar with a pestle, until smooth and nongritty; they are then stored in small screw-cap jars, where they will keep indefinitely. A drop or two of weak phenol solution (from the drugstore) may be added in order to prevent the growth of mold. If the colors were directly ground in egg yolk, they would deteriorate rapidly because egg tempera paints will not keep for more than a day or two, depending on climatic conditions. If for any special reason the painter wishes to grind his pigments directly in a mixture of egg yolk and water, there is no technical objection to it, except that the paint will harden or go bad in a day or two. The grinding is done in the same manner as the grinding of oil colors.

The approved list of pigments for tempera painting is the same as that employed in oil painting, listed on page 34, except that the lead-bearing pigments (flake and Cremnitz whites and Naples yellow) may be used only when the finished painting is protected by oil or resinous paints, glazes, or varnishes.

Setting the palette. One measure of pure egg yolk is mixed thoroughly with a palette knife on the palette or glass slab with about an equal volume of the water-ground pigment (Figure 88). This mixture is placed in a small jar and covered with a bit of cloth soaked in water, which keeps it from drying out. Small amounts are transferred to the palette as required. A palette or plate, with small depressions to hold the rather fluid colors, or separate little cups, are used; a hand palette is not convenient. Some pigments occasionally (notably the blues) require a little additional egg or gelatin in order to bind them securely. This can be ascertained by rubbing the paint with a soft cloth after it has dried.

Painting in tempera. The painting is usually done directly on an absorbent gesso panel with red-sable brushes. The colors are very freely diluted by continually dipping the brush in water. When completely dry, the surface can be polished to a dull, lacquer-like sheen by rubbing it with a wad of dry absorbent cotton. It may be varnished, waxed, or overpainted with thin oil colors or glazes.

The traditional handling of tempera paints is usually a pencil-like brushstroking with the point of the brush—although, if desired, broader masses may be applied, as is often done in modern work. By diluting paint with much water during use, its characteristic translucent quality is maintained, and solid, poster-like effects are avoided. The brush is ordinarily squeezed out between the fingers or a piece of cleansing tissue so that the color does not flood the surface, and so that it does not form drops or dissolve the underpainting and the gesso. It is never scrubbed into the surface.

Its handling is neither like that of the thick, pasty oil paints, which must be pushed about, nor that of the free-flooding watercolors and

gouache colors, but a special sort of flowing from a dryish brush—somewhat like pencil or pen manipulations.

Cennini's method was to strengthen and develop the original drawing by going over it with a fine brush, using three separately mixed shades of a mixed color like raw umber which he called *verdaccio,* and with which all the darks of the modeling were applied except on the portions of the panel underlying the flesh tones. These were given two veils or thin, transparent coats *(imprimatura)* of green earth and white; and then the modeling was put in with the darkest *verdaccio* used very thinly. The rosy or ruddy portions of the flesh were then underpainted with thin, transparent touches of pink made with vermilion to which a little white was added, and then the flesh color was applied in three ready-mixed shades, dark, medium, and light, finally adding small touches or highlights of a very pale fourth flesh tint or white where required. The colors and mixtures were prepared in advance and kept in little cups.

While it is neither necessary nor desirable for the modern painter to be bound too closely by an ancient procedure such as this, reconstructions of the effects of the early painters will give the tempera painter an invaluable insight into all the potentialities of the medium toward adapting it to his own use.

The principal way to achieve the luminous and full tempera quality is to keep the colors fluid by using sufficient water, but at the same time to apply them with a dryish brush in the manner previously noted. Otherwise a dead, opaque quality will result and one may as well use gouache paints. On the other hand, the finishing strokes should not be too thin and unsubstantial like watercolor washes or the veils used in the underpaintings. The bulk of the strokes should not be allowed to obscure the underpainting entirely, and all the layers of underpaintings should be permitted to contribute their effects to the final result.

Preservatives in egg. Experience has shown that the use of preservatives with homemade tempera colors is, in general, not successful. It is easier to add fresh yolk to the water-ground colors. The most frequently mentioned preservative is a few drops of a 5 per cent solution of acetic acid—or a few drops of vinegar (which usually contains about 5 per cent acetic acid). This solution will preserve egg yolk for a week or two, and has been used in the past, especially when tropical or excessivly humid atmospheric conditions prevailed. The commercially prepared tempera colors usually contain preservative, but these colors are seldom if ever of the pure-egg-yolk type, and the conditions involving the manufacture and distribution of commercial products vary greatly from those of homemade materials. Most experienced tempera painters dislike the use of preservatives.

OTHER TEMPERA EMULSIONS

Preparation. In order to make emulsions for tempera paints, other

than the pure egg yolk, one of four pieces of equipment is used. An electric mixer is most efficient in the majority of cases; it will beat the oily ingredients into tiny droplets and produce speedy and thorough emulsification. An adequate but less efficient substitute is the kitchen egg beater. There is also another type of beater with an up-and-down plunger motion which is useful when a recipe calls for gradual or drop-by-drop additions during the mixing, since it requires only one hand to operate. Shaking the ingredients in a half-to-three-quarters-full tall-shaped bottle is most useful for the mixing in of fluid ingredients as additions to emulsions, such as oil/egg emulsions. Grinding with a muller on a slab with small gradual additions of one of the ingredients is best for stiff, "mayonnaise"-type mixtures and water-in-oil emulsions. In factories, the large-scale mechanical equipment for making emulsions is based on the same principles.

The following recipes are typical for tempera emulsions:

Egg and oil tempera. Whole eggs stirred together with twice their volume of water are strained to remove the skins and clots, then emulsified by shaking with ¼ its volume of an equal mixture of stand oil and damar varnish.

Gum tempera emulsion
A—Aqueous ingredient:
 gum arabic . 4 ounces
 dissolved in hot water 6 fluid ounces
B—Oily ingredient:
 damar varnish . 1½ fluid ounces
 stand oil . 1 fluid ounce
C—Plasticizer:
 glycerin . 1 fluid ounce

A little more water in A produces a more fluid emulsion, sometimes preferred.
B is best added to A in a slow stream with constant strong stirring.
C is mixed into the finished emulsion.

Finishing tempera paintings. The glazing and varnishing of tempera paintings are carried out exactly as in oil paintings and may be done as soon as the water has dried completely out of the tempera film —in a day or so. The method calls for a thin coating of size (note precaution on page 74) to be brushed or sprayed over the painting in order to isolate it from the glaze which otherwise has too much tendency to sink in or become dull. A solution of white shellac very much thinned down with alcohol or a 5 per cent solution of gelatin in water is the usual sizing material. The water solution is more difficult to use because of its tendency to pick up the underpainting. Most tempera paints can be polished to a smooth, lacquer-like gloss by rubbing with a soft cloth

or a piece of absorbent cotton when dry and thoroughly set. If there is sufficient binder in the colors they will not rub off. Straight egg-tempera paintings, not glazed or overpainted with oils, may be cleaned with acetone but not with water.

Unlike faulty oil paints, which do not disclose their deficiencies and do not develop major defects until they have aged for a long time, faulty tempera paints will usually exhibit their shortcomings soon after drying. The permanence of standard, and even experimental, tempera paints can, as a general rule, be relied upon, provided that they dry promptly and show no evidences of failure on close examination after a day or two.

Mixed techniques. Tempera paints, particularly those made from emulsions of whole egg plus oil, are employed in combination with straight oil painting in several different ways. These complex techniques are used in order to obtain special effects which cannot easily be had by either oil painting or tempera painting alone. If a stroke of tempera paint is applied to freshly painted wet or tacky oil paint or oil plus varnish glaze, a crisply delineated effect is produced, entirely different in character from the results obtained by other means. If thin, transparent veils of tempera color are washed over a brilliant white gesso ground and the painting is built up with light and dark modeling, alternating and combining the effects of each of the oil and tempera mediums in both opaque and transparent ways, a great variety of textural and atmospheric effects may be produced. Provided that neither tempera nor oil strokes are applied with too much or too exaggerated thickness or impasto, and provided also that the paintings which contain more than just a little, occasional amount of tempera are done on panels instead of canvas, the mixed techniques can be considered permanent. They are not recommended for use by beginners or artists who are not familiar with both oil and tempera painting through first-hand experience.

AQUEOUS PAINTS 7

Watercolor

The specific term *watercolor* refers to paintings done on a special handmade rag paper with pigments very finely ground in a binding medium composed of a solution of gum arabic. Watercolor paintings are done in a thin, transparent manner; pale tones are obtained by dilution of the paint with water, thus producing such a thin layer of pigment that the brilliant white effect of the paper is mingled with the color. This method of coloring generally is called the *transparent* or *glaze* system, and it is entirely different from the other coloring method called the *opaque* or *body-color* system (see page 99).

Modern moist watercolor paints are sold in paste form in tubes and also in a stiffer, more solid form in pans. They are of equal value, tubes being more popular than pans because of convenience in handling. Originally, watercolors were put up in hard, dry cake form, but for the past hundred years or so the popularity of these has steadily declined in favor of the moist colors and they have almost entirely disappeared from the shops.

Papers. All artists' paper should be made of pure linen or linen and cotton rags, free from wood pulp, chemical agents, and resin fillers. The best watercolor papers are handmade by European firms of ancient descent.

Wood-pulp paper, which is paper in its most common form, becomes brittle and brownish with age, as evidenced by newspaper and newsprint pads. But age-deterioration is not produced by the wood pulp per se; it is the chemicals, particularly acids, that are the cause; witness the Oriental papers which are of wood or vegetable fiber origin. Modern wood-pulp papers are made that are sufficiently permanent for art, book, and many other uses; the paper should be certified as being free from acid, and preferably should contain enough alkaline potential to withstand acid effects. The chemists designate neutral paper as pH 6.5 to pH 7, at which reading a paper will be permanent. Conservators now frequently save decrepit works on paper by a process of de-acidification. But most artists are still limited to 100 per cent pure rag paper. Perhaps in the near future standards will be adopted so that the consumer can identify good, permanent paper, other than that of 100 per cent rag content. This would be an important improvement, especially in the case of such items as sketchbooks, which for the past 135 years or so have been made of nonpermanent wood-pulp paper that embrittles and turns brown within a few years—under one's own eyes, one might say. For

the present, 100 per cent rag paper is the artists' only option for sketch-book paper that will remain in good condition over the years.

The standard method of painting on the thinner grades of water-color (most widely used) is to stretch the paper on a drawing board by first wetting it in a tub of water, then blotting off the surplus water and adhering it to the board with the regular brown gummed-paper tape that is sold for sealing parcels. A strip of this tape along each edge will hold the paper securely; as it dries it stretches perfectly flat and will take wetting by watercolor paints and washes without the resultant curl-ing, buckling, and wrinkling that a loose sheet would display. Gummed tape is an improvement introduced about the 1920s; before that, white paste was used, applied about ½ inch in all around the edges; the gummed strips are simply more convenient. Some experience with any particular kind of paper will indicate how wet it should be; the stretching of a paper soaked too heavily may tear it at the corners, and if in-sufficiently wet it may wrinkle.

Most watercolor paper is sold in the "Imperial" size, the sheets measuring about 22 by 30 inches. High-grade watercolor paper is also sold in blocks (pads), but not in very large sizes. Watercolor paper is priced according to its weight, which is indicated by pound numbers that refer to the weight of a ream (500 sheets). The lightest is called 72 pound, the next lightweight kind is 140 pound, twice as heavy and twice as expensive. The very heavy papers designated 300 to 400 pound are really superb; they do not require stretching (they could almost be called cardboard; it is possible to paint on the paper holding it in one's lap). They withstand much more drastic treatment than the lightweight varieties do; scraping and other manipulations that would ruin these can be done on 140-pound paper. Their prices are high, but a profes-sional painter can consider this a normal expense if he sells only an occasional watercolor.

Most of the best watercolor paper is imported from Europe; few mass-produced American papers approach their quality. In recent years, however, individual craftsmen have set up facilities to produce hand-made paper in small-scale limited production. The texture of watercolor paper varies a little with each maker; the most popular finishes in cre-ative painting are the coarser ones, known as rough (R), followed by not-pressed (NP) or cold-pressed (CP). Papers with the smoothest finishes are hot-pressed (HP) and are occasionally used in techniques other than normal watercolor, but their principal use is for pen drawing and other techniques.

The mechanics of watercolor. Watercolor paints are made by grinding pigments very fine in a gum-arabic binding medium, together with certain necessary modifying ingredients. These ingredients usually are: (1) glycerin and honey (or sugar syrup), which are plasticizers

added in order to keep the colors moist and to improve their working properties; (2) a preservative to keep them from becoming moldy; and (3) a wetting agent such as oxgall or a synthetic one to make them take well and spread uniformly on the paper. The proportion of binder and pigment is very carefully balanced in order to give the paints exactly the correct properties. The tiny grains of pigment become enmeshed in the relatively coarse fibers of the paper, and this action is of much importance in holding the color to the paper, as is the adhesive action of the gum binder (Figure 90). Watercolor painting consists therefore of a very thin layer of pigment particles held just sufficiently to be a permanent coating; it is not a real paint film like the layer of gouache

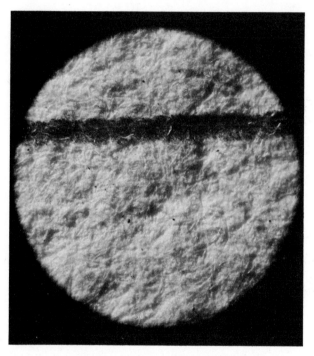

89. Photomicrograph: watercolor paper (streak is a pencil line).

90. Photomicrograph: watercolor painting.

in Figure 91 and therefore is not subject to some of oil paint's defects, such as cracking, peeling, or blistering.

A careful balance of the modifying ingredients in watercolor paints is necessary to give the correct working properties and to insure the proper balance of solubility; that is, the dried layer of a good watercolor paint is sufficiently resistant so that it is possible to apply subsequent brushstrokes without picking it up entirely. On the other hand, the paint will not be so insoluble that it cannot be softened or run into when the painter so desires.

Transparent watercolors are quite difficult to make successfully and the painter seldom attempts to make his own except in unusual cir-

cumstances. The best watercolors of the shops leave little to be desired; their universal popularity has led to widespread availability and the development of a high degree of quality.

Gouache. A gouache painting is a watercolor done in opaque instead of transparent coloring; whites and pale tints are obtained by mixing titanium or Chinese (zinc) white with the colors instead of by utilizing the white of the ground. The *materials* used to make gouache and watercolor paints are identical or nearly so, the difference between them lying in their method of preparation. Gouache pigments are ground with a greater proportion of vehicle to pigment, and when they are painted out, the result is a continuous paint film of appreciable

91. Photomicrograph: gouache painting. *92.* Gouache surface magnified further.

thickness rather than the thin wash or stain produced by watercolor (Figure 92).

The color of the paper usually has little effect on gouache paint as an underlayer, and so sometimes a tinted paper is used for special effects, the exposed areas of the paper being utilized as a part of the color scheme of the painting. Transparent watercolor is occasionally combined in a gouache painting; as a general rule this produces a better effect than when gouache is used in a picture that is predominantly watercolor. Some painters achieve a full range of textural and color effects by combining watercolor, gouache, and pastel in the same picture. Gouache colors have a certain robust solidity which gives the

133

93. Photomicrograph: pastel, normal strokes on plain pastel paper.

94. Photomicrograph: pastel, heavy deposit on sand-grained paper.

95. Photomicrograph: pastel, pigment grains enmeshed in the surface of velour paper.

effect of an impasto paint layer, heavier than that which actually exists and, therefore, the paint need not be piled up thickly. Because gouache paint is a real, continuous film with a not-too-flexible gum adhesive, it is likely to crack or peel off if applied too heavily.

A great variety of aqueous paints has been employed by artists to produce pictures popularly accepted as gouache paintings—for example, cheap poster colors, casein paints, tempera paints, watercolors mixed with Chinese white. True gouache paints, however, capable of being handled to give the best results in that technique, are made especially for the purpose, from the same gum solution and other materials used for watercolors.

The lines of artists' tube colors called "designers' colors," however, are usually good-quality materials and may be used as gouache colors with certain restrictions. Being intended for use by designers, illustrators, and commercial artists, these lines contain superbright pigments that are not lightfast, for the artists who work at those tasks are not concerned with permanence. One must therefore be careful to pick out the permanent pigments as listed in this book—the ochres, the umbers, the ultramarines—and avoid the geranium reds, the peacock blues, and others with nonstandard names (see page 34).

Unlike the transparent watercolors, gouache paints may be easily and profitably made at home.

A typical watercolor and gouache binder is made by adding to a 1:2 solution of powdered gum arabic about $1/3$ its volume each of glycerin and honey-water (1:1), a little wetting agent, and a very small amount of preservative (page 142). Some gouache colors are improved

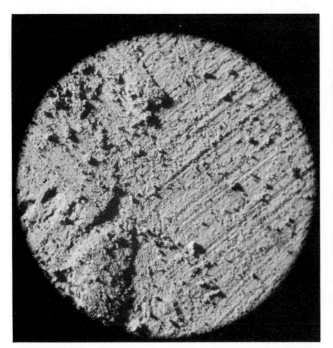 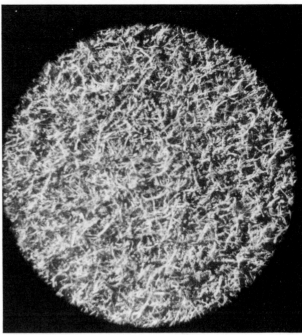

—to a greater extent than are transparent watercolors—if the vehicle in which they are ground contains a pasty adhesive in addition to the gum-arabic binder. A stiff solution of white dextrin added to the gum solution will overcome the sticky or stringy consistency which is an occasional defect in some aqueous paints. The amount may be varied according to the requirements of each particular pigment; the result will generally be a smoother, more easily brushable paint. It is generally said, however, that for finest and most sensitive professional use the gum content should remain the principal ingredient in homemade gouache; the more dextrin used, the more the paint will tend toward the less delicate and less permanent poster-color type of paint.

Inert pigments, such as blanc fixe or chalk, are often ground in with some of the colored pigments, not as adulterants but in order to increase their bulk and to improve their brightness or opacity. Those colors which are ordinarily transparent in oil and watercolor act as body-colors in gouache, and often yield somewhat different color effects.

Casein paints. Casein, a powdered protein made from milk, has been mentioned as an adhesive and as a binder for grounds (page 81). Modern casein is an improved material made under scientifically controlled conditions, but it has long been used in a crude form, homemade from curd or pot cheese, and accounts of it are found in some of the earliest writings. It is an acceptable and permanent binding material. For best results casein powder should be fresh; the strength of old casein may vary erratically. Casein colors in tubes were formerly all imported from Europe; in the mid-1940s a number of American brands came on the market and the technique gained a wide popularity, for the colors,

135

the handling, and the effects have desirable properties that appeal to many painters. With the rise of the acrylic polymer colors, many manufacturers discontinued their casein lines, perhaps on the premise that the new colors replaced them and that they would no longer be profitable under current economic conditions. However, casein colors are still made by some to supply artists who believe that their special properties are irreplaceable.

Casein powder is not soluble in water, but dissolves easily when ammonia is added. When treated with certain chemicals (for example, spraying the finished coating with a 4 per cent formaldehyde solution), it equals egg tempera in water resistance.

Paints made by grinding pigments in casein solutions are used for permanent painting in the gouache manner and also in mural painting in the fresco manner (see *Secco*, page 161). Their use to replace oil paints for large easel pictures has no precedent; it is a twentieth-century development. But approval as a permanent technique has been fairly universal. Cautious painters will confine their use to rigid panels; their ultimate permanence on canvas is doubtful. Casein solutions are also used as tempera ingredients; they emulsify readily with waxes, resins, and the vegetable oils, but the last named are not to be recommended since all mixtures of casein and linseed oil become quite yellow on aging. Most authorities agree that casein is inferior to glue as a sizing material and binder for grounds because of its tendency to become brittle with age; many find it less manipulatable than the gum-arabic type of water-color or gouache paint.

Typical recipe for dissolving casein. Allow 1 ounce of casein powder to soak in 6 fluid ounces of water overnight, then dissolve it by adding clear ammonia water, drop by drop with stirring, until the solution is as thick as honey and free from lumps or clots. For use as a paint binder add the preservative (⅛ to ¼ teaspoonful of sodium ortho-phenyl phenate [Dowicide A]) and thin to desired consistency with about 6 fluid ounces of water. For use in gesso, start with 4 ounces of casein, 24 fluid ounces of water, use ¾ teaspoon Dowicide A, and dilute with about 3 quarts of water. This should bind 4 pounds of chalk or whiting to a satisfactory gesso. Casein gesso is used like glue gesso but in much thinner coats.

There is also a form of casein powder called monoammonium caseinate or soluble casein, which may be dissolved by warming it in water without adding ammonia. Sometimes this material loses its ammonia content on aging; then it requires the addition of ammonia, the same as with the regular casein.

Casein is widely employed in industrial products, among which there are a few of interest to the artist. Casein glue, sold as a prepared powder to be mixed with water, is a very powerful adhesive for joining wood. Recipes for the use of adhesives made from curd date back to the eleventh or twelfth century.

PERMANENT PALETTE FOR WATERCOLOR AND GOUACHE PAINTS

In the regular or pure watercolor method of painting, almost all pigments are used for transparent or translucent effects, transparency being obtained from the more opaque paints by diluting them to a thin consistency. Paleness or whiteness of tone is obtained by utilizing the brilliant white of the paper showing through the colors instead of by the free, unlimited use of Chinese white mixed with the chromatic pigments to produce pale tints. The use of Chinese white in the pure watercolor technique is either avoided entirely or confined to occasional touches for special effects. The vividness or deep tones of the strong colors in the painting are also enhanced by the underlying brilliant white ground, because they, too, are never applied in a thick or pasty manner.

In gouache painting all the pigments are compounded and used in a manner that makes them opaque, and in painting, the pale tints are obtained by mixing them with white paint. The color effects of all the pigments are those of their mass- or top-tones, and many of those pigments that exhibit their undertones when used in transparent oil or watercolor paintings (such as burnt sienna or green earth) will therefore display a different color effect when used in the gouache technique.

The list of permanent pigments for watercolor and gouache is exactly the same as that used in oil painting (see page 34) with three exceptions. The lead-bearing pigments that are approved for use in oils —flake white, Cremnitz white, and Naples yellow—are not used in watercolor because of their susceptibility to turning dark on exposure to impure air when not protected by oil or varnish, their likelihood of reacting with other pigments when used in the gum-water mediums, and their poor brushing qualities in water mixtures.

GENERAL PROPERTIES OF AQUEOUS PAINTS

The paints made from pigments that have been ground with water vehicles require entirely different methods of brushwork and handling from those in which oil and varnish materials are used, and in this respect we can also include the acrylic polymer colors, for they are a water medium so far as handling is concerned, although they are not otherwise classified in this section but are described by themselves in a later chapter. As contrasted with oil paints, the technical handling of all aqueous paints (and their resulting pictures) have much in common. And yet the different varieties of water-soluble paints that are approved for permanent painting are distinctly different from one another, and each has its own characteristics that make it suitable for a particular kind of painting.

The bulk of the vehicle in an oil painting is linseed oil or, in some cases, a mixture of oils and resins; whatever volatile material may be used as a thinner (such as turpentine or petroleum solvent) is normally

present in a relatively small proportion.

On the other hand, the binding ingredients of all the water mediums are very powerful adhesives and binders; even with the least powerful of these, the greatest bulk of a normal water paint, when it is ready for use, is water.

As has been noted, the oil vehicles do not evaporate, but remain in the dried paint film in approximately the same bulk as that which they occupied in the wet paint. Consequently, the pigment, still surrounded by a substantial excess of dried vehicle, will display the same or nearly the same color effect as did the wet paint. This same surplus vehicle also serves as a protective casing for the pigment. It has such flexibility, and such resistance to harm from moisture, temperature changes, cleaning agents, and wear and tear, that a well-made oil painting may be done on canvas, framed without glass, and, if kept under the normal conditions of preservation which works of art are intended to receive, may be expected to survive for hundreds of years.

Paints made with water vehicles (as has been pointed out in commenting on the reasons for their mat effects as compared with the glossier oil paintings) contain much less of such surplus binder; unlike oil paint, the bulk of the paint—the water—evaporates completely on drying, leaving the pigment particles exposed or partially exposed to the air. This not only causes the mat effect and the brightness of the hues, but also eliminates a good many of the troublesome ills to which improperly painted oil paintings are subject. It makes necessary a different set of precautions as to the durability of the works, because they are inherently less resistant to wear and tear or to atmospheric conditions; yet many of the oldest paintings in our museums were painted in water techniques.

Regarding permanence, they can be said to be more fragile but just as permanent as oils if properly preserved. For example, watercolors are framed under glass and backed with rigid cardboards (or mounted on them), whereas oil paintings are normally framed without glass. Some of the aqueous painting techniques have a considerable degree of material flexibility, but none are so elastic as oils and are therefore not suitable for use on canvas.

The principal difference between the handling or brushing out of water paints and that of oil paints is the more limited special brushwork necessary for using water paints because of their extremely rapid rate of drying as compared with the slow-drying or more plastic oil paints. This narrows the working or manipulative properties of water mediums, and limits the brushwork either to free, fresh stroking or to more complex methods, such as allowing the paint to dry and then going over it with other manipulations. However, watercolor and gouache can be used in blended, graduated, and wash effects much more successfully than tempera or fresco, where handling is in general confined to pencil-like touches applied in single strokes and left alone. Oil paints are the

most versatile of all.

Paints with simple gum or glue binders, including watercolor, gouache, and poster colors, dry by simple evaporation of water, and the dry paint's physical properties and solubility remain unchanged. Casein colors and tempera colors become set by going through a chemical process (denaturing of a protein), and their binders or film formers become new substances, no longer soluble, which puts them in a different class or group of film formers along with oil paint and the acrylic polymer colors, both of which when dry are unaffected by the thinners or solvents that diluted them when they were liquid.

Status of watercolor painting. It may be noted that watercolor and gouache are sometimes considered minor techniques when compared with oil painting. This is principally because they are used to instruct beginners and children, or because they are popular for use in making sketches and rough notes from which to paint complete pictures in oil. Actually, watercolor painting is as difficult to master as any other technique. Although its effects are more limited than those of oil, it has a distinct appeal of its own, and the process is sufficiently flexible and adaptable to a wide enough range of effects so that it qualifies as a true fine-arts medium. It occupies a serious and important place in present-day easel painting.

POSTER COLORS

The water paints sold in glass jars are made by grinding pigments with simple water-soluble binders, such as glue, casein, or dextrin, and they ordinarily contain considerable amounts of inert pigment or extender for they are essentially cheap products. A preservative, an odorant, and, in some of the better grades, a little glycerin round out the recipes.

Because poster colors are not permanent enough for use in carefully controlled fine-arts techniques, they have received scant attention in the books on painting materials. They are widely employed for use in scenery painting, sketching, for purposes of commercial art, illustration and display, and to a considerable extent in educational work. Although poster colors are definitely inferior products from the viewpoint of the accepted, permanent fine-arts paints, they are entirely adequate for the purposes for which they are intended and usually fulfill their own requirements well. The user will note a difference in quality and performance between the cheaper and the more expensive brands. The inert pigments which they all contain are not used solely as cheapeners—such paints requiring a certain amount of bulk in relation to tinting strength—but the cheaper grades will always contain larger amounts of these fillers than the better ones. The distinctions implied in the names given to them by various makers are unstandardized and not indicative of quality. Poster colors, show-card colors, opaque water-

colors, and tempera colors are some of the names by which these products are sold; the last, however, is a misnomer and, as previously noted, has caused some confusion in the past.

Requirements for school use. For school and children's use in general, all dangerously poisonous pigments are excluded from the palette. The following pigments should be strictly forbidden:

Lead pigments—White lead (includes flake and Cremnitz whites)
 Naples yellow
 Chrome yellow, orange, and green (including all yellows and greens with common or fancy names not specifically identified in the lists of approved colors for professional artists' use)
Arsenic pigments—Emerald green (Paris green)
 Cobalt violet

These same pigments should also be strictly avoided in pastels and for use in any other method where their dust is liable to be breathed or swallowed. The poisonous colors in liquid paints are not dangerous when handled with a normal degree of care and cleanliness by adults.

Selection of school colors. The author suggests that the list be restricted to the regularly accepted artists' palette, so that the beginners' training in the mixing and handling of color will promote familiarity with the materials they will encounter in advanced work. To this end, the fancy or brilliant aniline colors and imitation pigments should be avoided; they are made for sign, display, and decorative work and not intended for general artistic or pictorial use. Handling of the more brilliant aniline colors used in art work designed solely for reproduction can easily be mastered later by the student whose training is based on manipulation of the more subdued permanent colors; habitual reliance on the brilliant lakes and toners at the start will only be harmful to the future production of permanent pictures in the field of creative art. Standard pigment nomenclature ought to be used in place of the fantastic names or simple hue designations often employed.

Recommended palette for school poster colors. The first six pigments in the following list constitute a basic, elementary palette; the rest are listed in order of their general usefulness and value. Individual preferences will vary, however, and selections made according to an instructor's preferences and opinions can very well alter their positions on this list. A full palette of 12 or 14 colors will not always be called for, since that is about the average of the professional artists' palette. The list follows:

Black: Ivory black, lampblack, drop black, or Mars black
White: Zinc or titanium white

Earth yellow: Ochre, raw sienna, or Mars yellow
Earth red: Indian red, light red, or burnt sienna
Bright reds: Cadmium-barium red, light; alizarin red
Blue: Ultramarine blue
Green: Viridian or phthalocyanine green
Bright yellows: Cadmium-barium yellow, medium (golden); cadmium-barium yellow, pale (lemon)
Brown: Burnt umber or raw umber

Making school colors. Because of its educational value, as an economic measure, or for some other reason, it is occasionally desirable to make some or all of the paints used in school work. The following notes on binding vehicles will be found useful for this purpose. Manufacturers of poster colors alter the proportion and composition of their vehicles to suit the requirements of each pigment, and a manufacturer's recipes may show completely different materials and proportions for different colors. However, this is, in general, too fine a point for amateur paint-grinders to consider.

The binding-vehicle requirements are somewhat different in nature from those that govern the making of fine paints for professional artists' use; permanence, working, and visual qualities are subordinated to economy, ease of mixing and handling, and other factors. As a general rule, homemade poster colors will be found adequate, but they seldom will equal the quality of the best commercially made products unless a considerable amount of care and study goes into their preparation.

All homemade products must be tested to see if they work satisfactorily; therefore, after the colors are made, they are examined to see if the proportion of pigment and adhesive is correct. When painted out on paper in the usual way, the color should not rub or dust off easily; on the other hand, the layer should not be so hard and brittle that it will crack. If the binder is too strong, more pigment and some water are added; if too weak, a stronger or more concentrated binder is used.

For this type of paint, rather generous additions of precipitated chalk or other fillers or inert pigments are allowed, and in the case of school colors this means that genuine, full-strength pigments can be used, since even with the more expensive colors the difference in cost between making a paint with them or with cheap substitute colors will seldom be an important consideration. It is not essential that pigments be of the ultimate degree of quality, brilliance, and strength—but if they are genuine, they will afford a better introduction to the later use of artists'-grade painting materials than the imitation or synthetic colors.

It will be found that Mars black is easier to mix into the water mediums than the other black pigments and, in most cases, will give a sufficiently intense color; its grain, however, is coarser than that of ivory black.

A binding solution made by dissolving white dextrin in boiling hot water to a creamy consistency will be found satisfactory for most poster and school paints. If circumstances warrant it, the more professional gouache or gum tempera binder can be used. In the case of paints for scenery and other large-scale decoration, a simple glue-size solution is customarily employed.

Fine grinding is usually unnecessary; the pigment, with its addition of precipitated chalk (or other inert pigment), is simply stirred to a smooth paste or batter consistency with the white dextrin or glue solution. A little preservative or mold preventive is then added and also perhaps a few drops of oil of cloves or other odorant.

Preservatives and odorants. The following mold preventives or preservatives are efficient for use in aqueous paints:

Small amounts of a weak solution of phenol (carbolic acid), about a half teaspoon of the 1 per cent solution to a pint. Drugstores will generally sell it up to about a 5 per cent solution, this low concentration being deemed harmless.

Sodium orthophenyl phenate (trademark "Dowicide A")—a powder obtainable in chemical supply stores. Small amounts (¼ teaspoon to a quart of binding solution) will effectively preserve gums, casein, and glues.

Another older but effective preservative for gum solutions is beta-naphthol used in small amounts.

A 4 per cent solution of formaldehyde. Formaldehyde is likely to react erratically with some binders and is better suited to industrial than to amateur use.

The odor of water paints is sometimes a little disagreeable; a *few drops* of any pleasant odorant will correct it. Care must be taken not to perfume the product too strongly, for that will usually be more objectionable than the natural smell of the paint. A "clean-smelling" material such as oil of cloves or sassafras is more appropriate than sweet, flowery odors. Oil of cloves also has a mild preservative action.

PASTEL

8

Pastel painting is a completely acceptable traditional method of creating permanent works of art, and is suitable or adaptable to a wide range of artistic purposes. Depending upon how the technique is handled, pastel is equally effective both for free, spontaneous work and for studied, carefully worked paintings. Bold, powerful strokes, velvety, blended textures, and hard, precise effects—all are within its range. Its color effect is closer to that of the natural dry pigments than that of any other process.

Because no fluid medium or vehicle is used, the method appeals to many painters who find their requirements met by its visual effects without any of the troublesome factors that sometimes accompany the use of oil or water paints. There is nothing present that is liable to change color, crack, peel, or blister, and the final effect is produced immediately without any waits or delays. Also, interruption of work has no technical effect on the process; incomplete paintings may be laid aside and finished at any time.

Pastel is a permanent medium, but the loose, powdery colors on paper are fragile; they demand framing under glass, continual maintenance of normal conditions for preservation, and avoidance of any drastic treatment. The two-century-old French portraits which introduced pastel to the art world as a serious fine-arts medium are as fresh today as when they were painted.

In the preservation of any kind of painting, mildew is an enemy to be combatted, but it is more serious in the case of pastel because it is more difficult to remove from the delicate surfaces than from less fragile materials of other works of art. Infestation and growth of mildew on pastel paper and colors may be prevented if a small amount of mold preventive is added to them during their preparation.

Basic principles. In the opening section on page 12, the basic principles that apply to the functioning of the various methods for making permanent paintings were mentioned. There pastel was referred to as the simplest, being the application of pure pigment to a surface. Its adhesion is the mechanical gripping or holding of the pigment particles by the roughness or irregularities of the surface. When any crayon, pencil, or similar implement is drawn across the right kind of surface, the action of the surface is like that of a file; the stick is filed down by the rough texture of the ground, and the particles are firmly held in its interstices (see Figure 89). Among the various papers and boards available to the artist for use with any sort of pencil, crayon, or pastel, there are just two varieties from the pastel standpoint: one will attract and

143

hold pigment particles, the other will repel them or allow them to fall away. This difference is to be found in all types of surfaces—smooth, rough, or granular—so that any new kind of paper has to be tried before using.

The sticks or crayons of artists' fine pastels are soft, although harder pastels are sometimes used for special effects. They contain just enough of a weak gum solution to hold them together in crayon shape and allow them to be used in a free manner without excessive breaking or crumbling if handled in a reasonably skillful manner. This small amount of binder has no effect on the colors or the picture, but it does give the particles sufficient cohesion to permit the color to be piled up to a slight impasto. Pastel colors cannot be heaped on too thickly or indiscriminately and remain permanently attached to the surface, but neither do they have to be extremely smooth or evenly applied unless the individual painter wishes them to be so by choice. It is this slight variation in texture and thickness of layer which produces effects with appeal for many painters.

Pastel grounds. There are two main kinds of pastel paper or board in general use: one has the normal coarse, rough, irregular grain of unpressed watercolor or drawing paper (see page 133) on which the particles of color are held by the paper fibers; the other is a type of specially prepared pastel surface which has a tooth (a granular roughness similar to extremely fine sandpaper; see Figure 94) produced by applying a special coating to a permanent paper or board. The two kinds are roughly equal in popularity. The granular sort is, in general, more versatile as it is best adapted to the smooth, blended type of work; however, the fibrous or ordinary rough drawing-paper type is not technically inferior and is often preferred for its textural qualities, especially for work characterized by bold or loose strokes. A third type, known as velour paper, has a flocked finish, appearing as though coated with particles of threads. It is valued for soft, blended effects (see Figure 95).

Pastel papers are often sold colored, or they may be painted on with watercolor before the crayons are used. If a solid, all-over pastel painting is made, the color of the ground has very little effect because, unlike fluid paints, the pastel pigments have a total hiding power. If the color is applied sparingly, with areas of the ground left visible, great advantage can be taken of a colored paper or an underpainting in watercolor. The impossibility of transparent color effect or of glazing has been cited as being the only technical shortcoming of pastel as compared with the fluid mediums.

Fixatives. Pastel paintings can be made somewhat more durable by spraying them very thinly with one of the prepared fixatives that are sold for the purpose. These are usually very weak spirit varnishes—solutions of about 2 per cent of some resin in alcohol. However, almost every artist who specializes in pastel from a serious or professional standpoint dislikes the use of fixatives because of the inevitable change they

1. Johannes Vermeer: "Girl Asleep." Oil on canvas, 34½″ ×
30⅛″. (The Metropolitan Museum of Art, Bequest of Benjamin
Altman, 1913) This work demonstrates a smooth, rich use of oil
paint.

2. Claude Monet: "Sunflowers," 1881. Oil on canvas, 39¾″ × 32″.
(The Metropolitan Museum of Art, Bequest of Mrs. H.O. Have-
meyer, 1929. The H.O. Havemeyer Collection) A vigorous oil
painting; the boldness of the brushstrokes is especially evident in the
detail (Color Plate 3).

3. Claude Monet: "Sunflowers," 1881. Detail.

4. Winslow Homer: "Bermuda," 1900. Watercolor, 20½"× 13½".
(The Philadelphia Museum of Art, given by Dr. and Mrs. George
Woodward) A loose handling of watercolor, showing the freshness
of the medium.

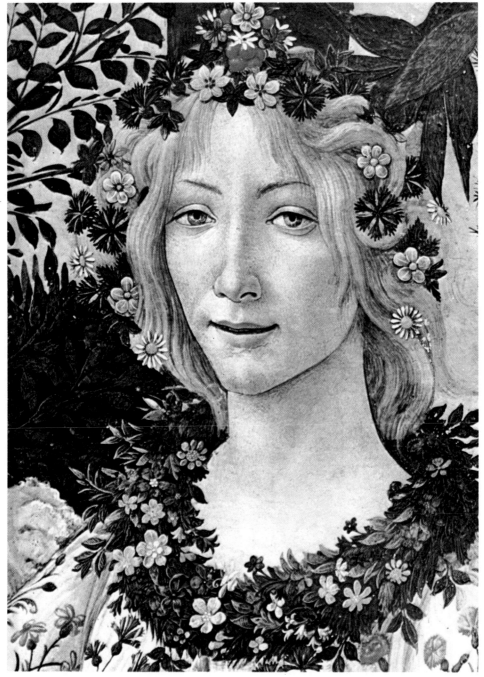

6. Sandro Botticelli: "Spring." Detail. (The Uffizi, Florence) Sixteenth-century tempera painting at the height of its development.

5. Robert Vickrey: "Plastic Umbrella," 1972. Tempera on masonite, 22¼″ × 16¼″. (The Midtown Gallery, New York) Tempera handled with precision for very realistic effects.

7. Hilaire Germaine Edgar Degas, "A Woman Having Her Hair Combed," c. 1885. Pastel on paper, 29⅛″ × 23⅞″. (The Metropolitan Museum of Art, Bequest of Mrs. H.O. Havemeyer, 1929. The H.O. Havemeyer Collection) A masterly handling of pastel, showing the great warmth that can be achieved.

make in the color and textural effect. As mentioned on page 24, the surrounding of pigment particles with a substance of different refractive index must, in conformance with an optical law, vary its color effect, and because no two pigments will be altered to the same degree, the color changes produced in fixing a pastel too strongly are often quite disappointing. Textural effect is also altered by a sort of hardening or tightening of contours, because of the fusion of particles in the liquid.

Despite a two hundred years' search for a satisfactory means of fixing pastels, the experienced, professional users of pastel still prefer to leave a pastel painting unfixed or to fix it very slightly, just sufficiently to prevent the color particles from dusting off by themselves—not to make the picture resist handling or rubbing, but to preserve it by framing it under glass with an extra-thick mat to insure against its coming into contact with the glass.

Mounting, transporting, and handling. Although pastel pictures can be smeared badly if rubbed, they will stand a limited amount of careful, steady direct pressure against shiny surfaces, such as glossy coated paper and cellophane. By exercising the proper degree of caution and avoiding any lateral or rubbing movement, pastels may be mounted, packed, and transported as are watercolors.

Pastel as a medium for sketches and notes. Pastel competes with watercolor as a sketch medium; an easily portable, compact outfit may consist of a small, flat box of pastels and a supply of granular pastel paper carried within the leaves of a glossy paper booklet or magazine.

Sanitary precautions. One must avoid the continuous inhalation of the dusty powder that is likely to arise from the normal application of pastels to the paper, as well as from rubbing or manipulating them. It is well known that no dusty powders (ordinary talcum powder, for example) should be inhaled. Harmless though their nature may be, the continued breathing of any powder is injurious to health. For this reason, pastels are not ideal materials for young children's use or for individuals who may be oversensitive or allergic to such powders.

The few definitely poisonous pigments are—or should be—strictly excluded from the pastel palette. The principal ones to avoid are as follows:

The lead pigments (which are also not reliably permanent for pastel use). White lead (flake and Cremnitz whites). Naples yellow, chrome yellows, and chrome greens.

The arsenic pigments. Emerald green and some cobalt violets.

With the observance of normal precautions against swallowing or breathing these materials, these pigments are perfectly safe in oil paints for adult use, but none of them should be employed in pastels.

Homemade pastels. Pastels may be listed among the artists' materials that can be homemade to advantage. The artist is rewarded for the time spent on this simple and easy process by obtaining a supply of

153

96. Materials for homemade pastels. 97. Measuring dry powder with a light touch.

good, practical materials at a small fraction of the cost of ready-made crayons. There are certain other advantages, which the pastels of the shops unfortunately do not always possess, that the homemade product has: one is assured that permanent pigments are used, that the sticks have the right degree of hardness or softness, and that any favorite shade, tint, or mixture of colors can be made. No elaborate apparatus is needed for homemade pastels. Figure 96 shows all the necessary materials.

The traditional binder is gum tragacanth; a modern substitute is methyl cellulose. One-half ounce of the material is allowed to soak in 24 ounces of water overnight in a warm place, and the resulting gelatinous mass is then shaken or stirred to a homogeneous consistency. A portion of this is diluted with an equal amount of water, another portion with three parts of water, and these binders in three different strengths are used to mix with the dry pigments (Figure 98) to make a stiff dough. From this dough the crayons are rolled out on sheets of newspaper and allowed to dry at normal room temperature (Figure 100). If it is desired to store the gum-tragacanth solutions, ⅛ to ¼ teaspoon of beta-naphthol added to it during its making will insure its keeping for years in well-corked bottles. It is always a good idea to have the pastel crayons contain preservative or mold preventive, as a safeguard against the growth of mold on the paintings.

The reason for the three different solutions is that each pigment contributes a different degree of binding strength to the crayon; thus it is necessary to do a little experimental or trial mixing of small test pieces to determine the best mixture for making crayons that combine *softness* of texture with adequate *crayon strength*. If the solution is too strong or too weak, the pastels will be deficient in one of those two requirements. For example, alizarin red usually requires a strong solution, burnt sienna a middle-strength solution, and raw umber a very weak

98. Mixing pastel dough.　　99. A lump of pastel dough in moldable consistency.

solution. Viridian usually has such strong binding properties by itself that even plain water will make pastels that are too hard, and a mixture of three parts of alcohol to one of water has to be used. Commercially made pastels contain a variety of binders and modifying ingredients to improve the properties and overcome the shortcomings of various pigments.

In addition to the full-strength colors and mixtures of colors, the artist will require a full scale of tints or reductions with white for each color. These are made, according to correct steps of equal visual ratios, by dividing the full-strength pastel dough into two equal parts (Figure 103) and, after rolling crayons out of one of these parts, thoroughly mixing the other part with an equal volume of white dough made of precipitated chalk and binding solution (Figure 104). The mass is then divided again into two equal parts and the process repeated, rolling crayons out of one part and mixing the remaining part with an equal amount of white dough. After repeating this procedure several times, the end of the series is reached when the tints are so pale that any further reduction with white will not produce useful shades. From five to eight or more tints can be made, depending on the tinting strength of the pigment.

The dough must always be mixed to the most convenient, stiff putty consistency, so that it can be neatly rolled to a ball between the palms without either stickiness or crumbling (Figure 99). Slight differences are adjusted by adding a few drops of water or a little chalk. Simple finger rolling (Figure 100) with the finger parallel to the crayon makes pastel crayons satisfactory to most painters; smoother ones can be made by rolling with a small piece of cardboard or cardboard covered with newspaper instead of with the fingers (see Figures 101 and 102). The inexpensive aluminum cake decorator (Figure 96) is considered prac-

155

tical by some people and an unnecessary gadget by others. An old telephone book is as good as newspapers for many such operations and is also a handy rag-saver about the studio.

Definite, measured recipes or proportions for binder and pigment cannot always be relied on because of the great variations in raw materials from different sources. The artist should keep an accurate and permanent record of his mixtures, so that they can be duplicated in

103. Halving a batch of pastel dough by approximation.

104. Measuring colored and white pastel dough for tints.

105. Preferred by some painters: mixing tints by grinding with a mortar and pestle.

100. Rolling a pastel crayon with finger.

101. Rolling a pastel crayon with cardboard.

102. Rolling a pastel crayon with cardboard covered with newspaper.

subsequent batches made from gum and pigments having the same sources. Pure precipitated chalk is the customary white pigment used for white and pale tints of pastels. When measuring dry powders, care is taken to prevent packing them into the measure; otherwise the results will be erratic and irregular. The careful worker pours the powder loosely into the measure and levels it off gently (Figure 97).

MURAL PAINTING 9

Compared with easel painting. Mural painting is a branch of art distinct from easel painting, because the decoration of walls imposes upon the painter a set of physical, technical, and artistic requirements different from those he is called upon to fulfill when he paints an easel picture in his studio, or a landscape outdoors, or any kind of readily portable painting.

An easel painting is a separate unit, an autonomous work of art. It is meant to go within the confining limits of a picture frame, and although it is ordinarily hung on a wall with care and some consideration for its decorative value, it is also placed where the spectator can view it from one selected, fixed point, under the best special lighting permitted by circumstances. A mural painting must be effective when viewed at any angle from any point in the room. Ideally, a mural painting is supposed to be a permanent and integral part of the architecture, a part of the building rather than a superimposed embellishment such as a framed easel painting. A mural for a new or proposed building must be planned in full co-ordination with the design and function of the room; for an existing structure it must be planned so that it seems to belong there, and its design must be subordinated to that of its surroundings. Appropriateness of choice must be considered even more carefully than in easel painting, and it is essential to avoid what Frederic Crowninshield called "the application of inappropriate materials to alien surfaces and surroundings."

Requirements. The technical requirements of a mural process are:

1. *Permanence.* A mural is meant to be unalterable for the life of the structure. Resistance to atmospheric conditions and to periodic cleaning carried out in a normally careful manner must be considered; also unavoidable effects of age and wear and tear. Materials that age agreeably should be selected, rather than those that become merely blemished and unclean. Walls must be waterproof; there is no paint method that will resist seepage of moisture from the rear.

2. *Effectiveness.* As much as possible, within the restrictions or limitations of circumstance, the completed murals should be effectively visible in all parts of the room without glare or interference by reason of textures; color effect must be clear and distinct. The modern taste generally favors bright and pure tones rather than subdued or dull colors.

3. *Mural quality.* The general requirements of a mural, including the aesthetic or design requirements (which are beyond detailed consideration in this study), must be served by materials of a nature as fitting and appropriate to mural decoration.

The first-choice mural process for virtually every undertaking is fresco. True fresco or *buon fresco* (for the word is sometimes improperly used) is one of the oldest decorative and artistic techniques of the civilized world and one of the most respected. In well-executed frescoes the attribute referred to on page 14 as paint quality is notable, especially when compared with other mural processes. The natural effects caused by the wear and tear of age do not diminish its "noble" effect. An expression that is often used describes it as aging gracefully instead of becoming shabby.

The process itself is simple and direct, having changed little, if any, in the thousands of years it has been in use, but it does require the most expert and skilled craftsmanship. In our day the number of painters who take the trouble to acquire a complete knowledge of the craftsmanship involved is quite small.

Fresco had its beginnings in the decoration of the lime plaster that was used as a protective finish on stucco, brick, and stone walls—and nobody knows how far back it goes. The classic ancient examples of technically expert frescoes are the relics found on the island of Crete from the late Minoan period (which ended about 1100 B.C.). These fragments from demolished buildings (notably the palace at Knossos) have survived in excellent condition. True fresco was used by painters in the earliest civilizations, but one notable exception is that of Egypt, where, because of the climate, lime plaster was not in general use and simple water paints served for wall painting. The Greek, Roman, European Renaissance, Hindu, and other cultures employed fresco. Its most recent revival, in any considerable volume of accomplishment, was our own WPA frescoes of 1930–1940, which proved it to be admirably suited to the requirements of all schools of painting.

Permanence. Fresco is one of the most permanent and durable of painting techniques and ages well under the most severe conditions. However, the consensus is that in the industrial atmosphere of our modern towns and cities it is reliably permanent for indoor use only; there is considerable doubt as to whether it will stand up under outdoor exposure, and there is much evidence that atmospheres polluted with soot and gases are definitely destructive to it.

The process. Frescoes are made by painting on fresh lime-plastered walls while they are still wet, using pigments ground in pure water. As the wall dries, the pigments dry along with it as an integral part of its surface; thus the painting becomes part of the structure rather than a superimposed decoration such as a paint coating would be. After drying, the lime of the wall soon becomes converted into calcium carbonate by the action of the carbon dioxide of the atmosphere. Calcium carbonate is chemically the same substance as limestone, chalk, and marble, and has a high degree of permanence; this together with the ex-

posed particles of the absolutely permanent pigments makes for a durable painting.

The careful preparation of the wall is the first and most important consideration in fresco painting. The first coarse or rough coat of plaster is carefully laid on a perfectly sound brick or masonry wall; in modern construction, sometimes on metal lath. Then two coats of progressively finer-textured plaster are applied, and finally the pure white painting surface, which is the finest in texture. Each of these coats is most meticulously proportioned; carefully prepared, selected ingredients are used, and they must be troweled in a skilled, experienced manner. An outline of the design of the mural is traced onto the wall after the last undercoat has dried, and the final painting ground of white plaster is laid over this drawing in sections. Only an area that can be painted in one day is covered each time, since the painting can be done only on the wet, fresh surface.

The chemical principle of fresco depends on some of the simple basic reactions of everyday chemistry. Quicklime (calcium oxide, CaO) is slaked or mixed with water, which produces hydrated lime $Ca(OH)_2$, and this is aged until it attains a plastic consistency called lime putty. The mortars for the various coats are made by mixing this with the proper amounts of sand and marble grit, which prevent shrinkage of the mass.

Fresco is a process in which the sole function of the vehicle (pure water) is to put the color into fluid form so that it can be thinly and transparently applied to the wet wall surface; the wall itself supplies the binding action as it dries and sets.

The pigments are drawn into the wall surface by capillary action and are securely bound with it; the binding action is no more or less than the binding or cementing action of the plaster particles on each other and on the sand and marble grit. They are not surrounded or encased by a vehicle, but are exposed to the atmosphere; hence they must be carefully selected from among the most chemically inert colors. Besides having to be proof against the powerfully alkaline action of the lime, the pigments must also resist the acid impurities of the atmosphere. The fresco palette is more strictly limited than that of any of our other methods.

Making a fresco. Undertaking a fresco is an adventure. It calls for complete preparation in advance and almost always, especially in frescoes of large scale, one or more assistants in the plastering, the transferring of drawings, and other mechanical tasks. The following outline will give an idea of what steps accompany the painting. The original drawing may be enlarged to fit the wall by squaring off (see page 192) on sheets of architects' detail paper, and it may be colored with gouache or any desired paints. This enlargement, which is usually carried out in complete detail, is called the cartoon. When the last undercoat of plaster is dry, and before the final surface coat or *intonaco* is applied, the cartoon is transferred to the wall by pouncing and the

160

pounce lines gone over with the brush. This monochrome drawing on the wall is going to be covered up piecemeal by the final plaster coat as each day's section is applied, but the artist requires it to be there. The *intonaco* is then expertly applied to the upper left-hand corner of the wall, extending as far as can be painted in one session. The perforated cartoon or its copy on tracing paper is then held against the wet wall and pounced again, after which the full-color final work is painted, traditionally in a thin, light brushstroke. Each successive day's work is plastered; the painting is done only so long as the wall remains sufficiently wet for the colors to be completely absorbed by the wall. Care must be taken that the borders of each day's plastered areas follow lines of draftsmanship in order that they appear inconspicuous or are invisible. Squaring off the wall, if needed, is done by "snapping." A sufficient length of soft white twine is kept in a tin or box with some dry charcoal or burnt umber. After measuring off the points of the squares, the cross-lines are made by two persons; one holds the pigment-covered twine firmly at one point, the other holds his end at the opposite point tightly against the wall with one hand and with the other snaps the line sharply.

More detailed accounts of fresco and secco will be found in *The Artist's Handbook of Materials and Techniques* and in *Fresco Painting* by Olle Nordmark, listed in the bibliography on page 194. Practical fresco painting may be learned by apprenticeship and by instruction, supplemented by individual trials. Written accounts of fresco will give less of an understanding of its control than is the case with any other of the various painting processes, unless it is supplemented by actual, first-hand experience with the materials and their application.

Methods of enlarging and transferring drawings will be found on page 191.

OTHER MURAL METHODS

Secco. Another process about which there are written records dating from the earliest European sources, and relics from still earlier times, is known as secco or limewash painting. In modern times it has been generally considered a good second-choice method to be used in circumstances where fresco is impractical. Unlike fresco, it can be painted on a finished, completely dry lime-plaster wall of any age. However, a pure lime-plaster wall is required, the more common gypsum or magnesian plasters being unsuitable. In this process the water-ground pigments are usually mixed with an aqueous binding medium, and the result is a superficial surface coating, like any other paint. Yet its effect is closer to true fresco than any of the other processes, and its handling requires much the same method of execution.

The process. At night, the clean lime-plaster wall is drenched with as much limewater (solution of quicklime in cold distilled water) as the wall will absorb, and in the morning it is again soaked thoroughly with

limewater. The water-ground colors—the same permanent ones as those used in fresco painting—are mixed with an equal volume of binding medium which can be either a strong solution of hide glue, or casein, or pure egg yolk. A little prior experimenting is necessary to determine the desirable strength of the binding medium because of variations in conditions. The wall is kept moist during painting by spraying with more limewater. Painting strokes and manipulations are the same as with fresco painting; plenty of water must be added, and the paint must be thinly used in a transparent or translucent manner, not piled up in impasto. Although casein is hardened by the action of the limewater, the work is usually not sufficiently water-resistant to be cleaned by water and requires the same cleaning method as tempera (page 129).

Many variations of detail have been developed through the years and in different localities, and numerous personal preferences exist among painters as to details. Another secco method employs *limewash* (a much-diluted lime putty) applied to a coarse plaster wall in several coats with a calcimine brush.

The variations encountered in the binding requirements of the various pigments in water mediums have already been mentioned; in secco painting one must be particularly certain that each color is going to be well attached to the wall. All the aqueous binding materials, such as glue, casein, egg, have been mentioned from the earliest writings down to the work of modern instructors. Some painters mix limewater with the pigments; this naturally gives them a paler color when dry. The processes outlined here are typical but by no means the only methods used or recommended by experts.

The word "secco" has also been used in another sense, meaning simply dry, or any kind of dry painting on a dry surface as distinguished from the above process with its specific routine. Cennini, for example, used the term to describe the finishing or retouching of dried frescoes with tempera paints, using pigments ground either in egg yolk or whole egg mixed with fig-tree juice.

Tempera on walls. Much of the desirable visual effect of fresco painting can be approximated by the use of tempera paints directly on a dry plaster wall (any well-plastered surface, not necessarily pure lime plaster). The paint is thinly applied in the fresco manner so as to produce a smooth, level, uniform surface. Tempera murals can be cleaned by sponging or swabbing with absorbent cotton moistened with acetone or anhydrous alcohol, as they are not sufficiently moistureproof to withstand periodic cleaning with water.

Murals in oil. Oil-painting techniques, although admirably suited to the production of easel paintings, give results that are inferior to all the other mural processes when applied to walls because they meet so few of the mural requirements. However, for practical reasons murals are commonly painted in oil; there are three principal ways in which

this is done, as follows:

1. Straight oil painting on primed plaster walls.
2. Imitations of fresco and other processes.
3. Paintings done in the studio on canvas and then cemented to the walls. The traditional cement for this purpose is commercial white lead in oil, mixed with a little varnish to give it a tacky or sticky consistency, a process known by its French name *marouflage*. Professionals, called mural hangers, also use several other adhesives, ranging from ordinary wallpaper paste to modern synthetic products, all of which have their good points, depending on the circumstances.

The use of oil paints falls short of the requirements of a mural process, as listed previously, especially as to permanence and optical effects. When oil paintings become discolored, dilapidated, or blemished, they require expert, skilled conservation treatments in order to be reconditioned, and most of these have to be done carefully by professional restorers. Even simple cleaning and revarnishing of an oil painting become extremely difficult when attempted on a painting that cannot be removed from the wall and laid flat. On walls and especially where canvas grounds are used, oil paint attracts dirt and grime and holds it tenaciously to the surface. Frequent dusting is necessary to prevent the rapid accumulation of dirt. The glossy or irregularly mat and glossy areas are far below the water mediums in visual effectiveness. Oil painting on walls is best confined to work of minor artistic importance: lesser decorative painting that is intended to be replaced after a limited period.

Murals to resist especially drastic conditions. For outdoor urban exposure or in places where very severe conditions exist, none of the foregoing traditional processes is recommended; if absolute permanence is required, some special method is usually devised to meet the circumstances. Among these methods may be mentioned the use of mosaic, painted and fired terra-cotta tiles, porcelain enameling on iron sheets, carved bas-relief in stone painted in flat colors that can be replaced when worn or discolored, and integrally colored Portland cement. Another possibility lies in the fresco-like results obtained from some of our modern synthetic materials which are at present in the development or experimental stage, notably the use of ethyl silicate and the silicones.

Acrylic polymer for mural painting. As noted on page 171, the acrylic paints, in use for little over a decade, do not as yet have a complete set of standard do-and-don't regulations, and at the present writing this application may be considered experimental. There is no reason to believe that acrylic painting on walls will not survive at least as well as oil painting, with one precaution. Although these paints are regarded as insoluble or water-resistant, the acrylic polymer film has a certain degree of porosity or permeability. If painted on a nonabsorbent surface, water, seeping through the colors and primer, will dislodge the

coating; if the surface were completely nonabsorbent, as glass, tile, enamel, or smooth metal, one could strip away an acrylic polymer layer clearly in an unbroken film by wetting it. Making sure that the primer is applied over a surface that has sufficient absorbency or porosity to hold it might be a way to insure its resistance to the periodic cleanings that murals usually require. A final coat of clear acrylic varnish would be a further safeguard.

Encaustic

Encaustic is a method of easel or mural painting, on any ground or surface, with paints made by simply mixing dry pigments with molten, white refined beeswax. One of the oldest of painting techniques, it was used extensively in ancient Greece, and the surviving Fayoum portraits from Egypt done in the second century attest to its permanence. Fluently executed portraits have survived, strikingly fresh and brilliant, when preserved under conditions that have protected them against mechanical wear and tear.

The usual method is to place the wax colors on a warm palette, then paint directly on a warmed surface with brushes and heat-resistant, spatulate implements. The strokes can be worked over, refined, and smoothed with warm implements; if ground and palette can be kept within the proper range of temperature (not too hot and not too cool), fluent and easy painting can be done in a direct, fresh manner. The term "encaustic" was taken from a Greek word meaning "to burn in," and the classic or standard method is to pass a heat source over the colors after they have been applied, in order to fuse the surface into one homogeneous mass, without overheating so that the colors do not run into each other. It is the consensus that no kind of wax painting may properly be called encaustic if it has not included this final burning-in treatment.

The brilliance, color, and textural effects are quite distinctive and lend themselves well to several modern tendencies in art; this accounts for a small but growing present-day revival of interest in this ancient method.

Encaustic became a lost art at the time when the kind of picture in demand was the egg tempera type, and it never regained its popularity as an art medium because of the cumbersome and unwieldly equipment required in the days when charcoal fires were used as the sources of heat. By adapting modern electric heating units to the purpose, it has been made possible to improvise reasonably simple arrangements by which the correct warm temperature of paints and ground can be maintained and the work done easily and without complications.

Wax, as previously mentioned, is one of our most permanent and chemically inert binding materials, but its film is more tender than that of an oil painting and must be preserved against wear and scratching.

The effect of a robust and full-bodied paint quality can be obtained without much actual heavy impasto, with smooth films of wax colors. If polished with a soft cloth, the surface takes on a pleasing dull sheen, and such a surface repels dust better than oil paint. Most investigators of this traditional or "classic" method recommend melting in varying amounts of resin with the wax to increase hardness.

Wax color is a clean material to handle; palettes, vessels, and instruments may be quickly and thoroughly cleaned by warming them and wiping off the color with a cloth. The brushes do not have to be kept spotlessly clean if each one is reserved for a separate color. Care must be taken not to overheat or singe the bristles. One can go through the entire procedure without the use of solvents; when a solvent is necessary, carbon tetrachloride has been recommended as the best. But take warning—it is toxic and must be used in good ventilation, preferably outdoors.

Many variations and modifications of the traditional encaustic process have been proposed by artists and by students of old techniques. Some of these have been presented as authentic versions of the original methods and others as inventions or improvements. Additions of a wax harder than beeswax, such as carnauba, or a softer one, such as Japan wax, are modern suggestions.

Oils and resins have been mixed with the wax; wax soap or emulsified waxes have been recommended, but none of these procedures is founded on completely reliable historical data. During an eighteenth-century revival of encaustic, a proposed method was advanced which gave quite interesting results. This method consisted of warming the surface of a canvas or panel and then coating it by rubbing it with a cake of white beeswax. The surface was dusted over with dry chalk, and the picture painted with pigments ground in plain water—the chalk permitting the watercolors to take on the waxy surface. The colors were allowed to dry, and then the work was brought near enough to a heat source to soften the wax (either by moving the picture or the heating unit), whereupon the softened wax surrounded the pigment particles, bringing out their full color value and encasing them in a protective film of wax. If a horizontal position is maintained (either face up or face down), wax colors will not run unless grossly overheated. Such a surface is much more tender and subject to damage than that produced by applying pigmented wax to the surface. Another variation was to paint on linen with water-vehicle colors, coat the rear with beeswax, and drive the wax through the canvas with a warm iron so that the colors became impregnated with it.

In mixing wax (or wax-plus-resin) colors with pigments for the usual or "classic" method, one of the principal points to be kept in mind is the proportion of pigment to wax—which, like that of pigment to oil, varies with each pigment. If there is too much pigment, the warm paint will not remain fluid long enough to give satisfactory brushing

qualities; if there is too much wax, the finished paint will be tender and will not resist the softening effect of a warm climate the way well-proportioned wax colors do to a remarkable degree.

All the pigments listed under the permanent oil painting palette on page 34 may be used in encaustic. At the present time, the practice of encaustic painting is hampered by the lack of reliable published data on its details, and some well-directed systematic research toward this end would be a welcome addition to our fund of information on painting techniques. Until then encaustic will continue to demand a certain amount of experiment by the painter.

Aluminum hot palettes are available; a homemade one can be made by mounting a sheet of steel or thick aluminum about 6 inches above a double-burner electric stove. Or an aluminum palette can be the cover of a box containing electric light bulbs as the heating element. A regular reflector floodlight or an infrared of the therapeutic variety can be used for the burning-in. Mounted in a metal reflector with a clamp or a wooden hand-grip, it can also be used to warm either the rear or front of the canvas while it is being painted, or it may be held in the left hand and moved toward or away from the surface to liquefy or congeal the area being painted.

SYNTHETIC MEDIUMS 10

Since the earliest recorded days of painting and sculpture, artists have searched continuously for new materials to create new pictorial effects in order to keep abreast with the ever-changing ideas and developments in art forms, and to improve the utility of traditional materials. In our own day there seems to be a greater incentive to seek out new discoveries than ever before, for many contemporary painters have aims that go far beyond the horizons of earlier generations, and at no time has there flourished a greater number of diverse schools of art. But specialists in paint technology remember that the history of creative painting abounds with examples of premature adoption of promising discoveries which at first sight seemed to meet the requirements for permanent painting, but which eventually resulted in relatively early failures. Familiar examples are the complex cooked oil and resin mediums of the eighteenth and nineteenth centuries and the early twentieth-century improvements in the color stability of aniline colors, which did not go far enough to prevent them from fading in a few years. New materials are now evaluated with a scientific eye, and nothing is put on the approved list that has not been tested and found to meet all foreseeable contingencies.

The two principal materials under investigation by artists and paint chemists in our own times have been brilliant synthetic organic pigments, vastly improved over the older ones in lightfastness, and the synthetic resins, a class of manufactured chemical products that have properties that have enabled them to replace almost all the older tree resins in the field of industrial coatings. The synthetic resins processed into solid forms are commonly known as plastics.

Lacquers. Historically the plastics go back to the late nineteenth century, beginning with the introduction of celluloid and its solutions, cellulose nitrate, and later cellulose acetate, used to make both clear and pigmented coatings known as lacquers. These cellulosic or pyroxylin lacquers are still used in large quantities for industrial spray coatings, especially on automobile and other assembly-line products where their high speed of drying makes them preferable to other synthetic resin coatings. While these other synthetic resin coatings have greater durability, their lengthier and more elaborate methods of application disqualify them for production-line use. Since their early days lacquers have been vastly improved, mainly by reinforcement with other synthetic resins, and an automobile finish now does not fail until after it has served a reasonable number of years, so it is not really necessary for them to have the more durable and expensive coatings that are applied to such objects as typewriters, bicycles, and military items.

Despite the universal rejection of lacquers a few artists continue to believe that the modern improved lacquers and lacquer enamels are sufficiently permanent. Much of this survival is, no doubt, due to the fact that the use of these materials was originally pioneered by celebrated American and Mexican painters of the 1920s, and artists who emulate their effects have not always realized that great modern painters were not necessarily knowledgeable technicians. Like any other ready-mixed coatings that are designed for industrial and household use, they contain additives that detract from their longevity and they employ pigments that will eventually fade. Many of the pigments used for the bright colors are of the bleeding variety, and they are formulated to give their best results when applied in thin layers of controlled thickness. Industrial coating materials are expected to fail eventually; artists' paints are expected to last forever.

Alkyd resins. During the 1930s the oil-modified alkyds were investigated for artists' use; their brilliant performances in high-grade house paints and varnishes gave promise that they would be superior replacements for the older oleoresinous mediums used as additives in oil painting, and perhaps improve the traditional oil technique in other ways. Interest in them seemed to wane during the 1940s, perhaps because the development of a completely new system of painting (the acrylics) was more attractive to the paint manufacturers than the improvement of an old one. The best types of alkyds are non-yellowing, confer good manipulative properties on oil colors, with which they are entirely compatible, and enhance permanence of adhesion and resistance to embrittlement. We shall almost certainly hear from them again in the future.

Acrylic (methacrylate) resins. The synthetic resin solutions of the plastics known as Lucite and Plexiglas are sparklingly clear and water-white; they do not crack or change color on long indoor exposure. A few varieties of methyl methacrylates are completely and easily soluble in turpentine and mineral spirits; these have been in use as excellent final picture varnishes (page 108) for nearly a half century and in widespread use for a quarter of a century. The success and easy availability of this material has prompted some painters to "experiment" with it (see page 173) as an oil-painting medium. However, the specialists do not consider it really compatible with oil, and what will eventually happen to oil paintings that contain it is unknown. Clear acrylic solution has also been used as a vehicle in one line of artists' "plastic" paints (Magna colors), miscible with turpentine or mineral spirits. These dry rapidly to a mat finish and are so soluble that a vinyl isolating varnish is sold with them so they can be overpainted or varnished. The Magna varnish can be used as an isolating varnish in oil painting. However excellent these paints may be for a number of purposes, it is a fallacy to call them compatible with the drying oils.

Polymer paints. By far the greatest employment of the synthetic

resins in artists' paintings has been the extensive commercial development and promotion of colors ground in colloidal water dispersions of acrylic and vinyl polymers. A polymer is a variation of a normal chemical compound, with the same proportional composition but with a different molecular weight. The use of such a broad term as polymer to designate these particular paints (most organic film formers, including linseed oil, are polymers) may be explained as originally being an effort to clarify the difference between them and the clear acrylic resin solutions. However, there hasn't been much confusion here, and a great many people refer to them as "the acrylics." The resin in these vehicles is dispersed in water, in the form of microscopic particles, akin to the oil droplets in the emulsion described on page 121. Painting is done by diluting the colors with water or the medium, and when the paint dries the particles coalesce to form a clear, insoluble, waterproof paint film. The first paints to employ the polymer binders were made with polyvinyl acetate, which was followed by methyl methacrylate (acrylic) polymers either alone or mixed with vinyl polymers. Sold under a number of trademark names, in jars, tubes, and squeeze bottles, these paints are easy to use, dry immediately, have an almost rubbery flexibility and a pleasing gloss; their color or tonal effect has a brilliance that cannot always be equaled in oil paint. Basing their claims on the success of these resins in industrial paints, the artists'-material firms state that these paints will never turn yellow or lower in tone and that they will retain their elasticity on aging. Like any other water-thinned paints, they cannot be manipulated and blended like oil paints, and so are not useful for the painter who needs the oil-paint kind of handling to get his results. The acrylics became enormously popular during the 1960s because of their desirable properties.

A typical way to handle the polymer colors that come in tubes is to use a sheet of plate glass as a table-top palette, and to keep a container of water handy to rest the brushes in, for once they become hard, a paint-remover type of solvent (sold with the colors) is necessary to remove the dried paint. The glass palette is cleaned with a razor blade which easily strips away the dried paint.

The kind of polymer colors that comes in jars is markedly thinner in consistency compared to the more buttery consistency of the tube colors. These more fluid colors may be handled by dipping the brush into the jar. It is economical to wipe the edges of the jars clean and replace the caps, but if, during use, the jars remain open long enough to skin over, the supply of paint is not injured and can be used after the whole skin has been picked out. The tube colors are liked by painters who want the impasto, "juicy" oil-painting effect of rugged brushstrokes; the jar colors are equally in demand by those who use the more fluid, smoother techniques.

Polymer adjuncts. A number of items are sold with each brand of polymer colors. These include:

Polymer Primer. Used to prepare canvases and panels. American makers have followed each other in labeling the primer "gesso," which has proved quite confusing, for it is not gesso at all and cannot be used for any of the other uses of true gesso, as defined on page 74. However, above the word "gesso" on the label, there is usually the brand name in small type, so the material should be called XXX brand gesso instead of just plain gesso, which it ain't. Colors may be thinned with water alone to a certain extent, but if this is done excessively and the coating made too thin, it will be too weak to support overpainting—the upper layer may crack, flake, or peel. Thin layers of color must be strengthened by adding medium. This point is one of the few well-known precautions to avoid failure in acrylic polymer painting. The medium, added in the proper amounts, also serves to assist in securing watercolor-like or gouache-like effects and approximating the effects of oil glazing.

Medium. A white, milky liquid which is contained in the colors. Its principal purposes are to thin the colors and increase their fluidity and to act as a final varnish over a painting.

Mat medium. Of similar appearance but containing a flatting agent is sold as mat medium, which, when mixed into the colors, gives a mat or semi-mat effect. The mat medium is, in general, more successful in the top layer of painting than when used in undercoats, where spotty effects may result. Mat medium is also used as a final protective coating for collages and other paper constructions.

Modeling paste. A stiffer variant of the white acrylic media sold as polymer "gesso"; it has the consistency of stiff putty and is useful for building up textures and for other purposes where plasticity and the property of staying put is desired.

Retarder. Each brand of acrylic polymer colors also puts out a retarder, which delays the drying of the colors so that manipulations and the alteration of brushstrokes may be prolonged. The colors, however, cannot be manipulated to the same extent or with the same result as oil colors can.

Gel medium. Another product that is sold with the colors is a special gel medium that increases the viscosity of the colors so that they can more readily be used for heavy impasto effects similar to those of oil painting. The gel is also useful for diluting the modeling paste without much reduction of its viscosity. It is said to be close to the acrylic medium in composition and therefore not likely to cause difficulties, as may be the case when jellied oil mediums are employed.

The careful painter who has a good knowledge of his materials, who adheres to sound principles, and who uses approved, time-tested paints will not discard them in favor of newer, less proven systems without good reason. It is not wise to adopt the newer materials simply to be up-to-date, or "in tune with modern technology," but they are to be used because they have special properties that are not duplicated by the

traditional materials and performance characteristics which the older ones lack. The experimentally minded painter is justified in the use of promising materials that have not yet been completely standardized, especially when they have no proven faults and when the older, approved materials fall short of serving his aims and purposes.

Among the outstanding attractive properties of the polymer paints are the quick drying and the special handling of a water medium, a new and special kind of tonal brilliance (appearing even more vivid dry than wet), and the great variety of effects that can be had from the colors, diluted only with water and its own vehicle as a medium. It can be manipulated to be opaque or transparent, thick or thin, glossy or mat. The polymer colors are definitely not a substitute for oil colors in the kind of painting that calls for any degree of finesse in fusions or gradation of tone and the general freedom of manipulation that the oil medium affords, but its water-paint handling makes it eligible to replace or duplicate the effects of casein paint and to approximate some of the effects of tempera, watercolor, and gouache.

Adhesives. The polyvinyl adhesives sold as milky liquids have the good property of long-lasting flexibilty, which suits them for use in collages on canvas and for the joining of cloth and other nonrigid substances. However, for joining such things as panels and wood strips, the older casein and hide glues, as well as the newer epoxy cements, are perhaps more desirable because they create rigid joins. Joining with casein and hide glue requires the pressure of strong clamps: with epoxy cements a good contact is all that is necessary.

Unknown qualities. At the present writing, after a relatively short period of use, the polymer paints seem, in general, to have lived up to expectations. But we have few instructions or precautions to observe in order to create the best conditions for their survival, as for example, the data which we have accumulated during our six-hundred-year experience in oil painting. We do not know about such limitations as how thickly the paint may be piled up without subsequent cracking or wrinkling, or how varied in thicknesses the brushstrokes can be in a painting. One point of difference among manufacturers' instructions concerns the combining of polymer colors and oil colors in the same painting. The dubious adhesion of oil and polymer layers, as has been experienced in industrial coatings, should give the artist pause. It has been said that permanent adhesion of oil colors to the polymer primer or over a polymer underpainting can be assured if one first roughens the surface by rubbing it with 6/0 sandpaper or 000 steel wool. But if our expectation that polymer paint will retain its excellent flexibility for many years is correct, then a layer of oil paint over it would be liable to crack and lose its anchorage, for we know beyond doubt that oil paint is subject to progressive embrittlement as it ages. When the procedure is reversed—that is, when polymer is painted on an oil canvas, or over

171

oil underpainting—roughening the surface would undoubtedly assist the adhesion, but it is not known whether this would be a sufficient improvement to assure the survival of these dissimilar layers over the years. There is no reason to believe that polymer paintings are an exception to our old rule that all paintings must either be protected by a film of easily removable picture varnish or be framed under glass for protection against the incrustation of dust and grime over the years.

Jelly mediums. The failures resulting from the use of megilp (see page 102) in the eighteenth and nineteenth centuries caused artists to shy away from the assistance of jelly mediums which enhance the manipulative qualities of oil colors or reduce their opacity or make them dry rapidly. But in our own time, on the theory that a jelly medium will give permanent results if it is composed of good materials that do not have the inherent faults of the older ingredients, artists'-material firms here and in Britain have placed modern jelly mediums in tubes on the market. The composition of few of these materials are ever identified by their makers and so no one can evaluate their permanence. There is also a strong possibility that jelly mediums made of ingredients whose properties are good might still fail because of the underpigmentation of their films. A paint layer of normal or greater than normal thickness requires the structural reinforcement of a substantial amount of pigment particles in order to prevent shrinkage, wrinkling, and other defects that are typical of sparsely pigmented films. Oleoresinous glazes are also underpigmented as compared with straight oil colors, but they survive because their films are so thinly and uniformly applied. None of my criticisms of oil-paint gel mediums apply to any such materials made on a water base and designed to go with the acrylic polymer colors or watercolors, which apparently do not often develop faults.

Special whites for textured effects. Scholars have noted certain outstanding crisp impasto touches in various oil paintings of the past, particularly in Dutch paintings of the seventeenth century, that defy reproduction with ordinary oil colors, and that undoubtedly were done with a white paint of a different character from that used in the rest of the picture. The most successful past reconstruction of these effects with a paint that seems to handle in the way the original did is to mix two parts of flake white oil color with one part of flake white tempera, preferably egg tempera either bought in tubes or homemade. (Note precaution for handling dry flake white on page 37.) When mixed thoroughly with a spatula or palette knife, it can be used straight or thinned with turps, and the paint will retain the crispness of its brushstrokes.

In recent years textural whites have been put on the market by several firms. The typical one is dryish in character and dries rapidly to a rather coarse, grainy, mat surface. So far, these materials have not been recommended by painting specialists; for one thing, the composition of none of them has been divulged; as secret proprietary materials there is no telling what ingredients or methods have been used to create

these properties. Second, the reduced toughness, flexibility, and adhesiveness of these materials (as compared with oil colors) make their use over large areas, as in underpainting, seem risky, for there is a great difference between the use of such materials in impasto touches and spreading it out like the icing on a cake. Third, a dryish paint which sets quickly to a dry top surface will act the same way at its under surface, where it meets the canvas; there is an absence of the adhesive stickiness that is necessary for an oil-paint film to have good anchorage to a surface. The risk would be far less and probably altogether absent when such whites are used sparingly, for occasional touches, and because of their relatively spongy, not-too-flexible nature, they should fare better on a rigid panel than on a canvas when used liberally throughout a painting.

Dangers of haphazard experiments. The artists'-material manufacturers are continually on the alert for new synthetic resins at low costs, the makers of these resins are anxious to sell them, and both employ chemical and technical experts who work full time at their development. The painter without technical training and experience who expects to save money by making his own "discoveries" with synthetic resins is not only presumptuous but also at a great disadvantage. The museum technical people tell us that they have more trouble with modern paintings going bad by reason of the misuse of modern materials than they have with ancient ones. The great majority of industrial resins have been rejected by the experts because of obnoxious odors and toxic effects of their poisonous solvents. Quite a few cases of serious poisoning among "experimental" painters and sculptors have been recorded in recent years, and the disappointing results of pictures going bad in a very few years from this cause have become quite common. The careful painter will use only the products made especially for artists, and if he makes his own he will use only the approved and standardized materials.

Most of the raw materials of the traditional recipes are available to artists, but the raw materials of the modern synthetic coatings industry are not so readily to be had at retail; most of them require specialized training to handle them and formulate with them. They are not manufactured to be sold to the public. Regular artists' supplies are designed to present no health hazards when used in a reasonably competent manner by a user who has no abnormal sensitivity or allergies.

STUDIO AND EQUIPMENT 11

There are a number of elementary, basic procedures, conventions, and habits that an artist acquires in a casual or accidental way on entering his career. Some of these seem so natural and simple that they are seldom treated as points of instruction, since the artist becomes acquainted with them by observation, by experience, and through chats with fellow artists, on which occasions such matters have always been favorite subjects of conversation and argument.

Some of the topics discussed in this chapter may appear to be of minor importance, since they refer to the artist's comfort and convenience rather than to the technical problems of paint, but comfort and convenience are by no means minor considerations. Successful work can be and has been done under the most unfavorable surroundings and with the most inadequate equipment; however, painting presents such problems and difficulties under the best of conditions that the first rule on beginning to paint is always to get comfortable and to take advantage of as many physical conveniences as are available.

THE STUDIO

An ideal painting room has always been designed with a north light and with an absence or minimum of outdoor obstructions. The light from the north is steadier, more constant, and less glaring throughout the day; eastern exposure is second best because the glare diminshes early in the day; a southern exposure is more uniform throughout the day, and perhaps better than east or west, if the window has a white muslin curtain across it to keep out the glare of the direct sun. However, some painters do not object to their light being glaring and changeable; they seem to be able to get along under conditions that would be intolerable to others.

Studio windows are large because the average painter requires a large area of his room to be evenly illuminated, not just a little spot. They are large because he wants *intensity* of light as well as quality and because it requires a large area of window surface to illuminate the painting area on dull days and in late afternoons. The argument over the advantages of overhead skylights versus side windows has been going on for many years, and it seems to be a matter of personal preference or to depend on the type of work being done. However, a skylight is most desirable when a studio is adjacent to taller buildings or other obstructions to light. Reflection of light from buildings, trees, and other objects can color the light, and windowpanes that reflect the sun can be quite annoying.

As for artificial studio lighting, progress has been steady during the past thirty-five years or so, since "daylight" lamps began to come into use, and I can now tell a different story from the one I told in the last edition of this book, when the best solution to the problem was a mixture of two different sources—an incandescent bulb (say a 150-watt reflector flood) and a blue daylight bulb or white fluorescent tubes, or simply a mixture of tinted fluorescent tubes. Whether artificial studio lighting is a makeshift to be used from necessity when a north-light studio is not attainable or whether it is better than daylight is a moot point. Some artists will work only by daylight; others, backed up by scientific optical specialists, tell us that this is mere prejudice combined with a psychological element and the conditioning of habit, and that a painter can easily adjust to the change from daylight to modern lighting. Also, they argue that, because of its uniformity and control of color quality, modern artificial studio lighting creates working conditions more efficient than the variable and unreliable circumstances that nature offers.

The lights that seem to have solved the problems of studio illumination to the satisfaction of most painters and sculptors are the color-corrected fluorescent tubes. One, called "critiColor," available from the Verd-A-Ray Corporation, 615 Front Street, Toledo, Ohio 43605, as well as some other makes, have been on the market since about 1967. Their appearance is no different from ordinary fluorescent tubes; they come in the same lengths and they fit the ordinary fluorescent fixtures. The inner surface of the glass tube has a coating that filters the light to a very close match to daylight over the entire spectrum, and it gives a quality of illumination that is agreeable to work under. Color-corrected tubes are widely used, not only in artists' studios but also in industrial applications, such as for color-matching in factories where accurate and uniform production is a necessity. In order to secure the intensity of illumination that is satisfactory for most uses, most painters will find that a longer or a larger number of tubes will be required than with regular white fluorescents. My own four ninety-six-inch tubes in an ordinary fluorescent fixture hang nine inches from the ceiling of a room nine feet high—that is, about one hundred inches above the floor. The tubes are five feet in from the windows. I can paint by window light until the daylight fades, then switch on the tubes and continue painting without being bothered in the least by the change.

Ambience. Although he frequently makes an effort to create an atmosphere of taste and comfort in his studio, the modern earnest professional painter is more likely to be found in a rather bare, utilitarian workshop, free from both the disorderly clutter or the salon-like over-decoration of the recent past. His tools and equipment are well cared for, kept under cover as much as possible, and the room is arranged so that it can be periodically cleaned without disturbance.

Dust. The combination of dust, soot, and fog which envelops large

175

106. Red sable watercolor brushes.

107. Bristle brushes.

towns and cities is a condition with which the painter has long contended. At some future date he may inhabit completely air-conditioned rooms, but at present dust and soot are more a bugaboo than ever, and each painter must work out his own arrangements for their control.

Ventilation. The dust menace is also complicated by the need for ventilation beyond the normal necessity for indoor work, especially because the presence of vapors from volatile solvents, dust from powdered pigments or pastels, and odors from paint make a continuous supply of fresh air essential.

Privacy. Whenever possible, the painting room should have provisions for maintaining privacy. Although the artist may not object to having company while at work and may not be concerned about being occasionally interrupted, he usually finds that eventually there come times when intruders and distracting movements must be shut out; and so, in choosing a painting space, an arrangement that permits the enforcement of privacy is desirable.

IMPLEMENTS AND EQUIPMENT

Brushes. The brushes used by the artist are sensitive tools, the products of a highly developed craft, with a history as long as that of the colors and paints he uses. Brushes are more than just little bundles of hairs or bristles stuck into metal ferrules or quills and attached to wooden handles. The making of best-quality brushes, both for artists'

108. Red sable oil-painting brushes.

109. Badger blending brushes or "sweeteners."

and for house painters' use, is an art which involves highly skilled manual operations as well as the selection of superlative materials. Hence, they can be obtained only from a limited number of sources, and the procurement of good brushes is generally one of the painter's first concerns. Like the instruments or tools of any craft, those of highest quality will give superior results, and if not abused they will outlast the inferior kinds and make their initial expense a worthwhile investment.

The painter must not stint himself on either quality or quantity. He should never buy a poor brush, and whenever he has the opportunity to buy a few fine ones, he should do so, even if it limits his purchases of other supplies; he should try to accumulate dozens of them. Very often, a brush that has been broken in by use and proper care will suit the artist better than a new one; if he has plenty in use and new ones in reserve, his favorites will not wear out too soon. If he has all types and sizes on hand, he will always have the one most sympathetic to his purposes when he needs it.

For normal use in all our accepted methods of painting, both bristle brushes and the softer hair brushes should possess a liveliness or springiness which the cheaper brushes usually lack. Their shapes should be symmetrical; the round ones should come to a fine point and the flat ones to an even edge. The careful purchaser tests these qualities by examining them closely.

The point of a brush is never cut or trimmed; the exposed ends are the natural tips of the hairs or bristles, and the shaping of a brush

177

110. Single-stroke and fan brushes.

111. Single-stroke lettering brushes.

is done by careful setting of the opposite ends during its manufacture. The hairs or bristles used in a good brush are sometimes twice as long as the visible portion that extends out of the metal ferrule.

Bristle brushes. For oil painting, brushes in either round or flat shapes made of bleached hog bristles (Figure 107) are generally used. In order to insure against the outer bristles of the round and the corners of the flat brushes splaying out to an undesirably ragged and uncontrollable fringe, incurving bristles are used at these points. The flat shapes are a comparatively modern innovation; prior to the mid-nineteenth century when the preference arose for more buttery, less fluid colors, painters seldom, if ever, used anything but round ones. Flat brushes are more versatile and convenient, especially with the pastier, less fluid paints preferred by most painters today. Besides the regular flats, a shorter-bristled, thinner variety called brights is also in use. There are two number eights in Figure 107; the one on the right side is a bright, the one in the center a flat. Another kind of bristle brush in less frequent use is the oval or filbert (Figure 107, extreme left), a flat brush with tapered rather than square corners; it resembles somewhat an old brush with worn-down corners.

Sable brushes. For all the water mediums, red sable watercolor brushes (Figure 106) are first choice. The so-called camel's-hair brushes and those made from other hairs which are limp or less springy in character than red sable—for example, squirrel hair—are less suitable for normal watercolor painting, but they have their occasional uses for various effects and preferences. Red sable is also used in brushes for oil painting, especially for smoother, blended, or less vigorous stroking; these are ordinarily designed with shorter hairs and longer handles than the watercolor brushes and are obtainable in both round and flat shapes (Figure 108). The kind called flats come to a

178

rather blunt point, almost like an oval or worn flat-bristle brush, and the kind called brights have more sharply squared edges.

Ox hair has a firmer and more springy character than sable; it is often blended with red sable for second-grade brushes. However, the blend is frequently preferred in the single-stroke brush (page 180), and straight ox hair is used in preference to sable for very large brushes like the architectural rendering brush which comes in size 28 or 30, a giant round watercolor brush that some painters find indispensable.

Few handicraft products are uniform, and watercolor brushes are no exception; the purchaser will find that while all the brushes in a lot of highest quality are acceptable, individual ones will vary slightly in sharpness of point or symmetry of form. In the case of the round, pointed brushes, it is customary for the artist to try out a few of the size he wants, and using the container of water that the dealer usually has on his counter for the purpose, moisten them, shake them out, and examine the point, the shape, and the resiliency in order to select the ones best suited to his purposes. Note the desirable features to look for, under *Brush terminology and characteristics* on page 181.

As a rule, first-class bristle brushes for oil painting are more uniform, and there is less choice between the individual brushes in a lot; their quality can be best judged after they have been put into use. In selecting them, one ordinarily depends on the brand name and the dealer's information. It should be noted that new brushes often have a bit of starch or very weak glue in them in order to keep their shapes from being distorted or damaged in handling, and so, in the shop, the inferior ones may be as good-looking as the fine ones.

Although the finest brushes for artists are usually well finished—their handles and metal ferrules showing evidence of high quality and workmanship—brushes cannot always be judged by their finish. Sometimes fine brushes will be found with very simple handles, whereas sometimes the handles of poor brushes are attractively polished. Some brushes are set in the old-fashioned manner in quills instead of in metal ferrules; these require mounting on pointed wooden sticks which are supplied with them. Quill brushes are not so widely employed as they were formerly. Very fine red sable, as well as more commonplace grades, are made.

Other brushes. A perusal of the brush section of an artists'-material catalogue or the examination of a dealer's stock will reveal the existence of a huge number of special-purpose brushes, some of which are extremely useful, although they may have been designed for use in other crafts or for artists' manipulations that were more popular in bygone days. Among these is the *badger blender* (Figure 109), which is meant for softening or "sweetening" the gradation between two areas of different shades or hues. It resembles a shaving brush and is intended to be used *dry and clean* with a vertical pouncing or tapping motion on wet paint, the painting being laid flat on a table. The texture produced is very smooth or else finely stippled.

Riggers (Figure 111) are springy, round, red-sable lettering brushes with blunt ends and usually rather long hairs. The small sizes are useful for thin lines. In America the name also refers to the size and proportion of this particular type of brush, which has a bulge or belly like the pointed watercolor brush but is blunt or straight-edged instead of pointed. The rigger is a favorite lettering brush; some painters also find it useful.

Single-stroke brushes. The red-sable single-stroke brush (Figure 110) is an extremely versatile watercolor brush. It comes in several fractional-inch sizes up to one inch, and the wider sizes, the less-expensive second-grade sable, which contains some ox hair, are very often preferred for their firmer, springier touch. Holding the fully loaded brush upright tends to create a dense, covering stroke. Holding it flat with the tip of the handle in the direction of the stroke tends to give a sparse, dry-brush effect. A rapid stroke also tends to give this dry-brush effect, and a slow one the solid dense result.

The finest kind of lines can be made with the *edge* of this wide brush by holding the handle so that its tip points in the opposite direction of the stroke; thus the individual hairs will trail out to a thin line. If the brush handle points in the direction of the stroke, the edge hairs will bunch up instead of trailing out, creating a thick stroke with its top edge sharp and its bottom edge rough.

Varnish brushes. Wide, flat brushes of the types illustrated in Figure 78 (page 112) are the most suitable for varnishing paintings and for applying gesso (page 78); their bristles are long and flexible. The thin types are the best, but when they are not available in good quality, the regular house-painter's varnish brush of thicker construction may be used. One kind, called the cutter (or sign-painter's cutter), has a chisel edge—that is, its bristles are beveled to a thin edge instead of being of full thickness at that point. Their handles are customarily unvarnished wood. The most annoying defect of a varnish brush is shedding of bristles; purchase of an inferior varnish brush is just as much false economy as is the selection of an inferior artists' brush. Stability of bristles, resiliency, and symmetry of shape are the characteristics of a good varnish brush.

The careful painter reserves his varnish brushes especially for varnishing, and when not in use he protects them by wrapping them in paper. They must be kept scrupulously clean not only for the sake of clean, speck-free varnish, but also because an accumulation at the base of the bristles will rob the brush of much flexibility and may cause bristles to break at this point. Some painters do not approve of washing them like paint brushes, but simply rinse them repeatedly in small portions of clean turpentine, shaking them out well, and changing the turpentine between each rinsing.

Brush sizes. The sizes of brushes are almost completely standardized, but occasionally there will be a discrepancy in some imported lines. The numbers assigned to the various sizes, however, are not the

same for each type of brush; for example a number 12 watercolor brush is nothing like a number 12 bristle brush. Some specialty brushes use special numbering; for example, some types of quill brushes are numbered in reverse order—that is, the highest number designates the smallest brush. Another group is named after birds: swan, goose, crow, and so on. The single-stroke brush is graded in widths; the one illustrated (Figure 110, top) is marked 1″.

The tiniest brushes have their uses and are invaluable in specific cases, but in general the artist prefers to use the largest ones he can. He prizes the big ones not only because they are more expensive, but because they give better results. They are usually the mainstay of his work, and the smaller ones are supplementary.

Care and cleaning of brushes. There is no point in going to the trouble of selecting fine brushes with care and discrimination unless they are to be treated with the care and respect such valuable instruments deserve.

As far as is compatible with the purposes of the painter, painting should be done with the forward portion of the brush. No brush, including the house painter's, should be continually plunged into the paint up to the ferrule, but the material should be taken up by the front part of the bristles. This not only allows of cleaner, neater, more efficient application but also makes for longevity of the brush. Paint that works its way into the root of the bristles or hairs and into the ferrule is extremely difficult to remove by ordinary cleaning methods. If the paint dries or becomes permanently caked there, the full usefulness of the brush is impaired. Of course it is not possible to conform to this rule in all cases, but the careful painter bears it in mind and tries to avoid unnecessary clogging.

Brushes of all kinds should be wiped, rinsed with turpentine, water, or whatever the solvent of the paint or varnish is, shaken out and wiped again as soon as is feasible after use. They are then washed with soap and running warm water; be careful to rinse out all traces of soap. The brushes are then "dressed" (squeezed out between the fingers and pointed) and laid away carefully to dry in a dust-free place.

If time limitations or other considerations make it seem desirable to keep the brushes submerged in turpentine, oil, or water in order to keep them moist, care must be taken to have them suspended freely in the liquid so their shapes will not become distorted by coming in contact with the container. Special holders for watercolor brushes are sold in the supply stores. For several reasons, long submersion in liquids is not the best way to preserve fine brushes.

Brush terminology and characteristics. Among the technical terms commonly used in describing the parts of a brush are the following:

The *tip* or *point* is the extreme end of the hairs or bristles. The natural tip of a red sable hair tapers to a fine point; the natural end of a bristle is forked; under a magnifying glass it looks like a tiny

112. Left to right: flexible wall scraper, 4-inch spatula, three palette knives, 6-inch spatula or factory knife.

branched twig. This is called the *flag,* and sometimes a manufacturer will refer to the entire tip of the brush as a flag. A close examination in bright light of the tips of a bristle brush will reveal these little twigs. The good working qualities of a brush are dependent on the good condition of these natural ends. The metal in which the brush and its handle are set is called the *ferrule,* and the point where the brushes emerge from the ferrule is usually called the *neck.* The best round watercolor brush should have a pronounced bulge about halfway between the ferrule and the point; this is the *belly.* When wet and pointed, no concavity should exist between the belly and the point. An extreme example of the shape generally considered undesirable or wrong for a red-sable watercolor brush is the "lemon-seed" shape assumed by most camel's-hair brushes when wet. The round oil-painting sable and bristle brushes do not have bellies; there is just a slightly outcurved taper from the ferrule to the tip. The *heel* of a brush refers to a shape it assumes in use, rather than to a part; for example, when a stroke is made with the side of a round bristle brush pressed rather firmly down on the canvas, and the principal point of contact is a firm, springy spot at a small but appreciable distance *away* from the ferrule, it is said to form a heel. A limp, floppy brush or one that is too stiff or rigid will not form a heel. Some painters rely on this sort of action; a rather worn, old brush is likely to have it, although one in which old paint or oil has accumulated at the neck is likely to have too much. The working quality of any brush is influenced by its tip; cutting or trimming a brush destroys its natural characteristics. In brushmaking, all trimming or shaping of hairs and bristles is done at the root end.

Palette knives. Figure 112 shows a group of the spatulas or palette knives that are essential studio equipment. All these should be of fine quality, well tempered and springy. The bluntly rounded type, No. 2 and No. 6, are most useful for heavy duties such as mixing pigments with vehicles and handling stiff pastes on the grinding slab; they

are also available in many other sizes. The tapered, more limber variety like No. 3, No. 4, and No. 5, are more suitable for handling or scraping paints on the picture and canvas. No. 5 has an angular tang designed to keep one's knuckles out of the paint, but to some may be considered a hindrance in other respects. No. 1, the broad blade with its edge at the front, is called a wall scraper in the hardware stores and is the best type of instrument for applying, scraping away, or spreading out coatings over large flat areas, or for handling larger quantities of paint on the grinding slab. Like the palette knife, it is efficient only if made of best-quality flexible, tempered steel. The cheaper, narrower putty knife of stiff construction, however, also has its uses about the studio.

With continual wear, the edges of palette knives will become very sharp, sometimes achieving a razor keenness. This hazardous condition can be avoided by watchfulness and occasionally blunting the sides with a file or whetstone, but when the knife edges wear exceedingly thin, they should be replaced.

Painting knives. (Figure 113.) The painting knife is distinguished from the palette knife by its extreme flexibility, springiness, and delicacy. Essentially miniature trowel-like implements made in a variety of shapes and sizes, they are intended to be used to deposit and spread oil colors on a painting *and for nothing else.* Painting knives are or should be sensitive, carefully balanced, fine-tempered steel blades; they are quite fragile and easily ruined if not given proper treatment. Although a thin spatulate instrument was used in one form or another by the ancients, especially the bronze *cestrum* used in encaustic painting, our modern delicate painting knife does not appear to have been used in European painting prior to the middle of the nineteenth century. Careful technicians warn against the use of oil color in excessively thick impasto (see page 116), and the painting knife sometimes tempts one to go too far in this respect. However, when it is thoughtfully and

113. Painting knives.

intelligently controlled, the painting knife can be a valuable instrument to secure various textures and effects that cannot easily be duplicated by the brush. Such pictures are known as palette-knife paintings.

Easels. There are many models of easels available; some are so adjustable that they will accommodate the size of the painting and the desired height without much effort; others are more troublesome. The artist usually tries to obtain the most efficient and complete easel for studio use and is limited only by his pocketbook in its selection. However, the first consideration in selecting an easel should be its rigidity and stability, since the prime necessity is that it hold the painting in a steady, motionless manner, without wavering or threatening to collapse. The larger models are generally most desirable; this does not necessarily mean that the very heaviest type is the best, but an easel must be in good, tight condition and designed so as to combine the maximum stability with sufficient adjustability.

Sketching easels. A very wide selection of portable folding easels for outdoor use will be found in the supply shops. Nearly all of them can be considered desirable for some requirement or another because for the most part their designs have been evolved as a result of long experience. However, artists have very strong preferences for certain types, and individuals usually make their selections according to personal requirements and the conditions of use.

Portability, which takes into consideration both size and weight, is balanced against rigidity, stability, simplicity, durability, and ease of operation. Experience soon determines the type best suited to the user.

Palettes. The surface on which the painter squeezes out the colors for his day's work and from which he takes them up with his brush to apply to his painting can be anything he chooses. He is not necessarily limited to the traditional oval or oblong thumbhole palette made of a thin hardwood board or any of its variations to be found in the dealer's stocks. He should, rather, select the kind of surface that is best suited to his way of working, the materials or techniques involved, and the circumstances or working conditions.

The regular thumbhole palette, meant to be held in the left hand, serves well in some circumstances, especially when the work is being done away from the studio or in a crowded classroom, but for studio use a large percentage of artists prefer to use a flat slab of plate glass, opaque white glass, or white marble, placed on a table next to the easel. It permits easier and more rapid color preparation and frees both hands for the work. Smaller pieces of plate glass, china plates and platters, cups, saucers, and tins may all be called into use on occasion. The color of the palette is of great concern to some painters; the modern tendency is to use pure white surfaces, and sometimes their hand palettes are lacquered white or some pale, neutral shade which they may prefer.

Painters sometimes become so accustomed to the use of a foul palette that they work with it in preference to a clean one, but this is

purely a habit and is to be discouraged on all grounds. Paint should never be allowed to dry and accumulate on the palette; it should be scrupulously cleaned away after each using. When there are appreciably large blobs of oil paint worth conserving, some artists collect them with the palette knife, place them on a small sheet of glass or on a saucer and submerge it in a pan of water. The water excludes the action of air and keeps the paint in usable condition. Any drops of water should be allowed to evaporate before these paints are replaced on the palette. There is some reasonable doubt as to the advisability of this ancient and widely used practice because of possible bad effect on the paint. Keeping the paint under refrigeration will also delay the setting of oil colors for a few days, but neither of these two procedures should be continued for a long time. The colors will continue to lose their freshness, adhesiveness, and durability, for their thickening is not suspended but merely retarded or delayed by these means, and upon removal they should be examined at room temperature for signs of loss of freshness. If they have thickened, they must be discarded for the reason discussed on page 93.

A great variety of useful watercolor palettes, plates, and dishes is available in the shops, and here, too, the user must select the kind best suited to his needs. The ancient painters, who made greater use of more fluid paints and lesser use of the pastier ones, used clam shells, small pots, and jars to a greater extent than the present painter, who usually prefers to spread his paints on the surface where he mixes them. White plastic dinner or soup plates make lightweight and satisfactory fresco palettes.

Mahlstick. The mahlstick is a slender, lightweight, inflexible wooden rod about a yard long and generally topped with a small ball which is intended to be padded by tying cloth or chamois around it. The modern ones are usually jointed like a fishing rod, and the better ones will have smooth, tight-fitting joints.

The mahlstick is not so universally employed as it was in former times, but it is a most useful implement, especially for those who work in detail or in small forms. Held with the left hand, its end resting on the edge of the painting or against the easel, it makes an effective hand rest so that details, thin lines, and carefully placed strokes can be done with greater precision. In the absence of the lightweight, professional implement, a hardwood yardstick makes a good substitute and becomes a multipurpose tool.

Storage of Canvas. It is customary to store average-size easel paintings on edge with a sheet of ordinary corrugated cardboard between each one; these may be cut from large shipping cartons or purchased in sheets. The material is ideal, easily cut, and it cushions the paint surfaces. Racks to store canvases on edge may be built against a storeroom wall out of 3-inch strips with 1½- or 2-inch strips for the dividers. An average arrangement for medium-size canvases is to have upright dividers 14 inches apart to hold 12 pictures in a section; larger

spaces may cause the pictures to lean too heavily unless the rack is completely full. Since at least as far back as the 1940s, artists have also been building their racks of angle-iron strips that bolt together, like industrial stock bins and storerooms; these are obtainable from factory supply sources.

GRADES OF ARTISTS' PAINTS

In the artists' supply shops one is usually confronted by a vast array of oil colors, watercolors, brushes, and other articles, which are confusing not only to the inexperienced but also to some mature painters who have become accustomed to specific brands of goods and are sometimes at a loss to decide, when called upon, to distinguish between unfamiliar makes and varieties.

The advice of all competent authorities and most experienced teachers is that, unless such severe financial limitations exist as to make their purchase impossible, none but the very highest grades of colors, brushes, paper, or canvas should ever be chosen either by students or serious painters. The difference between their working or manipulative qualities and those of the inferior grades is so great as to produce entirely different results; it has been noted, for example, in classes where groups of students attempt to work on new techniques, that the ones who have brushes of the proper quality usually turn out the best results as far as technical success and paint quality are concerned. The same is true of all other supplies and materials.

Three broad classes of paints are sold by the various artists'-material manufacturers. The first- or top-quality professional grade, sold at the highest prices, is supposed to be the finest material the manufacturer can put out—pigments carefully selected from what he honestly believes to be the finest available from worldwide sources; the oils, watercolor vehicles, or other liquids expertly chosen and compounded according to the most approved procedures. The grinding or other manufacturing operations for a first-rate paint are carried out with conscientious attention to secure the best results, and the entire production is kept under a rigid system of checks and controls.

In addition to their lines of materials that serve the creative painter, the art-supply shops are full of goods which, although they are excellent products that fill genuine needs and serve the purposes for which they are intended, are entirely unsuitable for permanent, creative painting. They are used by illustrators and others whose work is done for reproduction, where the original work has no function as a unique work of art; also in other practical and decorative branches of art where long-term permanence is not a factor. Such items as colored pencils and crayons, superbrilliant but fugitive colors, wood-pulp papers and boards, colored inks and markers that contain soluble dyes that fade, spray products not formulated for fine-arts use, low-cost

114 & 115.
Painting panel constructed of cardboard honeycomb in a wood frame and covered with museum board (rag board).

canvases and boards have often tempted painters to use them in easel paintings, drawings, and prints, with disastrous results.

Modern support materials. For the past five centuries records have shown that experiments have been carried on to meet the ever-changing styles and forms of art. Although the demands of art have been the moving force in the adoption of materials, the development of materials themselves has often presented attractive products to artists who have experimented with their use with such motives as economy or easy availability of supplies.

Artists have used modern materials such as the honeycomb material (Figures 114 and 115) shown here as a core, covered with rag board. This material is available in plastic and in aluminum. Another material, attractive to some artists because of its light weight, is a "featherweight" or foam core board that has smooth white surfaces and an inner core of urethane foam or similar material. As a board, it does not have much strength, and its age-deterioration qualities are unknown. As research on this subject is increased, we shall probably have new approved support materials in the near future.

187

Preferred brands of paint. For the most part, with hardly any exceptions, the *first-grade* lines of the well-known, widely distributed American manufacturers comply with the highest standards, and the differences between them are more likely to be those of personal judgment than of value since, naturally, there are as many opinions among the paint technicians as to what constitutes a perfect color as there are among artists. When it comes to the finer points, one will find quite a variation; one firm will believe that Indian red should be made of the bluest shade available; another will select an average medium bluish shade. One firm's medium cadmium yellow will be the equivalent of another's deep cadmium yellow. Some painters develop preferences for specific colors and buy one brand of burnt sienna, another brand of flake white, and so on, whereas others adhere to one entire make.

Furthermore, the top-grade oil colors are now more or less standardized in terms of basic, minimum quality. The National Bureau of Standards has established a set of specifications, Artists' Oil Paints CS98-62, to which oil colors should conform, and any tube of oil paint with a guarantee on the label that the tube complies with these specifications may be relied upon to be of acceptable quality. Paints that exceed these specifications would indeed be superlative in quality. The Standard is a voluntary agreement between artists' groups, manufacturers, and the Government. It quickly reformed a chaotic nomenclature that had plagued artists for centuries. Everyone should help maintain standard pigment names and discourage the use of fanciful ones (see page 32).

In evaluating the products of small, local, or new concerns, one must not be too prompt to condemn them, as it is entirely possible to make fine materials commercially on a small scale, and among such we find many entirely satisfactory products. However, it is well to remember that good intentions alone do not make good paints; experience over a long period of years in actual production is requisite, and the lack of sufficient resources to maintain uniformity of materials, experienced personnel, top manufacturing facilities, and rigid controls can be a great handicap to efficiency.

Second-grade colors. In addition to the top-grade lines of oil colors and watercolors, most of the larger manufacturers also put out a second-grade line under a distinctive trade name. Because there is a large class of users who have small concern with permanence and superior control, these products are an important item in the artists'-material trade, probably outselling the finer materials. The better ones among these second-rate products generally brush out well and have fair brilliance and strength, but they are inferior to the top grades. No restrictions or standards exist by which their quality can be controlled. If the manufacturer wants to cheapen a line of colors by using various extenders, or by using lower-grade pigments and oils or less expensive grinding methods, it matters little which course he takes; these paints

are not made for the utmost in permanence and performance that is expected of materials designed for serious creative work, and their habitual use is not recommended. For students' exercises, for paintings of a temporary nature, or for work intended solely for reproduction, their use is justified on the basis of economy.

Students' grade paints. A still lower grade of paints, sold at the lowest prices, is also to be found on the market. These are generally made as cheaply as possible with cost the prime consideration, and consequently they are of inferior quality. The "students' quality" lines often contain imitation colors, impermanent pigments and vehicles, and they are very weak in tinting power. It is doubtful that their habitual use is justified by serious students, on the theory that training in painting should be carried on with the same or nearly the same professional materials and implements as will be employed in more advanced work.

Modern attitudes on quality. Obviously, fine materials will not make a poor painter great; also no amount of care and success in technical details will make up for the lack of taste or other aesthetic virtues in art. These facts have led to a question in the minds of some painters as to whether the great emphasis placed on extreme qualities of materials and craftsmanship is not overdone; whether the statements of specialists are not a survival of a sort of unnecessary precaution, over-refinement, or preciousness. This reasoning is the sort of thing that led to the failures and the low level of technical accomplishment of the recent past. Our current standards are, as a matter of fact, based on a very practical basis. If one compares our present materials with those of former generations of painters, it will be seen that the element of preciousness has been entirely removed; even our most skillfully handmade products and our superlative grades are turned out in mass production as compared with the older procedures.

The regular high-grade industrial paints that are produced in bulk are no less carefully manufactured than the finest artists' colors, and although they are formulated to meet different specifications, the procedures for maintenance of quality and uniformity and the methods of control and testing are no different.

The artist of the past always realized that his brushes, colors, and canvases were, or should be, superlative in quality, and he accepted their greater cost as the necessary price one pays for materials that are beyond the run of the common merchandise of everyday use. The deliberate, habitual use of inferior materials by mature, professional painters is a new trend that has little precedence.

Painting materials in the earliest recorded days were indeed precious things; most of the raw materials were rare, they were obtained at the expense of much labor, and they were very costly. In the times of Giotto the colors were treated like jewels and placed upon the paintings with great care. Nowadays we can discard a left-over blob of

189

hardened paint without a qualm, simply because it would be foolish to spend a day's labor to wash out the pigment, purify and regrind it when it can be replaced by clean, fresh material for a few cents. Our best materials are superior to the old grades in every way; they should be handled with the proper respect for their qualities. The use of cheap and inferior grades should be confined to purposes for which they are best suited. As previously indicated, all sorts of inferior materials have been common to all ages and places, and the careful painters of the past have always had to learn how to cope with such conditions.

Toxic materials and hazardous procedures. The approved, standardized materials used by painters and sculptors are perfectly safe and may be used without any ill effects, provided that the precautions given for the various materials are observed. Most of these are simple, relating to personal cleanliness, housekeeping, and adequate ventilation. In other words, they are not automatically safe or free from latent or potential hazards as are the special materials that are supplied to schoolchildren. These materials do require some alertness and attention. It is something like driving an automobile on an easy trip. The experienced driver knows that dangers lurk on every hand, yet this does not deter him from the routine of a safe trip; he observes all safety rules.

As noted under White Pigments on page 37, white lead (flake white) requires special handling; despite its potentially toxic nature it is preferred by many painters over the alternative nontoxic pigments —zinc and titanium whites. Only two other approved permanent pigments are sufficiently toxic to receive special warnings—Naples yellow (lead) and the pinkish shades of cobalt violet (arsenic), neither of which can be used in pastels because of the hazards of breathing the dust.

The artists'-materials manufacturers are closely supervised by the U. S. Food and Drug Administration which has an eye not only on the user but also on the possible inexperienced member of his household; for example, even such a familiar item as turpentine must have a poison label when sold as artists' material. Precautions regarding turpentine and the other volatile solvents are noted on page 105.

A special class of materials that require special safeguards. Most professional painters and sculptors want to buy all their materials ready-made and to be concerned with their preparation as little as possible, and most are content to remain within the bounds of recognized approved methods and materials. But some find that they cannot secure some desired novel effect with conventional artists' materials and need to try other material that they have seen used to get the same or similar effects. They have turned to a class of supplies that are not sold as artists' materials at all, but are the raw materials and intermediate compounds of industrial chemistry, intended to be sold to factories staffed by expert technicians and equipped with every modern

industrial safeguard necessary for their safe handling. Such materials include industrial resins, their plasticizers, conditioners, and other essential additives—most important, the highly specialized solvents that these resins require and which are, for the most part, highly toxic.

Such materials should not be used for haphazard experiment; the user must be willing to go through a training in their handling and learn to know when to use protective gloves, special masks, and forced ventilation to carry fumes away from the work area. Some artists avoid these dangers by making models with conventional materials and then having them reproduced in plastic by professional firms.

Examples of materials with a notorious record as poisoners include the polyester resins, vinyl chloride solutions and dispersions, epoxy resins, benzol, and MEK solvent (methyl ethyl ketone). Do not confuse my remarks on the hazardous industrial resins with the acrylics or acrylic polymer products. Their volatile solvent is water, they have no toxic properties, and their behavior has become thoroughly known through decades of use.

Methods of Enlarging and Transferring Drawings

Tracing methods. Tracing paper, a thin semitransparent paper or plastic material, is the usual and simplest means of copying a drawing, the paper fastened or held firmly over the surface and the lines gone over with a pencil. A transparent sheet, such as acetate, may be used to cover and protect a valuable drawing from being injured. Tracing may be made on heavier paper if a tracing box is used, a wooden box that contains an electric light and has a top that is a sheet of ground glass. An assortment of modern thin tracing materials made of plastic rather than paper is available. One side is mat, the other shiny; they are more transparent than tracing papers. Tracing cloth is a thin, treated cloth used by engineers and architects in place of tracing paper when there is need for a tough, durable tracing that can be stored indefinitely. It has a faint blue color. A cartoon (the preliminary life-size drawing for a mural painting) is transferred to the wall by going over its lines with a tracing wheel—a small spiked wheel at the end of a wooden handle—which perforates the paper. The cartoon is then fastened to the wall, and its perforated lines are pounced, or tapped, with a small muslin bag containing charcoal, burnt umber, or another pigment in special cases. A cartoon can be saved by perforating a tracing-paper copy of its lines instead of the original.

Transfer paper. The ordinary typewriter carbon paper as well as colored varieties obtainable in art-supply shops are used by artists for transferring drawings onto canvas, but a much better product is *graphite paper,* which deposits an image that is the equivalent of a soft lead pencil which is generally better than the greasy carbon paper marks. A homemade version is made by rubbing soft graphite or a number 4 to number 6 lead pencil on tracing paper or other thin stock.

Squaring. The most widely used method of transferring a drawing to a large canvas or a wall and at the same time enlarging it to suit its new situation is called squaring or squaring off, and it consists of ruling the drawing into precisely measured squares. The canvas or wall is then ruled into the same number of squares as described on page 161. Each square of the drawing is then copied freehand onto its corresponding large square; the amount of detail which is feasible to include will depend on the number of squares one has chosen to use in the first place. When the original drawing or other work must be preserved intact, a sheet of acetate or tracing paper may be fastened over it and the grid of squares ruled on this protective surface with black drawing ink and a ruling pen. Squaring was used in early civilizations; it has sometimes been referred to as graticulation. It was used in ancient Egypt and perhaps earlier (see Figure 116).

Mechanical Aids to Enlarging, Reducing, and Copying

Pantograph. A simple, inexpensive device that operates on essentially the same principle as lazy tongs. Four rigid, flat bars (wood or aluminum) are jointed in a rectangle, the ends of the strips overlap and can be adjusted according to the scale of the copy desired; the end of one strip is securely anchored to the drawing table. There is a tracing point at one joint and a drawing arrangement, usually a pencil holder, at an opposite end. As the tracing point is passed over the original, the four bars move in unison and the copy is drawn on the sheet of paper that has been appropriately positioned on the drawing board. The pantograph is available at complete art-supply shops, in a number of grades, ranging from professional models of great precision to inferior, rather inaccurate toys.

Camera lucida. An optical device for projecting an accurate image of an object or a scene on a surface for tracing. It has been widely and successfully used, especially by commercial artists and illustrators, and is available from art-supply sources in various qualities up to finely made optical instruments for professional use. The modern camera lucida consists of a stand with an adjustable arm at the end of which is a prism which interposes an accurate image between the eye and the drawing paper, on which it can be traced. The size of the image may be varied by adjusting the distances or by the use of lenses placed between the prism and the drawing surface or the eye of the viewer and the prism. Popular since the early nineteenth century, the camera lucida replaced a larger, more difficult apparatus called camera obscura, which had been used since the sixteenth century. The camera obscura was a box with a small aperture containing a double convex lens, sometimes large enough to be a chamber in which the artist sat. Its Latin term means "dark chamber," and the principle of the apparatus is the source of our modern camera. Camera lucida means "bright chamber."

116. An ancient example of the squaring technique.

The opaque projector. This term covers several different versions of a machine, ranging from a simple lantern the size of a slide projector in which a small drawing (up to 6 × 6 inches) may be projected onto a canvas, panel, or wall for tracing, to large machines used in commercial-art studios that sell for hundreds of dollars and have a number of refinements and conveniences, such as a hood enveloping a slanting or horizontal drawing board and curtains to screen the working area from the room lighting. Each has its own proprietary name. Artists have also used ordinary slide projectors with black-and-white or color slides, tracing the images directly on wall or canvas.

193

BOOKS FOR FURTHER REFERENCE

Works that cover the whole field of painting

The Artist's Handbook of Materials and Techniques by Ralph Mayer. New York: The Viking Press, 3rd revised and enlarged edition, 1970.

The Materials of the Artist and Their Use in Painting by Max Doerner. New York: Harcourt Brace Jovanovich. Translated from the German by Eugen Neuhaus, 1934. Written in the 1920s.

The Painter's Method and Materials by A. P. Laurie. New York: Dover Publications, 1967; paperback reprint of a 1934 British book. By an eminent British specialist.

Notes on the Technique of Painting by Hilaire Hiler. New York: Watson-Guptil, 1968; reprint of a 1934 book.

Painting Materials by Rutherford J. Gettens and George L. Stout. New York: Dover Publications, 1965; paperback reprint of 1942 edition, New York: D. Van Nostrand Co.

Dictionaries

A Dictionary of Art and Artists by Peter and Linda Murray. Baltimore, Md.: Penguin Books, paperback, n.d.

A Dictionary of Art Terms and Techniques by Ralph Mayer. New York: T. Y. Crowell, 1970; Apollo edition, paperback, 1975.

Printmaking

Artists' Manual for Silk Screen Print Making by Harry Shokler. New York: Tudor Publishing Company, 3rd edition, 1960.

New Ways of Gravure by Stanley W. Hayter. London: Routledge and Keegan Paul Ltd., 1949.

194

Pastel

Pastel Painting Step by Step by Elinor Lathrop Sears. New York: Watson-Guptil Publications, 1947.

Tempera painting

Treatise on painting written in the fourteenth century by Cennino Cennini. Translated into English, in *The Craftsman's Handbook* by Daniel V. Thompson, Jr. New Haven: Yale University Press, 1933. New York: Dover Publications, paperback reprint, 1954.

Fresco painting

Fresco Painting by Olle Nordmark. New York: American Artists Group, Inc., 1947.

Synthetic mediums

Painting with Synthetic Media by Russell O. Woody, with a technical appendix by Henry W. Levison. New York: Reinhold Publishing Corp., 1965.

Synthetic Painting Media by Lawrence N. Jensen. Englewood Cliffs, N.J.: Prentice-Hall, 1964.

Encaustic

Encaustic Materials and Methods by Frances Pratt and Becca Fizell. New York: Lear Publications, 1949.

Watercolor

Making Water Color Behave by Eliot O'Hara. New York: Minton Balch, 1932.

Making the Brush Behave by Eliot O'Hara. New York: Minton Balch, 1935.

INDEX

Figures in italics indicate pages on which illustrations occur.

HPoF